INFINITE GAME UNIVERSE:
Mathematical Techniques

INFINITE GAME UNIVERSE:

Mathematical Techniques

Guy W. Lecky-Thompson

CHARLES RIVER MEDIA, INC.
Hingham, Massachusetts

Publisher: David F. Pallai
Production: Publishers' Design and Production Services, Inc.
Cover Design: The Printed Image

CHARLES RIVER MEDIA, INC.
20 Downer Avenue, Suite 3
Hingham, Massachusetts 02043
781-740-0400
781-740-8816 (FAX)
info@charlesriver.com
www.charlesriver.com

This book is printed on acid-free paper.

Guy W. Lecky-Thompson. *Infinite Game Universe: Mathematical Techniques.*
ISBN: 1-58450-058-1

Library of Congress Cataloging-in-Publication Data

Lecky-Thompson, Guy W.
 Infinite game universe : mathematical techniques / Guy W.
 Lecky-Thompson.— 1st ed.
 p. cm.
 ISBN 1-58450-058-1
 1. Computer games—Programming. I. Title.
 QA76.76.C672 L43 2001
 794.8'151—dc21
 2001001648

Printed in the United States of America
01 02 7 6 5 4 3 2 First Edition

This book is dedicated to my wife, Nicole,
for her encouragement and support.

CONTENTS

ACKNOWLEDGMENTS

The author's name is traditionally the only one that adorns a book, but it would be both ungrateful and dishonest of me to claim that this work is the result of one mind. First, I would like to thank my wife and family for their words of encouragement during the time it took to write the book.

I would also like to thank Dave Pallai and his team at Charles River Media, for their part in bringing this book from idea through to the final product that you are now reading.

There are many individuals whose work I have quoted from, read, and absorbed, and others who have helped and inspired me along the way, too numerous to mention. However, I feel that Mark DeLoura, the editor of *Game Programming Gems*, should be mentioned, because he accepted my first articles that brought me to the attention of Charles River Media in the first place.

Finally, I owe a debt of thanks to the various educational establishments that I have attended over the years; this is a work of my mind, and they helped to tune it.

PREFACE

Once upon a time, when 32KB of memory was considered *de rigeur* for affordable home computers, and the name Microsoft was not yet heard of, a British company released a series of machines carrying the name "BBC." There was a BBC Model A, a BBC Model B, not to mention in later years, machines with memory capacities reaching 128KB and beyond.

This company, Acorn, also released some other machines, a little brother to the BBC B called the Acorn Electron, with a cheap but functional 16KB of random access memory, and 16KB of read-only memory.

The reason for this brief history lesson is that the Acorn Electron was the first computer that the author owned, and bundled with that computer was a game that was to change the way he looked at these machines. The game was called *Elite*, written by David Braben and Ian Bell.

The name *Elite* should be familiar even today; although the original version was released in the early 1980s, the game has been ported to many platforms, including the Commodore Amiga, Atari ST, and, now, the PC. It has also been released in three versions.

Aspiring game programmers should attach great stigma to the *Elite* series, for the important reason that from the first version to the last, the core game style has not changed at all. The original version boasted a universe of literally millions of stars, each with its own name and characteristics.

Clearly, if we are to populate such an immense universe, with a machine that has no external storage possibilities (except a very slow tape drive) and 16KB of memory, there is more at work than just loading the entire collection of objects into memory. Especially since even to store the coordinates of the stars would require more memory than the machine possesses.

The key is, of course, entirely mathematical in nature. The neighboring stars are actually generated in real time as the player comes across them, as are the various ships that attack the player, the behavior of those ships, the prices of goods that can be traded, and just about every aspect of the interaction between the player and the Game Universe.

Each time that *Elite* was ported, all that changed was the quality of the human-machine interface. The wireframe spacecraft and space stations became shaded 3D polygons. The main graphical user interface became more colorful, as bits and pieces were added that added to the realism. The core game-playing algorithms did not change.

Thus, playing *Elite* on any platform feels like putting on a comfortable pair of slippers. No matter the game machine, a good *Elite* player will remain a good *Elite* player. Even from one version to another, pieces have been added, but they are all window dressing. The core idea behind the game remains identical: the driving force to trade, kill, make money, travel, and explore has not changed since 1982.

It doesn't need to; *Elite* remained one of the most played games on the planet for about 15 years, and helped inspire this book.

This is not a book about graphics programming. It is not really a book about games programming *per se* either. It is about technique, design, and implementation of algorithms with which an Infinite Universe can be built. The foundation for long-lived games, if you will, lies in the ability to retain the interest of the player—Infinite Universes tend to do that.

We will touch on many aspects of mathematical theory, from random numbers to fractals, taking in analyses of chance, probability, and predictability. Along the way, we will analyze a variety of game programming models, and look at how even the simplest can be represented using infinite mathematical techniques.

Of course, there will always be those who ask, "Why bother, when we can just stick it all on a CD?" In part, of course, they are right. The average DVD can hold *gigabytes* of information. A CD for the Sony PlayStation holds about 700 *megabytes*. The storage capacity available to modern-day equipment is phenomenal.

It will, sadly, never be enough. There will always be a limit as to how much video, sound, graphics, level files (a *Doom* "wad" file, representing one level, can easily reach 2MB), and associated media can be stored. In the end, something will suffer, and it is usually to the detriment of the entire game.

Taken to their logical conclusion, the techniques presented here will help to replace much of the aforementioned; after all, if random words can be generated that make good names for star systems, so can other facets such as video footage. The reader will hopefully be able to extend the algorithms, theories, and implemented examples presented in this book to be used in their next creation.

Of course, not everything that a game can do happens in real time. We have fast-access storage media, so we should make the most of it. The book also treats the preprocessing side of the algorithms, which will ultimately help to increase the efficiency, another facet of games programming that is studied within this tome.

The book is aimed at a wide audience. In a very real sense, anyone who is interested in mathematics or computers, game design, or game programming will get something out of reading it. Those who will get the *most* out of this book are those in the games industry (or those who want to be). For the game designers, programmers, and players of the world, this is a book for you.

The Infinite Game Universe

One of the most important elements of any game is the universe in which it is played. The Game Universe encompasses all aspects of the creator's dream. It defines the backdrop, rules of play, interface, characters, and story line. Each of these distinct elements need to be tightly integrated and woven together to create a theme that captures the imagination of the player.

Tying all of the pieces together requires the coordination of more than one person; quite often, a number of teams will be required, from programmers and level designers to the artists who render the final graphics. The common, sometimes overlooked, thread that binds them together is the realm of mathematics.

Everything that a computer does is because of mathematics; not only numerically speaking, but also logically. There is a branch of mathematics in each part of a piece of software, whether it is an office automation application or a game.

Often, however, we neglect the use of mathematics when we consider how a game might be defined. Obvious uses of mathematics include the rendering of graphical elements, the scaling, rotating, and drawing of those pieces that make up the interface and depict the action taking place in the Game Universe. Any game containing a modicum of artificial intelligence will also borrow heavily on mathematical techniques, in terms of the logical relationship between actions, and their consequences.

Quite apart from the end product, there is also a period of preproduction, during which the various elements that will eventually come together

to form the game that is released to the public need to be created, examined, defined, and stored in a way that will be easy to extract once the play begins. Here again, mathematical techniques can ease the chore of turning the dream into reality.

Within the software industry, games are the ultimate test of a computer's ability to perform. From high-end PCs to dedicated consoles and handheld units, game developers seek to push the machine to its limits. It is an industry in which failure can be catastrophic, and the audience one of the most critical around. Every little glitch will be found, noted, and held against the developers.

Games are works of fiction. They require that players become immersed in the Universe, and believe every aspect of it. For the time that the players are playing, they must be captivated, and led to hold their disbelief in suspension until dragged out of the Game Universe into the real world.

The only way that this will be possible is if, within the rules of the Game Universe, everything is uniform, well defined, and well depicted. Most games will have rules that mirror the real world to a certain extent. Deviations must be believable, or the game will no longer hold the attention of the audience.

We are quickly arriving at a situation in which the sheer processing power of today's games machines exceed the capacity of the slower hardware to react. This means that it is quite often the case that the game cannot wait for data to be moved from external media to memory while the game is in play, so it makes more sense to move required data in advance and act upon it in real time.

While this means that the capabilities of modern systems lend themselves to monumentally complex and realistic Game Universes, complete with full-motion video and photorealistic graphical elements, the expectations of the target audience have also risen accordingly.

The underlying aim of this book is to provide a set of mathematical techniques and tools that enable game programmers to realize the most complex dreams of the designers. The central theme is in providing ways in which almost Infinite Universes can be created, but along the way we shall see how the mathematics can lead to some savings in external storage requirements while also providing mechanisms for taking away the necessity to store unnecessary information.

An infinite resolution deals with the front end of the Game Universe— landscapes, buildings, or even a simple *Pac-Man* style maze—along with

other graphical elements, all of which may be described in a mathematical manner, with minumal storage requirements. This we shall refer to as *micro-infinite resolution*.

Linking this with the *macro-infinite resolution* of the Game Universe are the mechanics of the game, those rules that define the interaction between the objects and their surrounding environment.

No book on mathematics would be complete without equations and algorithms used to provide a way in which the principles and techniques can be implemented. Similarly, since this book covers programming, there must be ways to represent the algorithms in the real world.

However, while the equations are presented within the text, we have attempted not to provide reams of code within the text itself. Rather, snippets are used to elaborate upon the algorithms, as required, with the bulk of the code that provides the basis for the example applications on the companion CD. In doing this, we minimize the impact of the code on the flow of the discussion, while providing ample scope for the reader to experiment with real code.

The code falls into two categories: that which is a result of the algorithms, and that which is needed to provide a test harness application into which the core code can be placed. These applications are written for the Microsoft Windows operating system, but in such a way as we hope that porting to other operating systems can be performed as easily as possible.

The Contents of the Book

PART I: INTRODUCTION TO RANDOM NUMBERS

As a starting point, random numbers and the generation of sequences of numbers are a good introduction to the possibilities of using mathematics in creating complex Game Universes. Similarly, the examination of the interplay between numbers is also a very good way to present the other techniques in the book.

In this first part, the reader will learn how algorithms that create sequences of numbers can be put together, and how the reliability of number sequences can be tested and predicted. The reasoning behind using random numbers and the ways in which they can be useful in games programming are also explored.

PART II: PREDICTABILITY

Once we have established the mathematical theory behind random and pseudorandom numbers, we should take a more detailed look at how they fit into the theory of Game Programming. In particular, Part Two details why these algorithms are useful to the game programmer, and how they can be used to great effect in describing the Infinite Universe.

We will discuss how such techniques can be used to give both breadth and depth to a game, increasing detail while also dealing with multiple objects.

PART III: PROBABILITY AND EXTRAPOLATION

Following the theme of random algorithms, Part Three takes the reader through the various sampling and generation algorithms that are needed when creating an Infinite Game Universe.

Techniques are used from both the first and second parts of the book, bringing together all the threads of mathematics, algorithms, and Infinite Universe theory that are discussed therein.

PART IV: FRACTAL GENERATION

Taking a step away from the simple branches of mathematics, and moving into more complex areas, Part Four looks at how fractal techniques can be useful in creating an Infinite Universe.

It is also a good starting point for more elaborate theories, and plenty of scope for experimentation is given.

PART V: THE GAME SPACE EXAMPLE

Finally, we use the techniques discussed in the book to write a very simple game, which will allow the reader to see how the algorithms are applied in the real world.

Of course, it is, by necessity, not complete, and the reader is encouraged to play with the code and see just how far the simple ideas presented in Part Five can be taken within the restrictions imposed.

RANDOM NUMBER GENERATION

Generating random numbers provides games programmers with a good method of adding an element of infinity to their creation. In part, this is because by using techniques to generate objects and their behavior at random, one will never be sure what the outcome will be, and the chances of having the same outcome twice in a row are quite small.

The technique is best suited for adding a spark of uncertainty to the game, keeping the interest of the player, and also making the game just that little bit tougher to master.

There are, however, some aspects for which this is not a good technique, such as creating Infinite Universes in which a certain level of predictability is required. Consider, for example, changing the layout of a level such that it is entirely different each time it is played. This will serve only to confuse and annoy—the aim here is to stimulate.

We have a sibling technique, discussed in Part Two, "Predictability in Game Design," that deals with the use of entirely predictable random number sequences in game design, but it is important, for those who have not yet examined the area of random mathematics in detail to begin here.

INTRODUCTION

Before we embark on our journey through the mathematical principles of random number generation, we should first consider why, in the course of games development, random numbers are important.

More precisely, we are dealing with sequences of numbers that are generated on a random basis, as opposed to generating discrete numbers. Sequences are important because they relate to the events, attributes, and objects that make up the Game Universe, and the way in which they relate to each other.

Sequences of random numbers have an important part to play in populating the game universe. By way of example, let us consider a simple game such as "pairs," where the object is to scatter the cards face down in a random basis, and the players must attempt to match cards numerically by suit color.

The game universe in this case is populated by a deck of 52 cards, divided into four suits of two colors that contain cards that can be matched numerically. The cards are then spread in a random fashion, face down, on the playing area (the floor or a suitably large table).

The player chooses a card, and turns it over. He or she must then choose another card, and turn that over. If the two match, the player may then remove them; this forms a "trick." If the two do not match, the player turns them both back over, and play moves in a clockwise fashion to the next player.

The winner is the player who matches the most cards, thereby having the most tricks by the end of the game (when no more cards remain).

While a human can quite easily shuffle and spread out the cards on the playing surface in a random fashion, computers must approach the problem in a more ordered way.

Random number sequences are used in preparing the card layout on the screen with a different layout being achieved each time. Each card is assigned a number between 1 and 52. A series of numbers between 1 and 52 must then be generated, such that each number appears only once and there is no discernable pattern in the sequence.

The virtual deck now being shuffled, the cards are displayed on the screen in a regular fashion, the layout appearing as shown in Figure I.1. This is a screen shot of the PAIRS program that appears on the companion CD, with which the reader is welcome to experiment.

This same principle for shuffling items can be applied to any game in which a randomly shuffled deck of cards, or other objects, is required.

From this simple use, we can also devise a number of ways in which sequences can be used to instantiate a large number of complex objects on a random basis. In using a random number generator, we can continue to

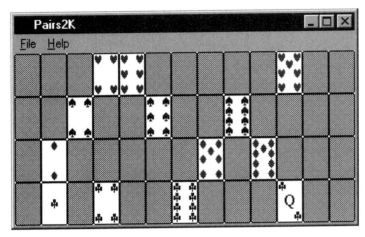

Figure I.1 The Pairs2K program.

instantiate an infinite number of such objects; constrained only by their properties, and the rules of the Game Universe. A deck of cards, for example, contains a limited number of cards, but we could choose to populate an infinite number of decks on a random basis, should that be required.

THE NATURE OF RANDOM NUMBERS

The *Longman Dictionary of Contemporary English* (Longman, 1987) offers the following definition of the concept of randomness:

> "without any plan, aim, or pattern . . . chosen in such a way that [anyone] is equally likely to be chosen"

Let us consider flipping a coin a certain number of times. There are two possible outcomes each time the coin is flipped; it lands either with the "head" side up, or with the "tail" showing. We cannot know in advance whether a particular flip will end with a "head" or a "tail," but we can say that there is a 50-percent chance that it will be one or the other.

In fact, if we were to flip the coin an infinite number of times, we would be fairly certain that a mathematical analysis would lead us to conclude that within reasonable bounds, the result would be either a "head" or a "tail." Of course, there is the infinitely small chance that the coin might land on its edge, but this occurrence can be considered negligible for the purposes of this discussion.

Taking another analogy, if we were to shuffle and pick a card from a deck an infinite number of times, we could be quite sure that each number would appear an equal number of times. This holds, even though there are four examples of each number (one per suit) within the standard deck.

For a slightly more technical description of random numbers, and in relation to mathematics and computers, we might prefer Dr. Hans Lauwerier's definition as it appears in his book *Fractals: Images of Chaos* (Penguin, 1987, p. 105):

"within statistical limits, all combinations occur equally often"

The important consideration here is the mathematical qualification that the possible combinations occur in a fashion that can be subjected to statistical analysis that proves that each is equally likely.

To be sure that a given generated sequence of numbers is random in nature—that is, without pattern—we can subject it to statistical analysis. In order to do this, we must define the sequence in mathematical terms. In essence, we need to be able to assign a strict algorithm comprised of mathematical formulae to the selection process.

Theories abound as to what the ideal algorithm for achieving such a sequence might be, and we will be examining some in the following chapters. In the meantime, we should concern ourselves with the mathematical proof, using statistical analysis, that will enable us to be certain that the chosen algorithm is in fact producing a fair approximation of random behavior.

Mathematicians will be quick to point out a variety of proofs that will satisfy, but since this book is not designed principally to be a mathematical text, we shall adhere to the simplest method available—trial and error. In this case, though, it could be named "trial by fire," since any algorithm that fails to satisfy will be eliminated.

Before we continue, however, let us consider the situation in terms of game programming.

THE MATHEMATICS OF CHANCE

Earlier we saw how the flipping of a coin can be expressed in terms of chance. Formally, we might say that for a given throw, the chance of each of the possible outcomes being realized can be expressed by Equation 1.1.

$$\frac{1}{n} \quad \text{Chance of outcome} \tag{1.1}$$

Where n is the number of possible outcomes. Arriving at a percentage is shown in Equation 1.2.

$$\frac{1}{2} \Rightarrow 0.5 \Rightarrow 50\% \quad \text{Percentage chance of outcome} \tag{1.2}$$

In other words, in English, there is a 50-percent chance that the result will be either a head or a tail; flipping the coin 100 times, we would expect that 50 heads and 50 tails would be forthcoming. Were we to actually perform the experiment and count the number of each, we would hope that within statistical limits, this would be true.

We also mentioned that there is the remote possibility that, if the coin is thick enough, it might land on its edge. However, in terms of game programming, we can deal with this neatly by saying that it falls outside the rules imposed by the Game Universe. Pure mathematicians would attempt to calculate the probability of the coin landing on its edge, but we have chosen not to concern ourselves with this particular mathematical conundrum.

This selectiveness will prove to be important later in this part of the book, where we discover that numbers in certain algorithms stabilize our generator due to the mathematical principles that are intent on restoring order to chaos.

If we were to build a coin-flipping algorithm, we could test it by applying the principle just discussed, and checking that, given a finite number of runs, the results tended toward a 50/50 distribution of heads and tails.

We will apply this method of establishing the effectiveness of a given algorithm each time we wish to check on the performance of a particular series of transformations. Let us temporarily close the discussion now by saying that the amount by which we allow the distribution to vary from the expected results will be proportional to the number of runs and the difference between the maximum and minimum possible values.

In short, the higher the number of possibilities, given a finite number of runs, the less certain we can be that the distribution is mathematically perfect. To be absolutely sure, we would need to apply the algorithm an infinite number of times. Indeed, for very large possible distributions, we would need to allow for a disproportionately large number of runs, which is why the application of statistical evaluations will prove to be invaluable to us in testing our algorithms.

ALGORITHM CHOICE

Before we move on to the next chapter, where we shall consider some possible algorithms, it is worth noting the observations of Dr. Knuth, who performed an experiment detailed in *The Armchair Universe* by A. K. Dewdney (W. H. Freeman & Company, 1998, p. 226).

Dr. Knuth decided that in order to choose a sequence of random numbers, he would establish a set of algorithms for generating number sequences that were fairly random. He then proposed that a number be chosen at the start of the execution cycle, of which two of the digits were to specify the algorithm to use in generating the next number in the sequence, and the number of times the algorithm should be repeated.

Despite being, on the face of it, a devious way to choose random numbers, the sequence converged on a 10-digit value 6065038420, which "by an extraordinary coincidence, is transformed into itself by the algorithm."

Dr. Knuth's conclusion:

"Random numbers should not be chosen with a method chosen at random. Some theory should be used."

No matter what devious algorithms we devise to generate sequences of random numbers, we should always bear in mind that they should be mathematically logical. The following chapters will enable us to determine how such an algorithm should be created, and how we can test to ensure that the sequence that it generates stands up to statistical analysis of its randomness.

SIMPLE RANDOM NUMBER GENERATION TECHNIQUES

In attempting to show what mathematical principles are important when creating algorithms to generate streams of random numbers, we will be looking at two examples that use different techniques. The first is semi-mathematical in nature; that is, it contains a calculating component and a component that is more abstract.

The second is entirely based on the rules of mathematics, using only calculations that can be performed by a calculator. The choice of algorithm will vary according to the environment; pure mathematical techniques tend to be less computationally expensive, as we shall see.

LAUWERIER'S ALGORITHM

Before we analyze exactly what mathematical principles can be applied in order to generate a sequence of numbers that do not follow a pattern, we should take a look at some examples that prominent mathematical figures have suggested in the past. The first is deceptive in its simplicity, and is taken from Dr. H. A. Lauwerier's book *Fractals : Images of Chaos*, page 105:

> Select a 4 digit number x
> $x => x^2$
> Remove 1st and last digits of the result until
> a 4 digit number remains

This is the random number
Repeat with this as x

ALGORITHM 2.1 Lauwerier's algorithm.

According to Dr. Lauwerier, this produces a sequence of numbers between 0 and 9999 that:

"does not fail statistical tests of randomness"

Exactly what these "statistical tests" are is not explained. It is safe to assume that mathematicians would not hesitate to furnish us with elaborate proofs by which it might be shown that this was true (or false). For our purposes, however, a more qualitative logical explanation will suffice.

We saw in Chapter 1, "The Nature of Random Numbers," that in order to satisfy the definition of *random*, each possibility should occur with an equal chance. Illustrated by a coin toss, we can extend the theory to state that this would require a distribution in which each number had the following chance of being chosen. Example 2.1 shows the application of Equations 1.1 and 1.2 to Lauwerier's figures.

$$\frac{1}{x} \Rightarrow \frac{1}{1000} \Rightarrow 0.001 \Rightarrow 0.1\%$$

EXAMPLE 2.1 Application of the outcome equations.

Therefore, we could say that if, in a given run, each number was seen to be chosen, on average, about one-thousandth of the time, our algorithm would at least generate a sequence of numbers in which each one had an equal chance of being selected.

TESTING FOR RANDOMNESS

However, a simple application of logic leads us to deduce that if an algorithm were applied in which the first number was simply incremented 1000 times, starting from 0, then this would also create a sequence of numbers that would satisfy our simple test. It would not, however, qualify as random, since a discernable pattern would evidently be apparent.

Clearly, then, the test should be more sophisticated than that. Instead, let us imagine that we will apply the algorithm 2000 times. If, after 2000 runs, the distribution of numbers were to remain within our limits, could we then say that a random generator had been found?

Unfortunately, no, since mere distribution is not enough to provide us with a test for randomness. It is, obviously, part of the test that needs to be applied, since it gives us a basis for saying that the distribution will at least be even. In other words, no number or numbers will be neglected, and each has an equal chance of being chosen.

In order to satisfy the other part of the dictionary definition that we examined in Chapter 1, there must be an "absence of pattern" in the results. The human brain is very good at analyzing data in order to spot the presence or absence of a pattern. Mathematics, with its base in logic and the intrinsic nature of calculations to be predictable (i.e., with a pattern), is not.

Therefore, it will be with the human eye that we devise our first test of randomness. The plot in Figure 2.1 is the output of the software found on the accompanying CD, called "DISTRIBUT." It is achieved using the Lauwerier algorithm, with a starting value of 1234, multiplier of 2, four-digit maximum length, and a "simple" plot style. Readers are welcome to experiment with the package to achieve a result that they find aesthetically pleasing, but we will be examining the other options at a later date.

The little crosses represent the numbers that have been chosen by the algorithm (0 to 9999). The line running roughly through the center of the figure indicates whether a value is higher or lower than the preceding one; that is, it moves up by one unit if the current value is higher, and down by one if it is lower.

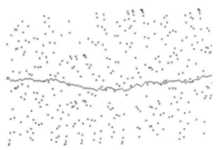

FIGURE 2.1 Basic Lauwerier distribution.

Broadly speaking, this line is a good indicator of whether the distribution is fairly random. If, as in this case, it finishes at roughly the same height at which it starts, and deviates in a way in which no pattern can be discerned, we might hazard that the numbers chosen satisfy this test of randomness. Were the line to be straight, or evenly "jagged," we would be able to say that the distribution was not, for this sample at least, able to satisfy the tests of randomness.

In addition, the crosses lend clues as to the randomness of this algorithm—they do not converge at any point, nor is there one specific area that is not covered by some of the crosses. Obviously, not every point is covered, and equally obviously, some are covered more than once; this is to be expected with such a limited run.

We say that this run is limited; in fact, the length of run that would be required to ensure that every single point is covered is something that we will consider in our conclusion to this chapter. However, we can say at this point that it is a function of the number of possibilities.

Furthermore, although there may not seem, on the face of it, that a pattern in the numbers chosen is forthcoming, we have no idea whether the sequence of numbers shown previously would be repeated in its entirety, were the sequence allowed to develop further.

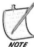

Numerical Limitations

In order to keep the number chosen within limits that are programmatically possible, we have modified Lauwerier's algorithm slightly, by performing a multiplication by 2 of the number rather than squaring it. As can be seen from the plot achieved in Figure 2.1, this does not change the outcome by a significant degree; the result is still without pattern—random.

Further investigation of the parameters that can be used to generate the plots can be seen in Figure 2.2.

The plot in Figure 2.2d is immediately recognizable, following our rules regarding distribution of crosses and meander of line, as a good approximation of random behavior.

Looking at Figures 2.2b and 2.2c, we can see that the distribution is anything but random, although in Figure 2.2c we might hazard that at least it appears to be fairly even. There is, however, a clear pattern to the choice of numbers.

Clearly, Figure 2.2b fails all tests of randomness that we might like to throw at it. Looking at the crosses (which now resemble lines rather than

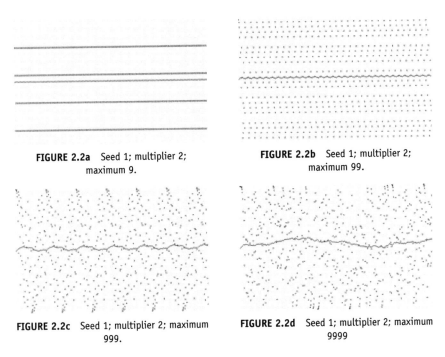

FIGURE 2.2a Seed 1; multiplier 2; maximum 9.

FIGURE 2.2b Seed 1; multiplier 2; maximum 99.

FIGURE 2.2c Seed 1; multiplier 2; maximum 999.

FIGURE 2.2d Seed 1; multiplier 2; maximum 9999

FIGURE 2.2 A selection of Lauwerier algorithm distribution plots.

points), we can see that the choice of numbers has settled on four different ones. We say that the algorithm has stabilized.

Which leaves us with Figure 2.2d, perhaps the most interesting of all. A very quick first glance might prompt the reaction that it appears to be random. However, upon closer inspection, it can be seen that this algorithm has settled into a pattern, that while less apparent than in Figures 2.2b and 2.2c, is quite regular.

The use of the centerline as an indicator of randomness is illustrated clearly here. Without the line, the extent of the pattern is unclear; however, the line indicates that there is a very definite pattern.

DEFINITION 2.1 PLOT ANALYSIS TERMS

There are a few terms that we will use in describing the results of the algorithms, derived from observing their plots. The first is *periodicity*, meaning the extent by which a pattern repeats itself. Figure 2.2c shows a high periodicity, while Figure 2.2d shows a low periodicity; the pattern repeats itself less often.

The second term we will use is *meander*. Derived from looking at the centerline, it is the extent by which the line fluctuates between its maximum and minimum values. Thus, Figure 2.2b shows a low meander, while Figure 2.2d shows a high meander.

The meander is caused by chains of consecutively rising or falling results, and may indicate a suspicious distribution of generated values. Points to watch out for in this case are repetitions in the meander of the line.

Finally, we have two terms that describe the individual numbers generated by the algorithm. The *distribution* or *spread* is used to describe the way in which the results are grouped. Figures 2.2b, 2.2c, and 2.2d all show fairly high distributions, while Figure 2.2a shows a low distribution of results: all the numbers generated fall within very specific bounds. Usually, results also have a *bias*, which simply indicates whether or not they are generally higher or lower than the median (being the "middle" value).

DEWDNEY'S ALGORITHM

In *The Armchair Universe*, Dewdney suggests a more complicated algorithm that follows a similar branch of Lauwerier's theory expressed earlier. The algorithm itself is thus:

$$n \rightarrow (n \times m) + k$$
$$n \rightarrow n \text{ MOD } p$$
n is the random number
Repeat with n

ALGORITHM 2.2 Dewdney's algorithm.

In this algorithm, the numbers represented by n, m, k, and p are chosen before execution.

The operator MOD (sometimes written %) is the remainder after an exact division of n by p.

The highest value returned in n will therefore be p-1.

This looks a little daunting at first sight, but if we choose numbers that are easy to manipulate, it is easy to see how it works. As a first example, let us look at Example 2.2.

Input Values
N = 2; m = 10; k = 100; p = 5

First Iteration
n → (2 × 10) + 100 n = 120
n → 120 % 5 n = 0

Second Iteration
n → (0 × 10) + 100 n = 100
n → 100 % 5 n = 0

Subsequent Iteration Results (n)
0, 0, 0, 0...

EXAMPLE 2.2 Dewdney's algorithm with low numbers.

Since 100 (k) is a multiple of 5 (p), the result of the modulo operation (MOD) will always be zero. Also, 10 (m) is also a multiple of 5, which is also undesirable, since anything multiplied by 10 will also be a multiple of 5. In Example 2.3, we have chosen numbers to avoid this.

Input Values
n = 3; m = 11; k = 101; p = 5

First Iteration
n → (3 × 11) + 101 n = 134
n → 134 % 5 n = 4

Second Iteration
n → (4 × 11) + 101 n = 145
n → 145 % 5 n = 0

Subsequent Iteration Results
1, 2, 3, 4, 0, 1, 2, 3, 4, 0...

EXAMPLE 2.3 Dewdney's algorithm with high numbers.

The choice of the input values n, m, k, and p is clearly of some importance. Dewdney notes that:

"unless m, k, and p are carefully chosen, the pseudorandom numbers fail to pass even the most primitive tests of randomness."

Consider Figure 2.3, which is a plot achieved with a starting value of 1, a multiplier (m) of 100, k being 500, with a maximum (p) of 9999.

FIGURE 2.3 Dewdney's algorithm plot.

This specific combination was arrived at after experimentation with different values for m and k, until a suitably random distribution was chanced upon. Looking at this plot in terms of the definitions we established earlier, we can say that the distribution appears fairly even, with no bias.

The centerline appears to have a very high periodicity, since it does not repeat within the set of results that we have plotted. It does not meander very much, indicating that there are no chains of successively rising or falling numbers.

A quick comparison between this and the Lauwerier plot in Figure 2.1 leads us to the conclusion that this algorithm chooses number sequences that meander less. In fact, a superposition of the two yields the plot shown in Figure 2.4.

The choice of p is important, since the sequence will tend to repeat itself after a number of iterations. The exact periodicity of the repetition is a function of the number chosen for p. This is illustrated in Figure 2.5.

FIGURE 2.4 Superposition of Lauwerier and Dewdney algorithm plots.

Looking at the meander of the central line, we note that the pattern that it indicates has a periodicity governed by p. In real terms, this means that the lower the value chosen for p, the quicker the pattern will repeat itself.

The distribution of the generated values in Figures 2.5a, 2.5b, and 2.5c shows clear groupings of values, and in particular a bias toward higher

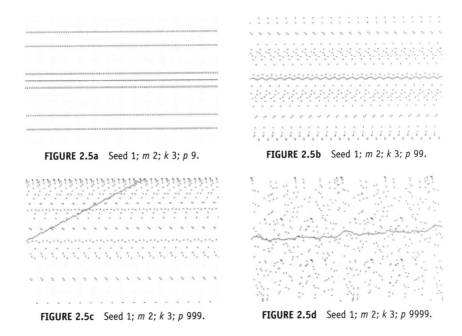

FIGURE 2.5a Seed 1; m 2; k 3; p 9.

FIGURE 2.5b Seed 1; m 2; k 3; p 99.

FIGURE 2.5c Seed 1; m 2; k 3; p 999.

FIGURE 2.5d Seed 1; m 2; k 3; p 9999.

FIGURE 2.5 A selection of Dewdney algorithm distribution plots.

numbers in Figure 2.5c; this is also indicated by the center line, which rises toward infinity.

The pattern in Figure 2.5d is less easy to spot from the distribution, due to the high periodicity offered by p. However, from the meander of the central line it is clear that there is a pattern repeating itself, and that it is following a rising trend.

One thing is clear: the choice of m, k, and p are clearly important and possibly related to each other in a way that could give a clue as to what the "ideal" choices of these numbers might be. In the spirit of research, the plots in Figures 2.6a through 2.6d were generated.

It seems reasonable to suggest that the closer together m and k (the differences in Figures 2.6a through 2.6d being 3, 4, 400, and 899, respectively), the higher the chance of there being a pattern in the meander of the central line. The general depth of the meander—that is, the amount that the line varies in each case—also seems to decrease for larger differences.

We might also speculate that with a lower depth of meander, the less likely there is to be a pattern. The conclusion is, therefore, that we should

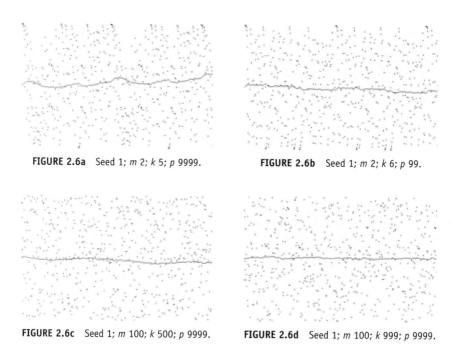

FIGURE 2.6a Seed 1; m 2; k 5; p 9999. **FIGURE 2.6b** Seed 1; m 2; k 6; p 99.

FIGURE 2.6c Seed 1; m 100; k 500; p 9999. **FIGURE 2.6d** Seed 1; m 100; k 999; p 9999.

FIGURE 2.6 A second selection of Dewdney algorithm distribution plots.

choose values for m and k that are far apart, as this will reduce the meander and hopefully reduce the chance of a pattern occurring.

Finally, we should also note that the length of any pattern that does occur is governed by p. This means that if we only need 52 numbers for our deck of cards, we might not care that the second 60 numbers are the same as the first 60 that are chosen by the algorithm that we choose. On the other hand, if we need to generate thousands of values, the choice of p can be influential.

COMPARISON OF LAUWERIER'S AND DEWDNEY'S ALGORITHMS

Lauwerier's algorithm seems after this brief analysis to be more reliable than that postulated by Dewdney. There seem to be fewer pitfalls in choosing our starting values, and the results seem to be less prone to forming patterns. It is the mechanisms by which the algorithms arrive at their results that influence the results. In understanding these mechanisms, we can use each algorithm more efficiently, and also suggest our own algorithms and enhancements.

The mathematics of the two algorithms is quite different. Dewdney uses pure mathematics; namely, a multiplication, addition, and modulo operation. Lauwerier, however, has used a part mathematical, part qualitative

DEFINITION 2.2 PSEUDORANDOM NUMBERS AND SEEDS

All of these algorithms must have an initial value, which provides input to the calculations. At the end of each iteration, the resulting value is used as the initial value for the next iteration. We call the original value the *seed*, since it is the value from which all subsequent values are "grown." By keeping the seed constant each time, we retain a scientific approach in evaluating the differences between algorithms. However, later in the book we will see how the choice of seed value for different situations can be put to good effect.

Since, for a given algorithm, using the same seed (and other input values) always yields an identical sequence of numbers, that exhibits patternless results, the algorithms are not strictly random number generators. Rather, we term them *pseudorandom* generators due to their repeatable nature.

approach in devising his algorithm. It may be expressed using mathematics, but less easily. Removing the last digit of a number is easy (it is merely a division by 10); removing the first digit less so. Readers may take a look at the source code on the CD-ROM to see how it could be done, ON THE CD but there surely exist solutions that are more elegant.

Nevertheless, looking at these two algorithms, we can see that they consist of a linear part and a nonlinear part. The linear components are shown here:

Lauwerier	Dewdney
$n^* 2$	$(n * m) + k$

What we have chosen to call the *linear components* in this case are those that, when applied, give rise to a linear progression, or sequence, of numbers that will tend toward infinity. Clearly, an algorithm consisting only of a linear part would be of no use at all for creating sequences of pseudo-random numbers, since it contains an easily discernable pattern.

In analyzing the nonlinear part (that which causes the pattern created by the linear part to be "broken"), we see that there is a real difference between the two algorithms. Taking Lauwerier's first, we have seen that it is simply expressed in English:

"remove the first and last digits until x remain"

but less so in mathematics. Nevertheless, it is clear that this operation, yielding a four-digit number that may contain zero and nonzero digits will cause whatever pattern was brought about by the multiplication to be severely disturbed.

We have changed Lauwerier's original algorithm to allow for two-, three-, and four-digit numbers, but, as we have seen, the best results are obtained with the original four digits. This is because there is more variation in using four digits rather than three or two or even one, since the set of possible numbers is comparably equal to the set of allowable numbers.

To explain this curious mathematical principle, imagine for a moment that we have chosen to use a limit of one digit. The set of allowable numbers runs from 0 to 9. The set of possible numbers runs from 0 to 18 (the upper limit being set by 9×2).

There is an overlap of the digits 0 through 8, since for those numbers that fall between 10 and 18 we remove the first digit. Therefore, the chances

of a 9 occurring are much reduced, and the other digits are twice as likely to be selected.

Applying the same principle with a two-digit limit, we see that the set of allowable numbers runs from 0 to 99, and that the upper limit of possible numbers is now 99×2, or 198. Again we see that, although the number of possible choices has increased, there will be an overlap, which will cause some numbers to be favored.

These observations are borne out by the plots shown in Figures 2.2a and 2.2b. The explanation for Figure 2.2c, where three digits are chosen as the limit, runs along similar lines. However, when we look at what happens with a four-digit limit, we find that the set of allowable numbers is now 9999, and the maximum limit for possible numbers is 19998. So, there is undoubtedly still more chance of choosing some numbers than others, but the results shown in Figure 2.2d appear to indicate that a good approximation of random behavior has been found.

By way of proof, we can plot a number of "runs" one on top of the other as shown in Figure 2.7 in order to check whether a pattern is forthcoming.

It would appear, then, that in Lauwerier's algorithm, the randomness is governed by the maximum allowable length of the number. Experimentation confirms that this is the case, and that the multiplier does not have a significant part to play; it is merely the engine that drives the process.

So, now that we have ascertained that a linear algorithm with an additional component that is designed to interfere with the pattern that it generates gives rise to fairly random numbers, we can look at Dewdney's technique by way of comparison.

In examining Dewdney's algorithm we have ascertained that the linear part consists of a multiplication and an addition, involving n, m, and k. This means that the remainder of the algorithm, involving p, should be a nonlinear component. Applying the same logic to this algorithm as before, we will hold the linear part constant and vary the nonlinear components. This is illustrated in the multiple run plots shown in Figure 2.8.

These plots differ from those created using the Lauwerier algorithm, in that there is a large amount of pattern left in Figures 2.8c and 2.8d that was not as pronounced as in the Lauwerier algorithm distribution plots. Clearly, there is something more at work than just the maximum number limit.

In fact, what we have dismissed as the linear part of the algorithm does itself contain a component that is designed to disrupt the order. That part

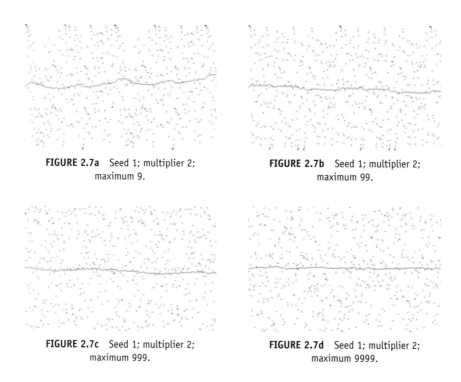

FIGURE 2.7a Seed 1; multiplier 2; maximum 9.

FIGURE 2.7b Seed 1; multiplier 2; maximum 99.

FIGURE 2.7c Seed 1; multiplier 2; maximum 999.

FIGURE 2.7d Seed 1; multiplier 2; maximum 9999.

FIGURE 2.7 Multiple-run Lauwerier algorithm distribution plots.

is the simple addition operation. This operation, when combined with the modulo operation that follows it, serves to delineate the pattern created by the multiplication.

The reader may experiment to see what occurs with a value for k of zero, in effect not using that portion of the algorithm at all, and checking against the plots achieved earlier. There is very little difference. Further experimentation proves the point we made earlier that it is the difference between the multiplier and addition that creates the random effect.

Examples 2.2 and 2.3 showed that this difference is not necessarily in magnitude, but in quality. That is to say that if both the numbers are even, then mathematically speaking, all the remaining numbers have a good chance of being even also. In the aforementioned examples, we saw this relationship at work.

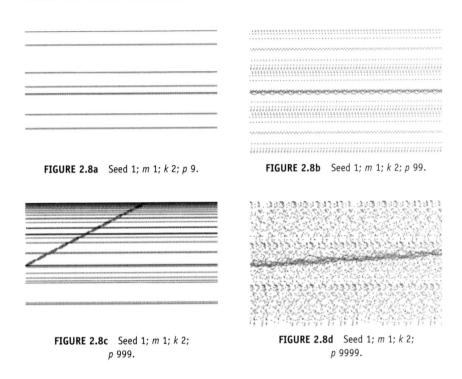

FIGURE 2.8a Seed 1; m 1; k 2; p 9. **FIGURE 2.8b** Seed 1; m 1; k 2; p 99.

FIGURE 2.8c Seed 1; m 1; k 2; **FIGURE 2.8d** Seed 1; m 1; k 2;
 p 999. p 9999.

FIGURE 2.8 Multiple-run Dewdney algorithm distribution plots.

Even numbers have a tendency to form a pattern, since they divide into each other with no remainder, whereas the introduction of an odd number will lead to a pattern that is less pronounced. However, even purely odd numbers will yield a pattern.

It is difficult, therefore, to believe that we will ever find choices of these numbers that produce a random sequence by themselves, which is where the modulo operator and choice of maximum number come into play.

The result may be even, odd, or zero, depending on the choice of variables. This adds a further element of delinearization to the algorithm. The qualitative differences between m the multiplier, k the addition, and p the modulo are the deciding factors when attempting to generate a patternless sequence of numbers.

Algorithm Choice and Comparison of Use

Deciding which of the two algorithms presented here is better depends largely upon their use within the Game Universe—different situations call for different solutions. However, one thing that they both share in common is that they work better with larger maximum values, and even in the case of the Dewdney algorithm, with large values for m and k.

Further differences are that Lauwerier uses technique to create the effect, and Dewdney uses pure math. We might decide, for example, to remove the central digit each time, instead of one from each end. Enterprising programmers are invited to pursue this line of thought; I would be delighted to hear the results.

Given that we have decided that it would be best to use large numbers, and that our Game Universe probably requires numbers that are limited between a minimum and maximum amount, how can we put them to work?

If we wish, for example, to simulate coin tosses, there is a limit of either a head, a tail, or as an outside possibility, an edge. Disregarding for the time being the latter, we have a binary possibility, head or tail. If we assign heads to be 1 and tails to be 2, we can use either of the algorithms presented here (which will generate numbers from 0 to 9999) by applying some simple mathematics:

$$v = (n \text{ MOD } 2) + 1 \qquad (2.1)$$

where v is the value for head or tail, and n is the result of the chosen algorithm. This will yield a number that is either 1 or 2. Generalizing Equation 2.1 gives the following:

$$v = (n \text{ MOD } choices) + 1 \qquad (2.2)$$

Rebasing Numbers

NOTE Equation 2.1 will always yield a result for v that is between 1 and *choices*. The act of restricting result values in this way is known as *rebasing*. Equations 2.1 and 2.2 are simple examples of rebasing to a range that has a minimum of 1 and a maximum of 2.

We might, however, wish to choose numbers in an arbitrary range, between a minimum and maximum value. Reworking these equations slightly yields the following:

$$v = (n \text{ % } maximum\text{-}minimum) + minimum$$

It is helpful to have a rebasing function handy when building pseudo-random number generators, since their natural output will rarely be of use without modification. One such function, implemented in C is shown here:

```
Long ReBase ( long lValue, long lMin, long lMax )
{
        return ( lValue % (lMax-lMin) ) + lMin;
}
```

We would like to somehow prove that combining the two algorithms indeed satisfies our quest for random coin-flipping, and so we can plot the outcome, again using the software provided on the CD-ROM. One such plot is shown in Figure 2.9.

The plot in Figure 2.9 was achieved by using a seed of 1, a multiplier of 2, and a maximum of four digits for the resulting number. This number was then rebased to be between 1 and 2, to simulate a coin toss.

The center line in this case shows the distribution of random numbers that are output from the algorithm, while the plotted values are the result of the rebasing Equation 2.2. The plotted points in this case resemble a solid line running through the center of the figure.

The result is far from satisfactory, since only the head ever falls. The meander can be seen to be roughly random, with very little pattern. Since this is the case, we need to establish why the coin toss itself is not similarly random.

Further examination shows that in fact, although we have seen before that the distribution appears random, the truth is that each and every number is in fact even. Thus, when we modulo this number by 2, and add 1, we will always get 1, since any even number modulo 2 is zero.

Clearly, a more sophisticated method of rebasing our numbers is needed. As an aside, the distribution shown in Figure 2.10 was achieved for the simulation of dealing a deck of cards (52, Jokers removed), using the Lauwerier algorithm with a seed of 1, a multiplier of 3, and four digits maximum.

It is interesting to note that while simply changing the multiplier from odd to even helps, in this case, the same is not true for the coin-toss

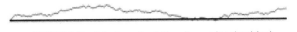

FIGURE 2.9 Coin-toss simulation (Lauwerier algorithm).

FIGURE 2.10 Card-dealing simulation (Lauwerier algorithm).

simulation. Even here, although the result appears to be fairly random, we cannot without further examination be sure that every card has been dealt!

The solution to the coin-toss problem, and also to determining whether all possibilities have been covered, are linked by statistics. Thus we have now come full circle, since we began by stating that we required an algorithm that generated statistically random numbers, and we now wish to ensure that we can prove that. By a curious coincidence, we must apply what we know about the statistical probability of the possible outcomes in the algorithm for determining those outcomes.

A coin, for example, has a 50-percent chance of landing on a given side. Therefore, we can say that were we to toss the coin 100 times, we could expect that 50 times it would land showing heads, and 50 tails. Therefore, rather than basing our decision about whether the outcome is a head or a tail outright, we should consider the chosen number as a percentage of the maximum possible number, and test against the probability table for the coin toss. This can be summarized by looking at Figure 2.11.

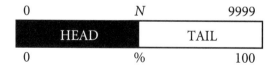

FIGURE 2.11 Spreading probabilities with the coin-toss simulation.

Therefore, if we were to have the number 6270 as our chosen random number, it would be a tail, and if we had 4280, it would be a head. Extending this we can see that even if our random number generator were to generate all even numbers, the chance of a head or a tail would still be even.

SEEDING AND DETERMINISTIC ALGORITHMS

In the preceding chapter, we examined the various factors that influence the randomness of the sequence of numbers that are generated, and came to the conclusion that at least part of the randomness was due to the choice of the numbers used to produce a nonlinear result from the linear algorithm. However, the seed itself does play a part in the result, since it provides the starting point for the resulting sequence.

Part Two of this book details how sequences of numbers can be used and how they might be seeded; this chapter provides an analysis of the impact of those choices. For example, if we use the same seed twice, we can be sure that the result will be the same. This property of pseudorandom numbers enables the game programmer to be sure that the sequence is repeatable.

Repeatability is important because quite often we will require a sequence of numbers that is infinitely variable, but that also can be reconstructed at will. If we consider that a given Game Universe contains a set of objects, which are in given places with given characteristics when the game is played, we have two choices as to how this universe can be populated.

In the first instance, we can create the Game Universe by hand, store the result in a file, and read it in during game play. However, if this means that we need to read in and dynamically allocate space for a large number of complex game objects, we are wasting resources.

A better approach would be to populate at least part of the Game Universe using a suitable algorithm. If we were to require a near infinite universe, the only way in which this could be achieved would be to populate it based on calculations and not on storage.

In addition, we may require that there are sequences of events that can be determined using an algorithm, which are keyed to the game state. Rather than store the sequence and check for a trigger in order to chain them, it may be more efficient to actually use a pseudorandom generator to create the events in real time. In fact, if the events are part of the game play, this will prove to be an indispensable technique.

SEEDING: A FIRST ANALYSIS

Even if the sequence needs to be random, a seed can be found that is constantly updated such as the time in play, or game time. This means that the same sequence of events will unfold at the same game time during each session of play. On the other hand, it can also mean that the sequence has a very small chance of being repeated, especially if it is seeded on total number of seconds in play.

In the latter case, it would require that the player "trigger" the sequence at the same time each time the game is played, which is not very likely.

Therefore, we have a technique that enables us to be sure that a seemingly infinite sequence can be created that may be used for populating the Game Universe, but which at the same time can also be used to create discrete sequences that have no obvious pattern.

By discrete sequences, we mean that there are a limited number of times that the algorithm may be applied. Referring to our deck-of-cards example, we can say that, for a given shuffle, only 52 cards can be chosen. The algorithm will be applied a maximum of 52 times for a given seed. However, the deck can be shuffled an infinite number of times, meaning that we need a sequence of numbers that can be used to provide a seed for the dealing sequence.

The fact that there is a chance that the same seed will be chosen more than once is of no consequence in this case, since there is only a limited number of ways in which a deck of 52 cards can be shuffled. It is actually quite likely that the same sequence of cards will be dealt more than once.

The seed is part of the deterministic nature of the algorithms. Lauwerier (*Fractals…*, p. 106) states that:

"the sequence is deterministic, but gives the impression of being chaotic"

There are times, however, when the actual choice of seed has a large impact on the resulting sequence. Let us consider what happens when we use Lauwerier's algorithm with a seed of 5, multiplier of 2, and maximum of 9999.

Figure 3.1 shows a distinct pattern, compared with the previous plots that show that using a seed of 1 yields no pattern at all over the same number of applications of the algorithm. Furthermore, we also need to consider the consequences of the value 5 being chosen at some point as the next number in the sequence, which is then used to seed the subsequent choices.

FIGURE 3.1 Deterministic Lauwerier plot.

This situation does not improve when we apply the algorithm over a larger number of runs. It is not as bad as one would expect, since looking at Figure 3.1, we would imagine that this pattern continues *ad infinitum*. Figure 3.2 shows the actual result (obtained by repeating the algorithm on top of the original until no changes were detected).

A clear pattern is discernable here, and we say that the algorithm has *stabilized*. While not entirely useful in the context of creating an Infinite Game Universe, knowing that such patterns can be generated using an algorithm rather than needing to store them externally can be very useful.

There are some properties of the mathematics that lie behind all of the preceding that can be put to good use in determining whether a sequence falls into one of the following categories:

FIGURE 3.2 Deterministic Lauwerier plot after multiple runs.

- **Deterministic.** A steady stream of entirely predictable numbers.
- **Semideterministic.** Where several repeating streams are present.
- **Nondeterministic.** A stream of numbers that prove impossible to predict.

What makes these pseudorandom generators even more interesting is that for a single algorithm, different choices of the static components—for example, the *multiplier* in Lauwerier's algorithm—lead to the various sequences possibly falling into more than one of the preceding categories.

LEVELS OF PREDICTABILITY AND DETERMINISM

Before we consider this further, we should define what exactly we mean by *predictable.* To date, we have used the term frequently without actually stating the meaning behind it. If anything is clear from the previous examination of the effects of pattern and pattern "breakers," it is that two runs with the same set of starting values produce identical sequences of numbers.

Predictability is not the same as deterministic. The difference hinges on the extent to which the observer has *prior knowledge* of the results of the algorithm. In Chapter 2, "Simple Random Number Generation Techniques," we saw some examples of semideterministic and nondeterministic results.

We stated that the length of pattern, the periodicity, can be affected by the choice of maximum number. For the nondeterministic results, it would

be difficult to spot a pattern unless the same sequence was seen on two separate occasions. Semideterministic results show a pattern that repeats itself often enough that the observer becomes aware of it.

Deterministic sequences of numbers are usually entirely predictable in nature, without *prior knowledge*.

All this leads us to the conclusion that predictability is hard to define, and that we can only approximate it to mean that a sequence of numbers is unpredictable if the next number to be chosen cannot be guessed from the examination of the previous n iterations. In this case, n can be defined as the limit of analysis, and is similar in concept to the *periodicity* that we first encountered in Chapter 2.

So, what does this mean when we attempt to formulate, without trial and error, the exact combination of terms that will cause the output of our algorithm to fall into the desired category of deterministic, nondeterministic or semideterministic? As always, it is easier to consider from the most basic principles first.

Let us imagine that we wish to find a deterministic sequence of numbers, with a limit of analysis equal to 5. We are, in effect, stating that we wish a predictable pattern to occur where analysis of the previous five digits will lead to a successful prediction of the next digit in the sequence.

Arbitrarily, we might choose the following algorithm:

$$x = x * 2$$

The output with a starting seed of 2 would be thus:

2, 4, 8, 16, 32, ?

Without prior knowledge, an outside observer would probably be quite able to determine that the next number should be 64. Given that, he or she would also be able to be fairly certain that 128 would follow. Therefore, there is a pattern to the sequence.

However, since the sequence tends toward infinity, it is not a great deal of use to us in the context of games programming, since we would probably like to keep the numbers within some bounds that define the extent of their effect on the Game Universe, as we did with the rebasing technique in Chapter 2.

Therefore, we could refine our algorithm to read:

$x = (x * 2) \bmod 10$

Given our seed of 2, we are then able to generate:

2, 4, 8, 6, 2, ?

Depending upon how sharp our observer is, he or she may or may not be able to predict that the sequence repeats itself. On the other hand, if the observer were given:

8, 6, 2, 4, 8, ?

it becomes more likely that the he or she will spot the pattern. Here, we have a seed of 8, instead of 2, and the sequence becomes slightly easier to predict. This is a borderline case, chosen explicitly to indicate the ease with which the human mind is capable of "spotting" patterns.

In mathematical terms, it is equally easy to predict, given the algorithm, that since the modulo operator is even, as is the multiplier, that the sequence will remain even. If the sequence remains even, with an even multiplier and an even modulo, it is also quite likely to stabilize into a pattern at some point. Bearing this in mind, what happens if we set the seed to 3?

Consider it briefly before following the sequence of numbers. What would one expect to occur? The end sequence is:

3, 6, 2, 4, 8, 6, 2, ...

Equally clearly, choosing 5 is out of the question, since this will converge on a single value. Using 1 has equally clear results. In fact, it is fairly easy to see what will happen with any digit between 1 and 10.

The preceding examples are all deterministic in nature. Some are even examples of a semideterministic sequence, but in a very limited sense. The power of a deterministic algorithm in games programming is that some behavior will undoubtedly be repetitive.

Consider, by way of example, the ghosts in *Pac-Man*. They always move in a way that is entirely predictable up to a point. If the player procrastinates too long, they turn nasty and attempt to corner him or her, but for the large part, simple observation of their movements is enough to be able to predict with a fair degree of certainty what their next move will be.

Rather than store each move, or make multiple nested decisions as to what to do when one ghost reaches a junction, we could instead use a seeded deterministic algorithm. In fact, we could even use the same one for each ghost, even if they are in different corners. Variations in what they can or cannot do could be built in by simply changing the seed as required.

Indeed, why stop there? Could not the input of the position of a ghost at a given time be used to reseed their private generator and change their behavior? Indeed, it could, and further discussion of this will take place in Part Two of this book. For the moment, however, let us examine the role of the seed in determining how sequences of numbers can unfold.

THE DETERMINISTIC NATURE OF MATHEMATICS

The rules of mathematics can help us to determine the exact nature of the sequence of numbers that will be generated; a simple example of which we have already seen. The previous observations might lead us to state that:

> The result of taking the modulo of an even number with another always yields an even number.

This may seem obvious, but when we combine it with another "obvious" rule of mathematics:

> Any number multiplied by an even number produces an even result.

We can say that for any seed that is involved in a calculation such that it is doubled, and then the modulo taken by way of an even number, the result will always be even. Indeed, since the number generated provides the seed for the next iteration, the entire sequence will consist of even numbers. This being the case, it is certainly destined to contain a pattern of some kind.

Although this would seem simple enough, it describes the behavior of half the Dewdney or Lauwerier algorithms that have provided the meat of this discussion. We have previously established a term for this—it is the *linear* part of the algorithm—and we have seen that the behavior that is described has limited, but very real potential in games programming.

By way of an extension to these rules, let us also consider what occurs when odd numbers are involved. For example, what happens for odd

numbers modulo even ones, or even numbers modulo even ones? Tables 3.1 through 3.4 show some limited results. Please note that the % sign has been used rather than the word *MOD* to represent the modulo operator.

TABLE 3.1 Odd Numbers Modulo Even Numbers

9 % 8 = 1	7 % 8 = 7	5 % 8 = 5	3 % 8 = 3	1 % 8 = 1
9 % 6 = 3	7 % 6 = 3	5 % 6 = 5	3 % 6 = 3	1 % 6 = 1
9 % 4 = 1	7 % 4 = 1	5 % 4 = 1	3 % 4 = 3	1 % 4 = 1
9 % 2 = 1	7 % 2 = 1	5 % 2 = 1	3 % 2 = 1	1 % 2 = 1

TABLE 3.2 Odd Numbers Modulo Odd Numbers

9 % 9 = 0	7 % 9 = 7	5 % 9 = 5	3 % 9 = 3	1 % 9 = 1
9 % 7 = 2	7 % 7 = 0	5 % 7 = 5	3 % 7 = 3	1 % 7 = 1
9 % 5 = 4	7 % 5 = 2	5 % 5 = 0	3 % 5 = 3	1 % 5 = 1
9 % 3 = 0	7 % 3 = 1	5 % 3 = 2	3 % 3 = 0	1 % 3 = 1
9 % 1 = 0	7 % 1 = 0	5 % 1 = 0	3 % 1 = 0	1 % 1 = 0

TABLE 3.3 Even Numbers Modulo Even Numbers

8 % 8 = 0	6 % 8 = 6	4 % 8 = 4	2 % 8 = 2
8 % 6 = 2	6 % 6 = 0	4 % 6 = 4	2 % 6 = 2
8 % 4 = 0	6 % 4 = 2	4 % 4 = 0	2 % 4 = 2
8 % 2 = 0	6 % 2 = 0	4 % 2 = 0	2 % 2 = 0

TABLE 3.4 Even Numbers Modulo Odd Numbers

8 % 9 = 8	6 % 9 = 6	4 % 9 = 4	2 % 9 = 2
8 % 7 = 1	6 % 7 = 6	4 % 7 = 4	2 % 7 = 2
8 % 5 = 3	6 % 5 = 1	4 % 5 = 4	2 % 5 = 2
8 % 3 = 2	6 % 3 = 0	4 % 3 = 1	2 % 3 = 2
8 % 1 = 0	6 % 1 0	4 % 1 = 0	2 % 1 = 0

From this very limited set of results, we could speculate that:

For a given number x, for x MOD y where $y > x$, the result is x.

For a given odd number x, for x MOD y where y is even, the result is odd.

For a given odd number x, for x MOD y where y is odd, the result is indeterminate.

For a given even number x, for x MOD y where y is even, the result is even.

For a given even number x, for x MOD y where y is odd, the result is indeterminate.

These observations may seem obvious. Less obvious are the conclusions that may be drawn from them. The first is that all algorithms that use a multiplier and a modulo by themselves will stabilize into a discrete pattern. This is probably what prompted Lauwerier not to use a simple modulo operator in his algorithm, and is certainly the reason for the introduction of the k factor in Dewdney's algorithm.

Following on from this, we can say that if we wish to persist in using a pure multiply followed by a modulo, alternating between odd and even will break the pattern. In this case, we need to make a decision based on the result *before* we take the modulo. In essence, this is how Dewdney approached the problem.

On the other hand, by removing digits from either end of the result until the desired number of digits is resolved, as in the Lauwerier algorithm, we are assured that the number with which we intend to proceed (the generated value and next seed) will be odd, even, or possibly zero.

This musing leads us to our final conclusion: beware of the zero. Zero is a killer for any algorithm, since it represents an alley from which there is seemingly no escape. Indeed, the number 1 holds this dubious honor also.

Needless to say, Dewdney deals with this with an addition of k that, providing k is not zero or one, will effectively enable us to break out of this blind alley. Lauwerier does not on the face of it offer any escape, but we would have to concede that the possibility of falling prey to the problem where large numbers are concerned is fairly remote.

All of the preceding discussion about breaking the pattern offered by the linear part of the algorithm, using a discrete number, can be taken one final step further, which will enable us to tie up this theme in a neat package.

Consider the effect of combining two linear algorithms in order to generate a deterministic, but nonlinear sequence. Lauwerier has offered one way to do this, granted, but surely there are others that would also yield good results. Indeed, there are, and in the next chapter we will turn our attention to dealing with combinations of algorithms.

CHAPTER **4**

ALGORITHM COMBINATION TECHNIQUES

The first idea that we shall consider is that of using a second linear algorithm to provide input into a first, in the hope of producing a nonlinear result. Simply put, this means that for one of the factors used by the algorithm for turning a deterministic sequence of numbers into a nondeterministic one, we shall use a continually changing number rather than a fixed one.

This harkens back to our previous observations, where we decided that, based on a very limited run of tests:

For a given odd number x, for x MOD y where y is odd, the result is indeterminate

In this case, indeterminate does not mean that it cannot be determined, just that given the case where the property of both numbers is odd, the result may be even, odd, or zero, depending on the numbers themselves. Clearly we have very little control over x, since it is probably the result of a mathematical operation (if we are using algorithms in the style of Dewdney or Lauwerier), but we can exert some control over y.

To explain: We have presented the modulo operation as a way to limit the result to a specific set of numbers. A useful side effect of doing this has been shown to be that it serves to break the linear sequence that otherwise might have resulted.

We have also seen how certain combinations of linear algorithm para-meters coupled with the modulo factor seem to stabilize into deterministic or semideterministic sequences. These have their uses, but for the time being we wish to step over the line and say that we want to be as certain as possible that the resulting stream will be nondeterministic.

LINEAR VARIATION TECHNIQUES

Given all of that , we may choose to vary whatever is causing the pattern, or lack of it; namely, the number used in conjunction with the modulo oper-ator, which we have designated y.

We shall start with the simplest approach, and work our way toward more subtle variations.

Taking into account the previous observation regarding the modulo op-erator, it would be a good idea if we were to vary it between an odd and even number. In this way, we hope to achieve the largest possible variation in odd/even results. This theory might lead to a very simple linear algo-rithm designed to produce this effect, as shown in Algorithm 4.1.

$$x = x + 1$$
$$\text{If } x > max \text{ then } x = max - 1$$

ALGORITHM 4.1 Simple linear variation algorithm.

In Algorithm 4.1, max is set by the programmer to be the maximum number that needs to be generated. It is designed to be a part of a larger al-gorithm, in which the value x is used somewhere as an input to a modulo operation.

The algorithm ensures that the number generated is never greater than max, and that the modulo operand x alternates between even and odd.

One further point is that x should be initialized to be equal to $max - 1$. Otherwise, the initial chain of numbers will inevitably be limited to a much lower value than that which is required.

Algorithm 4.1 gives rise to something we could choose to term a *wave*; that is, the value alternates between a minimum and a maximum with a regular cycle. Figure 4.1 serves to illustrate this effect.

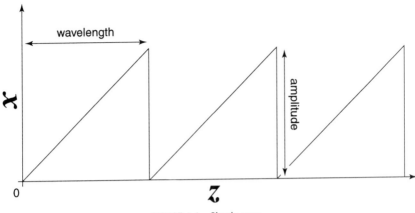

FIGURE 4.1 Simple wave.

One way in which we might be able to refine Algorithm 4.1 is to use a wave with a greater amplitude and length. This would have the effect of providing a greater variation between odd and even numbers.

Why, though, might this be desirable? The answer is that while the simple algorithm does serve to ensure that the linear sequence generated by the core algorithm is broken in some way, it does so with very little interference in the actual number sequence. If we consider that we have chosen an algorithm that consists of the first part of the Lauwerier algorithm, followed by a simple modulo operation, as in Algorithm 4.2:

$$n = n * 2$$
$$n = n \ \text{MOD} \ x \qquad \text{(where } x \text{ alternates as per Algorithm 4.1)}$$

ALGORITHM 4.2 Simple Lauwerier variation.

for the first z steps (where n is less than the maximum *max* of Algorithm 4.2) of the resulting sequence, x will have no real effect, since as long as n remains less than x, a modulo operation involving the two always results in n.

Therefore, in order that the operator x has a worthwhile effect, we would prefer to use it to "break" the sequence as early as possible. To do this, we have several choices, starting with a minor modification to our earlier algorithm:

$$x = x + 1$$
$$\text{If } x > max \text{ then } x = 1$$

ALGORITHM 4.3 Modified linear variation algorithm.

All that has changed in Algorithm 4.3, compared to Algorithm 4.1, is that we are returning x to 1, rather than the maximum minus 1. Also, we would use 1 as the starting value for x. This produces a saw wave, alternating between 1 and *max*, with a larger amplitude (difference between the minimum and maximum values) and wavelength (since it takes longer to reach the maximum) as depicted in Figure 4.2a.

This may serve to break the sequence up, but since at some point it returns abruptly to 1, a fairer distribution might be achieved if we were to modify the algorithm further. The following code segment illustrates the underlying algorithm for a triangular wave.

CODE SAMPLE 4.1 Triangular wave generator.

```
int TriangularWave (
    int nStart, int nPrevious,
    int nMax, int nMin,
    int nAmplitude )
{
    int nTemp;

    nTemp = nStart;
    if ( nPrevious > nStart )
        nStart = nStart + nAmplitude
    else
        nStart = nStart - nAmplitude
    if ( nStart > nMax ) nStart = nMax;
    if ( nStart < nMin ) nStart = nMin;
    nPrevious = nTemp;
    return nStart;
}
```

In Figure 4.2b, we see the general wave that this algorithm attempts to apply to the value *nStart*.

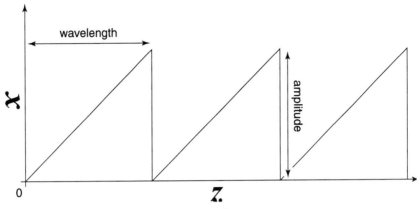

FIGURE 4.2a Simple saw wave.

There will be a better way to code this, since we need to store the previous value in the main program, reducing efficiency and increasing complexity. However, Code Sample 4.1 serves to illustrate the principle.

ON THE CD　The plots in Figures 4.3.a through 4.3.e were achieved with the DISTRIB application (found on the accompanying CD—see "About the CD-ROM"), illustrate the use of the saw tooth and triangular modulo operand modification routines, as applied to a previously stable Lauwerier plot. The plot used is the simulation variant. The reason for this is that it is here where the Lawerier algorithm stabilizes, as noted earlier, due to the modulo operand generated by the previous cycle tending to be regular.

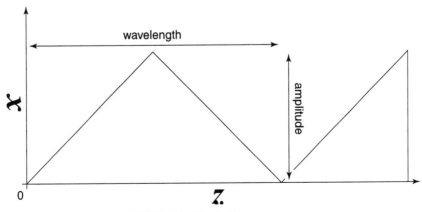

FIGURE 4.2b Simple triangular wave.

FIGURE 4.3a Seed 1; multiplier 2; four figures.
Simulation: 100 Choices, No Wave

FIGURE 4.3b Seed 1; multiplier 2; four figures.
Simulation: 100 Choices, Saw, Min 1; Amp 1

FIGURE 4.3c Seed 1; multiplier 2; four figures.
Simulation : 100 Choices, Saw, Min 97; Amp 1

FIGURE 4.3d Seed 1; multiplier 2; four figures.
Simulation : 100 Choices, Triangular, Min 1; Amp 1

FIGURE 4.3e Seed 1; multiplier 2; four figures.
Simulation : 100 Choices, Triangular, Min 97; Amp 1

FIGURE 4.3 The effect of waves on Lawerier simulation runs.

Figure 4.3a clearly shows the effect of using the Lauwerier algorithm to generate numbers between 0 and 9999, using a modulo of 100 to restrict the choices to 0 to 99. Although the centerline shows a random meander (a line that does not change, no matter what wave we apply), it is clear that the actual numbers that result after the modulo has been applied are distributed in a regular fashion. These choices, between 0 and 99, are depicted by the crosses in the plots.

The effect of using a wave as modulo operator is clear: all semblance of pattern is broken simply by varying the operator based on a saw wave and a triangular wave (Figures 4.3c and 4.3e). It is interesting to note the effect of using a small minimum value (Figures 4.3b and 4.3d). It is a quirk of the technique that this results in a denser scattering of high choices; indeed, the overall shape of the plot resembles an inverse of the plots in Figures 4.2a and 4.2b.

The optimum appears to be to use a minimum value of 97, with an amplitude of 1, but the reader is welcome to experiment to find a combination that fits his or her needs. There might be cases where a bias toward higher generated values (depicted by the dots) is useful, leaving the lower possible values to receive a smaller portion of the choices. The application of a wave with a small starting point is one way to achieve this as seen in Figures 4.3b and 4.3d.

What if the opposite is required; that is, a selection of numbers biased toward smaller values? There is no way to achieve this with a wave, because if we increase the modulo past the maximum value that we require, which would be the logical suggestion, we are no longer constraining the values to the selection that we want.

In fact, if we wish to have this behavior, we only need to perform a simple subtraction. Subtracting the value chosen from the maximum that we require will produce the inverse of the plots in Figures 4.3b and 4.3d, thus achieving the opposite effect.

WAVE VARIATION TECHNIQUES

There are, of course, other waves that can be used in place of the simplistic ones that we have mentioned here. Key among those are sine, cosine, and tangent waves. The use of these mathematical functions is fairly simple.

There is a relationship between geometric circles and the "magic number" π (or pi), which is explained in good mathematical textbooks. For our

discussion here, it is sufficient to know that the sine and cosine operators, when applied to a number between 0 and 360 degrees, produce a periodic wave, which alternates between –1 and +1.

Some example values are shown in Table 4.1.

TABLE 4.1 Sine and Cosine Value Chart

Degrees	0	45	90	180	225	270	315	360
Sin	0	0.71	1	0	–0.71	–1	–0.71	0
Cos	1	0.71	0	–1	–0.71	0	0.71	1

The tangent operator is a little more peculiar, yielding a graph that, while periodic, is somewhat less well behaved. From a purely qualitative point of view, we note that it has some strange properties, such as "blind spots" where the value that it yields cannot be calculated.

These blind spots are a result of the definition of the tangent function. The book *AS Mathematics* (Berry, et al; Harper Collins Publishers, 2000) defines the tangent function thus:

$\text{Tan } \theta = \sin \theta / \cos \theta$ Where θ is the angle, in degrees

The first of these is at 90 degrees, since from Table 4.1, it is the undefined value represented by 1/0, a division by zero. Table 4.2 shows the tangent values up to an angle of 89 degrees.

TABLE 4.2 Tangent Values Up to an Angle of 89 Degrees

θ	0	15	30	45	60	75	89
Tan	0	0.27	0.58	1	1.73	3.73	57.29

One would be forgiven for assuming that the preceding is itself a random number sequence! The sequence continues in Table 4.3.

TABLE 4.3 Tangent Values for Angles between 91 and 180 Degrees

θ	91	105	120	135	150	165	180
Tan	–57.29	–3.73	–1.73	–1	–0.58	–0.27	0

Although it looks periodic from the values calculated up to 90, it then seems to deteriorate into an almost chaotic sequence. Following on from this, Table 4.4 continues the sequence.

TABLE 4.4 Tangent Values between 195 and 271 Degrees

θ	195	210	225	240	255	269	271
Tan	0.27	0.58	1	1.73	3.73	57.29	−57.29

The sequence seems to have returned to a vaguely predictable periodicity, however. To examine whether this is indeed the case, Table 4.5 completes the sequence.

TABLE 4.5 Tangent Values between 285 and 360 Degrees

θ	285	300	315	330	245	360
Tan	−3.73	−1.73	−1	−0.58	2.14	0

Continuing the sequence is left as an exercise for the reader. In advance, however, it is useful to know that for values above 360, the waves repeat themselves ad infinitum. This is the case because any value greater than 360 is taken to be that value modulo 360. This gives us a range of values from 0 to 359, a complete circle.

The values generated previously will generally be very useful, however. What can we do if we need values between 0 and 100, not −1 and +1, or −57.29 and +57.29? The last step in our quest for waves is to modify the values, based on the operator used, so that they are within the set of numbers that we require. All that we need to do in qualitative terms is increase the amplitude of the wave.

The simple rebasing that we saw in Chapter 2 would work here, but in using it we would lose a certain amount of information, as the result is usually an integer. Rather, we would prefer to ensure that the entire range of fractions is used.

In the case of the sine and cosine waves, this is an easy proposition, since they vary between −1 and +1. A simple multiplication by the maximum value (*max*) that we require will yield a number between −*max* and +*max*. Clearly, this is not really the desired effect; we need rather to

oscillate between 0 and *max*. Algorithms 4.4a and 4.4b illustrate how we achieve this.

$$(\sin (degrees) \text{ x } (max / 2)) + (max / 2)$$
$$\text{or} \quad (\cos (degrees) \text{ x } (max / 2)) + (max / 2)$$

ALGORITHMS 4.4a and 4.4b Rebasing sine and cosine wave values.

where *degrees* varies between 0 and 360, and *max* is the maximum number that we require.

By way of example, let us assume that we require numbers between 0 and 51 representing our deck of cards from Chapter 1. Using the degree values from Table 4.1, Table 4.6 can be created (*max* in this case is 52; therefore, *max* / 2 is 25.5).

TABLE 4.6 Rebased Values for Sin/Cos Wave Values

Degrees	0	45	90	180	225	270	315	360
Sin	26	44	51	26	7	0	7	26
Cos	51	44	26	0	7	26	44	51

The class implementation in standard C++ in Code Sample 4.2 shows how the sine wave may be encapsulated.

CODE SAMPLE 4.2 Simple sine wave class.

```
// sine_wave.h header file
Class sine_wave
{
    private:
        int nDegrees;
    public:
        // The constructor
        sine_wave() { this->nDegrees = 0; }
        // Retrieve the next sine value
        double Get_Value();
};

// sine_wave.cpp implementation file
#include <math.h>    // The ANSI Maths library
```

```
#include "sine_wave.h"        // Our class definition
double sine_wave::Get_Value()
{
    this->nDegrees = (this->nDegrees + 1) % 360;
    return sin ( double this->nDegrees );
}
```

In fact, as can be seen from Table 4.6, the output is probably more suited to being used in some other way. By way of example, we can use it to modify the modulo operand (designated y at the beginning of this chapter).

We could use Sin/Cos waves to modify the modulo operand for a given Lauwerier implementation. If we assume that the Lauwerier function has been implemented as described in Chapter 1, the code would look similar to that shown in Code Sample 4.3.

CODE SAMPLE 4.3 Sine wave applied to the Lauwerier algorithm.

```
sine_wave * Sine = new sine_wave();
.

.
seed = Lauwerier ( seed, multiplier, number_of_digits );
value = ( Sine->GetValue() * ( maximum / 2 ))
+ ( maximum / 2 );
.

.
```

Here it is assumed that the values for *max, seed, multiplier,* and *number_of_digits* have been set elsewhere in the software that is using this algorithm.

One final point to note is that we do not have the same problem as with the saw and triangular waves; we never need to reduce the value once the "peak" has been reached. The sine, cosine, and tangent waves generated using the standard ANSI C++ math library all oscillate naturally around a certain value.

Figures 4.4, 4.5, and 4.6 show the wave graphs for all values between 0 and 360 degrees for the functions that we have discussed so far. It is these wave properties that make them desirable to use when modifying the various input values to the pseudorandom number generators. This is because

FIGURE 4.4 Sine wave.

FIGURE 4.5 Cosine wave.

FIGURE 4.6 Tangent wave.

they ensure that we avoid the problems associated with pattern forming (as in the modulo example) that can result when using static values.

They are not applicable in all circumstances, however, since they oscillate, which increases the danger of choosing two identical values in a given run. For dealing a "shuffled" deck of cards, this would mean that there is a possibility of "dealing" the same card twice. This is quite clearly undesirable, since each card occurs exactly once in the deck. Problems such as these are overcome in the next chapter.

SEED MODIFICATION TECHNIQUES

So far, we have concentrated on the modification of the output of the Lauwerier algorithm. This was in answer to the problem that we came across in Chapter 3 and also illustrated in Figure 4.2, where it was seen that the Lauwerier technique is deterministic when a sequence of numbers is required that fall within a given range (say 0 to 100).

However, both the Lauwerier and Dewdney algorithms contain many inputs, and it stands to reason that the input to an algorithm must also have an effect on the output. Indeed, in Chapter 3 we saw how the seed, when combined with other input values, could also lead to deterministic results with distinct patterns.

Although the seed can be used to have an effect on the output, it cannot be used to restrict the range of the output, in the same way as we can by directly modifying the output with a modulo operation. The use of varying input values, such as seeds, can only serve to provide different combinations of values in the hope of reducing the order to chaos, or a near relative.

In forcing a modification to the seed, we can directly influence the output value from the algorithm. After all, it is the seed that is used as a starting point. In fact, this is a useful technique that we shall come back to time and time again throughout the rest of the book.

Modification of the seed is powerful because it can be used to generate not just one sequence of numbers, but multiple parallel sequences. What we mean by this is that we have the power to generate sequences of numbers that all have a different starting point, and from that starting point yield different sequences of numbers. In Part Two, we discuss seeding techniques in detail, and how this is applied in the games

programming world. For the time being, we will be content with the knowledge that it is possible to generate several sequences of numbers with different seeds.

The reason we are attaching so much importance to this at this stage is because we can feasibly generate a number of different sequences with the same seed, using a combination of two algorithms. We'll use one algorithm to generate a sequence of seeds, and one to take each seed and generate a sequence of numbers, which could in turn be used as seeds for other sequences, which could act as seeds, and so on.

Before we consider how to do this in detail, we must first turn our attention to the effect of using different seeds for the same sequence generator. There are pitfalls to avoid, the most important being that if we use the same algorithm to generate the seeds as we do to generate the sequences of numbers, each sequence will be the same, but displaced by n places.

By way of illustration, consider the Table 4.7, which was generated using the Lauwerier algorithm with a seed value of 8192 to generate the first row. These are the seeds that are each fed to the Lauwerier algorithm to get each iteration entry for the columns.

The value of 8192 was chosen because it is the first number before the algorithm deteriorates into chaos. This is due to a number of factors, the main one being that the number of digits is limited only to four, and the multiplier is 2. Therefore, the first n repetitions starting from 1 should be discarded, since they are less than four digits in length.

TABLE 4.7 Seeding the Lauwerier Algorithm

	Seed Values								
Iterations	**8192**	**6384**	**2768**	**5536**	**1072**	**2144**	**4288**	**8576**	**7152**
1	6384	2768	5536	1072	2144	4288	8576	7152	
2	2768	5536	1072	2144	4288	8576	7152		
3	5536	1072	2144	4288	8576	7152			
4	1072	2144	4288	8576	7152				
5	2144	4288	8576	7152					
6	4288	8576	7152						
7	8576	7152							
8	7152								

TABLE 4.8 Avoiding Repetition in Self-Seeded Algorithms

Iterations	Seed Values					
1	8192	7152	0912	3472	8832	...
2	6384	4304	1824	6944	7664	
3	2768	8608	3648	3888	5328	
4	5536	7216	7296	7776	0656	
5	1072	4432	4592	5552	1312	
6	2144	8864	9184	1104	2624	
7	4288	7728	8368	2208	5248	
8	8676	6456	6736	4416	0496	
Next Seed	7152	0912	3472	8832	0992	

The only ways to avoid the repetition seen in Table 4.7 are either to use a different multiplier for each algorithm, thereby varying two inputs, or to choose successive seed values that exceed the periodicity of the required sequences. The latter means that if a series of eight values is required, then the next available seed is the eighth iteration of Table 4.7, as in Table 4.8.

The preceding is sufficient for instances where predetermined finite sequences of numbers are required, but is not good enough if we need a near-infinite, or indeterminate number of sequences. For these cases, we should resort to using two different multipliers. The plots in Figures 4.7a through 4.7e show this in action. They are all achieved using the Lawerier technique. The first generates the seeds, which are then used to generate subsequent sequences of plots.

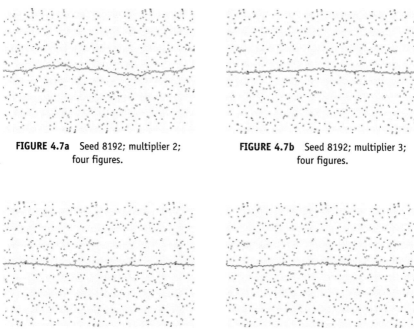

FIGURE 4.7a Seed 8192; multiplier 2; four figures.

FIGURE 4.7b Seed 8192; multiplier 3; four figures.

FIGURE 4.7c Seed 6384; multiplier 3; four figures.

FIGURE 4.7d Seed 2768; multiplier 3; four figures.

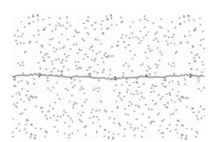

FIGURE 4.7e Seed 5536; multiplier 3; four figures.

FIGURE 4.7 Seeding Lawerier plots.

CHOOSING INPUT VALUES

Although the Lauwerier technique that we discussed previously centers heavily on the use of the seed to control the ensuing sequence of numbers, there are also other inputs that are used to influence the generated sequence. This is clearly shown in the Dewdney technique, using numbers that, in combination with the seed, also serve to influence the number sequence.

These numbers can be known as *breaker* numbers. This is a particularly apt description, because they serve to disturb the otherwise regular sequence. Akin to the qualitative technique that the Lauwerier algorithm uses, the Dewdney algorithm uses a purely quantitative, mathematical approach by combining the effect of several inputs.

Care must be taken when choosing breaker numbers, however. We have already seen how the modulo operator can alter the results from a sequence generator so that any lack of pattern is replaced by a clear sense of order. This is also the case with breaker numbers. In particular, when using an algorithm such as that proposed by Dewdney, involving purely mathematical operations, the choice of input variables plays a vital part.

We've already seen one solution for avoiding patterns: to vary those parameters that are supposed to remove the order from a sequence, such as

IMPLEMENTATION NOTE 4.1 PREPROCESSING

Varying arguments used as input to an algorithm is *computationally expensive*; that is, the additional overhead on processing time may well slow down the rest of the processes that are attempting to execute at the same time. Games software usually requires a heavy dose of processing power, so reducing the impact of our number sequence generations should be forefront in our minds when choosing an algorithm.

However, it is important to note that if we only require a table of values, which we can then use in the software, it can be created ahead of time, and stored with the rest of the game data on the distribution media. These stored values may be generated using a processor- intensive algorithm since we can perform this *preprocessing* in our own time, and not game time.

We will re-visit the practical applications of this theory in Chapter 6, "Performance Issues." It is important to note that there is a very real use for algorithms that are as reliable as possible, but require a lot of processing in real-time, thereby making them a poor choice in some circumstances.

the breaker number k from the Dewdney algorithm. This is all very well, but computationally expensive, and probably cannot be used in real time. Part Three of this book discusses in detail how we can measure the efficiency of a particular algorithm, but for now we can say that we should reduce the number of operations as far as possible for real-time work.

Therefore, it is far better to find a set of breaker values that work well, and keep them static. Mathematically ambitious readers may be tempted to do this by way of calculation; however, it can be done by experimentation. Taking by way of example the Dewdney algorithm, we can form a few basic "rules," or common pitfalls. Algorithm 4.5 briefly restates the core calculation of the Dewdney algorithm.

$$n = ((n * m) + k) \text{ MOD } p$$

ALGORITHM 4.5 The core Dewdney algorithm.

There is nothing new here; Algorithm 4.5 is merely a restatement of the Dewdney algorithm presented in Chapter 2. The seed is n, the breaker numbers are m and k, and the limiter p ensures that a certain maximum value is not exceeded, and serves as another breaker number. Dewdney offers little advice to go with his algorithm, other than:

> "Sooner or later, however, the resulting sequence must repeat itself because there are only p possible remainders."

So, what should we avoid by way of input values? The first point to note is that if n is even, m is even, and k is even, the result will be even. By way of example, Table 4.9 shows an example run.

In Table 4.9, the value arrived at as a result of applying the Dewdney algorithm is fed back as the next value for n, the seed.

Therefore, avoiding using even numbers for each variable is a *first rule*. Some readers might feel that choosing very large numbers will help to escape this problem, but consider Table 4.10.

TABLE 4.9 Low Even-Number Dewdney Sequence

Step	n	m	k	$(n * m) + k$	MOD 10	
1	2	4	6	14	4	
2	4	4	6	22	2	
3	2	4	6	14	4	etc.

TABLE 4.10 High Even-Number Dewdney Sequence

Step	n	m	k	(n * m) + k	MOD 10	
1	1234	4936	19774	6110798	8	
2	8	4936	19774	59262	2	
3	2	4936	19774	29646	6	
4	6	4936	19774	49390	0	
5	0	4936	19774	19774	4	
6	4	4936	19774	39518	8	etc.

Step 5 in Table 4.10 shows a good reason for k; which is to avoid zero. This is very important, since anything multiplied by zero is zero. This is our *second rule*: always avoid multiplications by themselves, because eventually we will obtain a value that is either zero or one. These two numbers have very undesirable qualities.

Our first rule states that we should avoid using numbers that are all even. We might like to experiment to see what the result is if we use all odd numbers, by way of comparison.

Table 4.11, shows an improvement, only repeating after 11 steps (as pointed out by Dewdney), but with a period of 5 thereafter. This is also the case for larger numbers, as in Table 4.12.

TABLE 4.11 Low Odd-Number Dewdney Sequence

Step	n	m	k	(n * m) + k	MOD 11	
1	1	3	5	8	8	
2	8	3	5	29	7	
3	7	3	5	26	4	
4	4	3	5	17	6	
5	6	3	5	23	1	
6	1	3	5	5	5	
7	5	3	5	20	9	
8	9	3	5	32	10	
9	10	3	5	35	2	
10	2	3	5	11	0	
11	0	3	5	5	5	
12	5	3	5	20	9	
13	9	3	5	32	10	etc.

TABLE 4.12 High Odd-Number Dewdney Sequence

Step	n	m	k	(n * m) + k	MOD 11
1	1357	4071	12213	5536560	7
2	7	4071	12213	40710	10
3	10	4071	12213	52923	2
4	2	4071	12213	20355	5
5	5	4071	12213	32568	8
6	8	4071	12213	44781	0
7	0	4071	12213	12213	3
8	3	4071	12213	24426	6
9	6	4071	12213	36639	9
10	9	4071	12213	48852	1
11	1	4071	12213	16284	4
12	4	4071	12213	28497	7 etc.

Again, we repeat after 11 steps, and have a period of 11. Our *third rule*, therefore, is that if a modulo is used, in order to obtain the largest possible period (equal to the number chosen as the operand), the number used as input to the modulo function should be at least as large as the operand.

Perhaps it is also worth pointing out that the application of simple mathematical rules dictates that, in fact, it is best to stick with odd numbers, since two odd numbers added together may result in an even one, the inverse is not true. Multiplications and modulo operations follow similar behavior. So, to summarize, when designing pseudorandom number generation algorithms, the following rules should be respected:

- Avoid using even or odd numbers *only*.
- Do not use multiplications by themselves.
- Modulo input values should be larger than the operand.

These rules cover purely mathematical algorithms, such as that presented by Dewdney. For techniques that are qualitative in part (like Lauwerier's technique), the rules to be followed are less strict. However, our basic rules for the modulo and number choices should be respected for the mathematical portions. Other than that, experimentation is the key, and some basic principles that can be explored include:

- Removing head and tail digits until a certain length is arrived at [Lauwerier]
- Removing the center digit until a certain length is reached [Lauwerier variation]
- Adding the digits together
- Hashing the seed by adding and subtracting digits

Each of these will come with its own set of limitations, which will only be arrived at by applying the principles and experimentation.

Before we move on to explore this further, it should be pointed out that our rules should not be flouted. For example, if a given algorithm used to vary the multiplication factor in the Dewdney algorithm (represented by m) yields a string of even digits, then the k factor must not, by our rules, be even; else, the result will have order.

ADVANCED ALGORITHMS AND COMBINATIONS

Besides combining algorithms arrived at by strict mathematical principles (such as the saw and triangular waves in Chapter 4, "Algorithm Combination Techniques"), combinations can also be arrived at by way of applying several pseudorandom number techniques. We have already discussed how varying the modulo operands can yield a better result, but there are other inputs that can also be varied, the exact number depending on the algorithm or algorithms chosen.

Given the amount of values that are present in Dewdney's algorithm, one might be tempted to use other techniques such as Lauwerier's to provide values for those components. Experimentation shows, however, that it is much more reliable to use one good-quality algorithm to seed another. This is because it is difficult to guarantee that we will not flout our rules by using algorithms to provide values for m and k (in the case of Dewdney's technique).

As we saw in Implementation Note 4.1, which introduces preprocessing techniques, we could use a computationally expensive method to pregenerate a number of seeds that could then be used with a less expensive method to generate the sequences themselves.

One such mathematical technique is at the root of the 1982 game *Elite* (David Braben and Ian Bell; published by Microsoft). Remembering that *Elite* is set against a backdrop of near-infinite stars, it is a clear contender for the use of these techniques—aimed as it was for an 8-bit home computer with 16KB of RAM. One aspect of such machinery is that space in memory is at a premium, and techniques for generating in game-time make impossible designers' dreams a reality.

THE FIBONACCI SEQUENCE

The technique is based on a specific sequence of numbers known as a Fibonacci sequence. Ivars Peterson (*ScienceNewsOnline*, June 1999) notes that it is a sequence of numbers in which:

"Each new term is the sum of the previous two terms."

Hence, the first 10 terms of the standard Fibonacci sequence:

1, 1, 2, 3, 5, 8, 13, 21, 34, 55

The easiest way to define the Fibonacci sequence in programming terms is by using a recursive function.

NOTE

Recursion

Most programmers will be familiar with the notion of *recursive functions*. In simple terms, a recursive function is one that calls itself with a different argument until a condition is reached whereby it returns a value.

There are inherent dangers to watch for when using recursion. The first is that the condition by which the recursion is halted must be infallible. Failure to ensure this will leave the function endlessly recursing into infinity.

Secondly, it is quite possible that since a recursive function can not be stopped once it has been started, that it will consume vast quantities of processing time before it completes.

Finally, it is usually a safe bet that recursive functions will take over the processor until they complete; therefore, it might be desirable to provide a get-out such that the recursive function yields to the other tasks that might want processing time.

Following these three basic guidelines will avoid needless debugging sessions to find out why a game has "crashed" unexpectedly.

Now that we have pointed out the dangers of using recursion, we are free to dwell on its usefulness. The standard recursive Fibonacci algorithm might look like Code Sample 5.1, coded in standard ANSI C.

CODE SAMPLE 5.1 Recursive Fibonacci function.

```
int Fib ( int n )
{
```

```
  if (n <= 1) return n;
  return Fib(n-1) + Fib(n-2);
}
```

To use the *Fib* function, one simply supplies it with the term *n* for which the Fibonacci value should be calculated. The resulting values spiral up toward infinity, quickly becoming very large.

The best use for the previous recursive definition is to build a table of values that can be stored on the distribution media and accessed as required. We shall look at how this is used later.

Meanwhile, let us concentrate on the theory behind the sequence itself. It exhibits a few undesirable characteristics, such as a tendency toward infinity. This can be corrected by using techniques similar to that in Code Sample 5.2.

CODE SAMPLE 5.2 The FibMod generator.

```
int FibMod ( int nCurrent, int nLast, int nMax )
{
    return (nCurrent + nLast) % nMax;
}
```

To use this function, the routine using it must keep track of the *nCurrent* and *nLast* values. These values are the seed and result of the previous iteration. The DISTRIBUT software on the companion CD-ROM uses the FibMod generator in the following way:

CODE SAMPLE 5.3 Using the FibMod generator.

```
// Initialization
  .
nLast = nSeed - 1;
nCurrent = nSeed;
  .
// Begin loop
  .
nSeed = FibMod( nCurrent, nLast, nMax);
  .
```

```
// Code to plot this iteration
.
nLast = nCurrent;
nCurrent = nSeed;
.
// End Loop
```

In Code Sample 5.3, *nSeed* is chosen by the user, as is *nMax*. The results from the FibMod generator are surprisingly useful immediately. The distribution of the generated numbers is fairly random, and the periodicity is directly related to the value chosen for *nMax*.

Allowing for a margin of error, it is suggested that the best input values to use can be arrived at by way of some simple formulae:

nSeed = (Required Number of Values * 2) –1
nMax = (Required Number of Values * 2)

The output of the FibGen algorithm, using a seed of 998, and a maximum of 999, is shown in Figure 5.1.

While this is fairly reliable, there are a number of ways in which it can be modified to make the sequence even more evenly spread. Earlier in this chapter, we mentioned storing a table of Fibonacci numbers that can be accessed as required. These numbers have many uses.

The first is to provide seed material for other generators. For example, for the Dewdney algorithm, we might choose Fibonacci numbers for the various input values. Alternatively, we could choose successive values to provide input to the Lauwerier algorithm.

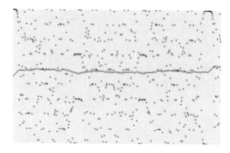

FIGURE 5.1 Distribution of the FibMod generator.

Indeed, we might even combine all three techniques, one to choose the Fibonacci-based arguments, that can then be fed into a generator, that gives the value for seeding the final pseudorandom number generator. This technique is an ideal example of using an intensive algorithm "off-line" before the game is distributed, followed by a slightly less intensive one by way of initialization of the game, and finally a nonintensive algorithm that can be used in real time once the game is in play.

If all of the preceding seems a little too complicated, there is a final approach, mentioned in the "Fibonacci at Random" article (*ScienceNews-Online*, June 12, 1999). In this article, the author, Ivars Peterson, points out that it is possible to use another generator to decide the operation that will be performed on the two input arguments.

The example that he uses is a coin toss. Each time the algorithm is called, a coin is flipped. If it falls on heads, we add the two arguments; otherwise, we subtract them. By way of demonstration, he considers the following:

"According to this scheme, the successive coin tosses H H T T T H, for example, would generate the sequence 1, 1, 2, 3, −1, 4, −5, −1."

Following this, he also notes that experimentation by Divakar Viswanath of the Mathematical Sciences Research Institute in Berkeley, California shows that when using this scheme, the absolute values still tend toward infinity. That is, even though one might expect that the fluctuation might be more even, when we ignore negative values, the tendency of the sequence is to rise in a regular exponential manner.

Given that we have already established that the modulo operator can help to avoid this, while still giving a good spread of values, we could use this technique here also. Therefore, we have another combination technique using one algorithm to provide input to the other. Since it is designed to run in real time, however, it is probably a good idea to use a nonintensive algorithm.

Many more combinations could be used, involving multiplications, divisions (being careful to avoid division by zero), subtractions, and complex seeding patterns and lookup tables. In fact, one common use of such algorithms is to build a random number lookup table so that no calculations are performed in real time. This is good where only a small number of values are required; in general, this book deals with cases where a near infinite supply of reliable pseudorandom values is required.

PERFORMANCE ISSUES

This final chapter of Part One relates to issues that have to do with performance. We shall in the course of this book touch upon this subject many times; indeed, it is a bane of every game programmer's life that the techniques that produce the best results often consume the most resources.

Here, we shall consider only that we wish to generate a near-infinite sequence of numbers that are without pattern. We will use these numbers for the generation of game objects and their properties. With these considerations in mind, we must devise a way of ensuring that we obtain the maximum effect with the minimum performance deficit.

MATHEMATICAL ALGORITHMS AND GAME STYLES

First, a word about using mathematical algorithms in game programming. The place of mathematics in a given game design relates strongly to the game itself. By way of example, let us consider two very different categories of games: action and board-strategy.

The former could be represented by *Doom* (or a variant), and the latter by chess. Most other games will fall between these two extremes. In the first, the classic arcade-action game, processor time will be taken largely by the display of complex three-dimensional figures, sound effects, and music. In the second, the display is less important than the level of artificial intelligence with which the game is endowed.

In addition, we can say that in terms of pace of game, it is fair to assume that action games are played faster than board-strategy games. In essence, this leads to the conclusion that response times are different in each case.

A player does not mind waiting for a comparatively long length of time in a chess game before some event occurs, which is patently not true of an action game.

Therefore, in the case of the chess game, we do not really have a preference as to how long a particular algorithm takes to execute, so we can discard this. On the other hand, if we are writing an action game, we have a very real need to make the generation mathematics as fast as possible, so that the flow of the game is not disrupted.

This may sound painfully obvious, but we have mentioned that there are other games that fall between the extremes, so it is worth pursuing this further, as the majority of programmers will be working on projects that fall into this category. Besides which, there are techniques that can benefit all developers who wish to create games that combine powerful graphical realism with incredible depth of game-play.

It is also interesting to note that most games of the genre that benefit from all the techniques in this book can be divided into several pieces:

- **Preparation.** Generation of the immediate universe
- **Action.** The core "game"
- **Reaction.** The response of the universe to the player's actions

The third part is optional for games such as *Doom*, where the only reaction is that the difficulty (number and speed of adversaries) may increase if a player proves particularly adept. In a game such as *Elite*, the preparation and reaction parts are given as much weight as the action segment, if only because there is a strategy component as well as an action one. In fact, *Elite* is an example of a game that is as close to infinite in depth as is possible, and the weight of the aforementioned three components in the mind of any one player changes according to the way in which he or she chooses to play the game.

The simplest section about which we can come to a conclusion is the second, the action. Any calculation that is performed that is not part of that required to perform action tasks should be faster than the time taken to perform all other calculations. As an aside, perfection dictates that any calculation used should be performed faster than the time taken to display the frame before and after the action that caused it.

In preparation, the situation is less clear. If we want to generate a maze, for example, is the player prepared to wait while it takes place? This is

something that only the designer can decide; in any case, there must be some form of activity occurring while it does take place. If we assume that the preparation results in data that must be used in the action phase, we can divide the workload to a certain extent.

Although we have spent this first part of the book devising ways in which sequences of numbers can be generated in real time, it does not preclude us from storing such sequences for later retrieval. In fact, this may sometimes prove to be more efficient, since it generally requires less processing power to retrieve a number from memory or external storage media than it takes to calculate it.

Indeed, we might choose to generate a sequence of numbers using an advanced algorithm ahead of time (during design, for example), and package this as data to be used as material for a simpler algorithm that can be used in real time. Taking this even further, it may well be that we only require small quantities of generated numbers that have no pattern within x digits, but that can contain a certain amount of repetition. This is especially the case where the starting digit is different enough times that the repetition is not apparent to the game player, since the objects that are created in this way are far enough apart in distance or appearance as to have no direct link.

Examples of this could be using the same sequence to generate a map of a country, or a constellation of stars. They are different enough that the use of the numbers will not show a pattern, even if the sequences were to be the same. Likewise, it is unlikely that a player will notice if two sections of wall in an action game are similar in appearance—most walls are.

By a similar token, the third issue, that of reaction, could benefit from this approach. That is, we might express the possible outcomes of a particular piece of interaction between the game and player as a set of finite pregenerated pseudorandom numbers. This, however, is limited to those cases where there is a finite number of ways in which the player can have an effect on the game universe.

Clearly, there will be cases in which there is either a potentially infinite number of ways in which the player may affect the environment, or indeed no clear way of determining the effect that the player will have at a given moment of game time.

These will probably be linked in part to the second issue; more explicitly, they will be a direct consequence of something that occurs in the action sequences of the game. In these cases, we might choose to generate an event, or change the attributes of a game object in real time. In order to do this,

we must feed as input to the generator algorithm the current player's action, and possibly some information about the object or event sequence.

In these cases, we can say that the algorithm should be as fast as possible, as we have previously expressed in detail. However, as to what information to feed into the algorithm and the way in which the result is translated, we have yet said very little. Indeed, the discussion of such matters will take place in Part Two, where we look at seeding in detail.

For those readers who feel that we are bordering on a discussion into the artificial intelligence (AI) aspects of the game, we should note that in no way are these techniques a replacement for game AI. In fact, they can be seen more as a complement to established AI techniques, to be used where a touch of unpredictability is required. On the other hand, there are many tasks that could be attributed to the AI engine that we can replace with some of these techniques.

The drawback in doing so, however, is that we lose control, to some extent, over the result. By way of example, we could consider replacing the movement AI of a character in the game with a set of rules derived from a pseudorandom number generator, seeded on the player's action.

Rather than coding a set of rules stating the reaction of the character to a player's various possible moves, we could feed in those moves in relation to the character, and derive an action of its own from a table of randomly selected possibilities. This should be used to select from a variety of possibilities, all of which make sense to the AI engine. It is no good trying to replace the AI engine, since this will lead to some unrealistic choices being made.

In essence, this chapter has introduced one family of techniques that can be used to great effect on their own. Much of the material we have covered provides a good solid foundation upon which we can discuss other, complementary techniques. In addition, we shall be refining our discussions that relate to performance in further chapters.

As a final note, we should reconsider, before continuing, what we hope to achieve with these discussions. The first is that we set out to replace much of the storage of data relating to the Game Universe with algorithms. This has the dual advantage of reducing the space required on the distribution media (a CD, for example), leaving space for more productive or product-enhancing items such as video sequences.

The second advantage is that we have the means to create instances of objects at will, by which we mean that we can populate our Game Universe

on an infinite basis. In addition, we can also choose to provide infinite detail to game objects, whether visually (a face) or logically (a sequence of events).

However, with just the techniques in this chapter, we cannot generate new objects or events. Without great programming leaps, the techniques presented in this chapter preclude this. We need to store data that represents a finite set of game attributes, although we can combine them in an infinite number of ways.

In conclusion, we can say that every usage of these techniques will be based upon an algorithm that depends on storage and generation together. If we want seven types of trees, we must store seven types of trees, although a generated forest of trees may contain an infinite mix of varieties chosen from the seven types.

PRACTICAL APPLICATION: CARD SHUFFLING

In choosing a simple example to illustrate the application of the techniques just discussed, we will see some of the pitfalls that we will need to avoid in future applications. Consider a deck of 52 cards: four suits each containing 13 cards. If we needed to shuffle them (as we did in our "Pairs" game earlier on), we have several options, using random number generators, when implementing a shuffling routine.

Before we shuffle, we need to determine how we are going to represent the objects in the Game Universe. We have two options: assign a number between 1 and 52 to each of the cards, or instantiate 52 objects, each of which has a set of properties. Using the former representation, we would know that, if we order the cards by suit (hearts, spades, diamonds, clubs), the card numbered 15 is the 2 of spades. The latter representation requires storing the number and suit for each individual card object.

Either way, we will probably end up with a set of 52 objects (numbers or cards) that we need to shuffle. The logical first technique is simply to use a random number generator to create a sequence of 52 numbers, each of which is placed in our set, one after the other. Using a simple array, the following pseudocode would suffice:

```
For each card[n] where 1 < n < 52
    card[n] = a random card value
```

The first pitfall of this technique is that we need to explicitly check the array to see if the card we have chosen has already been chosen. Since there is exactly one of each card, we must check this every time; if we have already chosen the card, we must choose again.

In addition, we must also be sure that every card is represented. We run the risk that this proves to be impossible. The nature of our algorithms is such that it is very difficult to be sure that each card is represented exactly once. Our application could find itself in an infinite loop forever chasing after one card that proves elusive.

We can avoid this unwelcome effect by using the "swap-shuffle" technique. Here, we initially populate the array in a linear fashion, such that each "slot" contains a different card. We then proceed to generate a sequence of numbers between 0 and 9999 (coincidentally, the output of the simple Lauwerier algorithm), which we test against a value x.

Starting from the second slot, we generate a random number, and test it. For a value greater than x, we swap the second slot with the first. We then move through the array, generating and testing numbers that determine whether we swap the neighboring values. By the time we arrive at the end of the array, we will have effectively shuffled the cards.

The value x is chosen with respect to the amount of shuffling we need to occur. We may even need to pass over the array several times before the result is of sufficient quality. Embellishments to this technique also include varying the x value based on the output of another random number generator.

Our third, and final, enhancement is the "offset-swap-shuffle." This technique is the same as the "swap-shuffle," except that instead of swapping neighbors, we swap one value with another at a given offset in the array. The precise offset that we use could be arrived at in a number of ways, including choosing a random value higher, or lower, than the current position.

These last two ensure that we will have every card value represented exactly once, and that a fair approximation of a shuffle is performed.

There is one last mystery to solve. We have mentioned that random number generators have been used fairly freely. What we have not mentioned is how they are seeded. Bearing in mind that there should be a different shuffle achieved every time the software is run (within reason), we need some way to provide a unique seed value.

IMPLEMENTATION NOTE 6.1 : SEEDING TIPS

In Chapters 2 and 3, we came to a number of conclusions about pseudorandom number generators. In the end it was established that pure mathematical techniques (Dewdney) should remain unchanged once parameters have been found that work well. For semi-mathematical techniqiues (Lauwerier), this is less important.

The same applies to the seed that is chosen. Within a mathematical algorithm, it is likely that there is only a limited set of seeds that work well. Semi-mathematical algorithms have less of a problem in this respect. Therefore, when attempting to seed on an unpredictable and constantly varying value that we have very little control over, it is generally better to use a semi-mathematical algorithm.

We have a number of possibilities, the most obvious being the time and/or date. It is unlikely that the player will play the game at exactly the same time every day, so it might be realistic to use a number derived from the time of day.

Time seeding can be performed in a variety of ways, depending upon application. This is covered in much more detail in Part Two; for now, we will assume that Time of Day seeding is sufficient. Even here, though, we must be careful.

Since we assume that the game will be played at least once an hour, we must seed based on hours, minutes, and seconds. We achieve this by using the standard ANSI C function *time*, which returns a *struct* of type *tm*. Again, this is covered in detail in Part Two. Briefly, it contains details about the date and time, of which we are interested in the following:

tm_hour The hour, in 24-hour format

tm_minute The number of minutes past the hour

tm_second The number of seconds past the minute

In Implementation Note 6.1, we noted that a semi-mathematical generator is best to use here. Thus, with the Lauwerier algorithm in hand, we can seed on a number as follows:

(tm_hour * tm_minute) + tm_second

This will always return a number greater than zero, since it is in 24-hour format, and the maximum can be calculated as:

$(23 * 59) + 59 = 1416$

This is very important, because we require that the first-pass generation yield a number that is within our calculable bounds as represented by an integer value. This value is 2832, using the doubling algorithm first seen in Chapter 1.

CONCLUSION

The *performance* of an algorithm is thus measured in terms of execution speed and fitness for use. It is well to remember the rules and tips presented here when deciding exactly what kind of algorithm to employ. Special attention needs to be paid to the computational requirements, as well as the stream of numbers to be generated.

Sometimes it will be necessary to trade pregeneration against real-time generation. This becomes important when the reduction in reaction time is deemed less important than "wasting" precious resources in terms of memory and disk space.

The techniques for seeding and generating sequences will be revisited in the next two parts of the book, where the impact of seeding on the predictability of the number streams is seen. All of the techniques that we have seen here will be put to good use.

PREDICTABILITY IN GAME DESIGN

In Part One, "Random Number Generation," we saw how some of the basic mathematical properties of numbers offered the possibility to generate sequences at will, each adhering to a specific set of properties. These we discussed in some detail, leading to some conclusions regarding the algorithms used. In the following parts, we will be putting those algorithms to work in the world of game design, beginning with the use of predictability.

We will see how the properties of the techniques can be put to good use when applying them in the game design and implementation phases of the life cycle of game development. There are, in fact, two places in which we can use the techniques: creating levels that can be shipped on the same media as the game itself; and in real time, once the game is in motion.

Even in the latter, we may choose to combine the application of real-time techniques with some that create data that is to be shipped on the game media. We will explore these and their uses noted for different game styles and situations. The role of the different objects in the Game Universe will also be explored, ranging from game-specific objects to the player and hardware. Everything that is either created for use with the game, or with which the game is designed to interact, can be put to good use within the mathematics of an Infinite Game Universe.

INTRODUCTION

In general terms, any sequence of numbers that is generated using a mathematical algorithm will be entirely predictable. Chapter 1, "The Nature of

Random Numbers," concentrated on patternless sequences of numbers that can be generated using mathematical algorithms starting with a set number of values. One or more of these may be the seed from which all following sequences may be generated.

We defined pseudorandom in Part One, but to refresh this definition, we can reduce it to two words: *predictably random.*

This may sound slightly at odds with itself; almost a misnomer. Surely, the quality of random numbers is that they are not predictable? This is partly true, as we saw in Part One—our definition of *random* simply means *without pattern.* Thus, it is perfectly reasonable to suspect that a patternless sequence can be predicted if one knows the algorithm from which it is created. It is entirely predictable.

Astute readers will have noticed that these pseudorandom sequences of numbers are entirely predictable in their proliferation. One might see this as a drawback, namely that the inability to generate truly random sequences is somehow a failing of modern technology. In game design, however, we count this inability as one of the most powerful techniques in our formidable arsenal, as we shall see.

Even if a given sequence is patternless, it should also be patternless within the parameters of the game. The player will expect that if the designer sets rules that govern the way in which the game is played, then at least the game will respect these rules. Thus, the predictable nature of the pseudorandom number generation algorithms allows us to be certain that this is the case. We saw examples of this in Chapter 5, "Advanced Algorithms and Combinations," where we examined how to shuffle a sequence of objects (in that case, a deck of cards) in which each object is discrete; it appears only once.

During the course of Part Two, we will also discuss repeatable sequences. Closely related to *predictable, repeatable* simply means that each time we generate a given sequence, it will be the same. Seeding allows us to be certain that this is the case. Another quality of pseudorandom numbers is the repeatability that ensures that we play by the rules of our universe, and we do it consistently.

We will expand on these definitions throughout the following chapters as we learn how to create an entire universe from very simple beginnings. A quick note before we begin: The techniques that we develop in this part of the book are a practical application of the principles explored in Part One—the two go together. Those of you who have not read Part One are advised to take a moment to review Chapters 4 and 5.

PREDICTABILITY AND REPEATABILITY

The term *predictable* has a different meaning depending on which side of the table one is sitting. More explicitly, the meaning changes subtly from designer to programmer to player. To the designer and player, the definition is somewhat abstract, detailing only the effects of the predictability. Programmers have a more precise view in which almost everything is predictable. Indeed, the inherent predictability of programming makes it possible to realize the dreams of the designer, and produce solid, reliable software.

The programmer should be aware of the effects of writing predictable behavior into games. Several levels can be used to control the predictability that is presented to the player. The player is, in effect, the only true unknown; by holding at least some of the elements constant, there is at least a chance of catching all the bugs during coding and pre-alpha testing. This increases the quality and reduces the cost of the venture.

THEORETICAL AND APPLIED EXAMPLES

Given a game in which the backdrop revolves around a given theme in which objects and their placement play a large part, the player may not expect the objects to be in different places each time the game is played. Certain features, such as planets, objects such as keys, or even maze configurations must be kept static, both in placement and in appearance, with such aspects only changing within the confines of the rules of play.

It is perfectly acceptable to have series of mazes (levels) that change depending on the ability or score of the player, but these should provide a natural progression, plus a sense of achievement to the player as they are conquered. In order to develop this fully, the player must be given unlimited chances to succeed; although these may be granted within the confines of the game rules. Examples of such games might be:

Lemmings/Worms	:	Ladders and Levels
Doom/Quake	:	Maze
Elite	:	Simulation

Three of the games listed use stored level files, at great expense of resources (memory, external storage) in the case of *Doom* and *Quake*. *Elite* generates the entire backdrop, involving a near-infinite universe of stars, each with its own name and plenty of other properties such as trade, political bias, and so on. *Worms* provides a halfway house, storing only the generator IDs that are passed to the main engine to generate the levels.

Consider what we have just stated. There is not only an alternative to intricate, huge level files that are traditionally used to store level files, but that this can be applied at several levels to increase the depth of play and intricacy of the game.

PREDICTABILITY AND REPEATABILITY

On the one hand, predictability and repeatability are two sides of the same coin. After all, if an algorithm is predictable, it follows that it is also repeatable. By this we mean that if the outcome can be predicted once, it can be fed with the same data, and predicted again—thus it is repeatable.

Predictability and repeatability also have slightly different connotations for the game programmer. By way of example, let us consider the following statement:

Predictability adds realism, repeatability adds depth.

In essence this means that while almost all aspects of the backdrop can be predicted, this adds to the realism by ensuring that generated universes do not change suspiciously from one session to the next. These universes

may be propagated almost indefinitely, since every aspect is repeatable—not necessarily identical, but repeatable for each object.

Repeatability does not restrict us to making carbon copies, but it does ensure that every combination of generated objects will be successful. We do not need to visit every planet to know that every planet will be generated in a manner that is reliably realistic. Predictability will ensure that these planets, once discovered, will remain in the same place.

DEPTH AND BREADTH

In fact, the preceding is an example of *breadth*, a concept that we shall come to know as a macro technique; effectively zooming out to view multiple generated objects. This is a powerful technique, as long as the limitations are understood.

One of the limits was seen in Part One, where we encountered the effect of overgenerating, where the repeatability leads to repetition. Repetition being the point at which objects begin to be created that are identical, it is something to be avoided unless actually part of the properties of the Game Universe.

The partner to macro-resolution is micro-resolution, in which we add detail to the objects. More precise definitions of macro- and micro-resolution and techniques for their application appear later in the book. For now, let us merely consider it as adding detail to objects in the universe.

Depth and breadth are both arrived at through the same processes. More accurately, objects have properties that may themselves be objects with properties of their own. It is possible to generate sequences of numbers that represent objects, which can also be used to generate a sequence of properties for that object. The technique may be scaled in both directions, from many objects with properties to objects with many properties.

It is the combination of number sequence generation techniques, which adhere to both predictability and repeatability principles, that result in being able to generate near-infinite universes, as we shall see shortly.

INTRODUCTION TO SEEDING

One of the underlying principles of the techniques that we explored in Part One was the use of a starting value to feed the algorithm. This seed value provides the starting point, and as such is of utmost importance in the use of Game Universe generation.

Of course, the choice of seed is not a black-and-white proposition. Indeed, for every way in which we wish to use the techniques from Part One, there is at least one way in which we can choose the starting values, including the seed.

There are "software" ways to choose the seed, which rely expressly on the game configuration at a given moment in game time, and "hardware" techniques, which use external inputs. In general, the techniques that prove to be the most useful are those that use both hardware- and software-oriented algorithms to choose seeds.

Of course, the seeds can also be determined ahead of time. That is, it is not required that all seeds be generated in real time, especially if the performance of seed selection algorithms is such that the playability of the game suffers as a result.

One point to bear in mind is that the choice of seed should be made quickly and use as little resources as possible. The algorithm that the seed is to be fed to is likely to be quite intensive; we would like to reduce the impact as far as possible. Often, we should be prepared to compromise, and keep at least some of the input static; it is probable that retrieving data from storage is less resource intensive than calculating the value in real time.

The following sections detail the theory behind choosing seed values, not how they might be applied. It can be seen as an introduction to the rest

of this part of the book. The various uses for the seeds are detailed in Chapters 9 through 11, with real applications following in Chapters 12 through 14. Readers tempted to skip this part in favor of seeing the techniques in action risk having to refer back to this chapter on a regular basis.

Seeding on User Interaction

Using the reactions and responses of the player to affect the outcome of a game is not a new concept. In *Elite*, if a player trades heavily between two planets, always exporting the same product (food, for example), the laws of supply and demand will eventually come into effect as stocks dwindle on one side and rise on the other. This has a direct effect in the price difference between the two planets for that item, thus reducing the profit for the player.

Action games also use the actions of the user to dictate the actions of other objects within the Game Universe. Enemies fight or flee, spacecraft perform evasive actions, the player to your right leads with a trump; user interaction is the *raison d'être* for many games, and almost every game uses it in some way to drive part of the experience.

Seeding takes the simple action/reaction principle one step further. While the game should always be in control of the general flow of events, control of the details can be relinquished in favor of the player. The best way to appreciate this concept is with an example.

Consider an action game in which the player must fly over and into a planet in a spacecraft that can be armed with a variety of interesting weapons that have different characteristics. Along the way, there are a number of strange beasts and opposing spacecraft all trying to destroy the player before they are destroyed.

The general flow is that the player must get from the beginning to the end in one piece. In order to have a reasonable chance of achieving this, the main opposition should always be in the same place, and react in a way that is vaguely predictable. This flow, both in positioning and behavior, should be predetermined, and forms part of the rules of the game.

Within these rules, there will be variations to increase difficulty and to surprise and amuse. Variations can exist in different forms such as movement, appearance, and actions, and may be stored or generated, but all will adhere to the rules of the Game Universe.

The variations make the game playable in the long term. Every time the player plays the game, he or she will play it in a different way. The differences can be used to seed a number of algorithms that will produce different results each time. Thus, we use the way in which the player is playing to influence the way in which the universe reacts to the player.

Simple variations can be implemented using the action/reaction model. The player moves up, the beast moves down. The player shoots the beast, and it moves away from the player before attacking.

To go beyond this, we might want a whole scenario of events to unfold, a plot involving many game objects, and possibly some variations generated specifically in an attempt to thwart the player's latest tactic. To do this using action/reaction programming would require a large chunk of resources, and in some cases would prove impossible.

Doing this using seeded algorithms becomes almost easy. We can produce a whole stream of numbers based on the player's actions that can be applied to the Game Universe to create intricate subplots and scenarios that would be impossible to achieve using traditional techniques. Throughout this part of the book and in future chapters, we will see exactly how the techniques can be applied to provide a realistic and stimulating Game Universe.

HARDWARE USER INTERACTION

The most obvious example of user interaction is via hardware input devices such as the mouse (or joystick) or the keyboard. Although this might sound like a simple proposition, there are a surprising number of variations that involve the user interacting in some way with the machine.

How the technique is used depends on what it is to be used for. The simplest use is for occasions in which discrete events are required. Such events may be single, timed actions or reactions, or more complex compound sequences.

Hardware interaction depends on something the player does, doesn't do, or the way in which it is done, and is therefore not appropriate for building static parts of the universe. This is because the player (as previously noted) is the one unpredictable element in the Game Universe.

While an unpredictable element cannot be used to seed the creation of a universe, for timing events that are carried out by either passive or active

game objects, an unpredictable element becomes very useful. There is an increase in realism, for example, that comes from added fluidity. The fact that the player is leading the action also gives a sense of immersion.

There are other bonuses, but before we can consider them, we should first expand upon exactly how the interaction between the user and the hardware is used. The majority of the interaction can be discussed in terms of "buttons." To keep consistency between platforms, the various input devices can be considered as handheld controllers as in Figure 8.1.

FIGURE 8.1 Typical controller layout.

In Figure 8.1, we consider that joystick/mouse forward, the up-arrow/8 key, and up button are equivalent. Also equivalent are the A/B buttons on the joystick or controller, Return/Shift keys on the keyboard, and left/right buttons on the mouse. These equivalencies are entirely arbitrary and will change from platform to platform.

IMPLEMENTATION NOTE 8.1 GAME ENGINES

The core of the game software is the *Game Engine*. It can be seen as a logical core that handles the decisions required to power the Game Universe.

For the purpose of this book, we shall assume that it is an entity that receives messages in a format that it understands, and generates messages that other entities understand.

This abstraction means that all hardware aspects of the game device (PC, console, handheld) can be represented by specific units that translate between the hardware and message system.

From a seeding point of view, we shall also assume that the logic is performed in the Game Engine, but that the translation is performed in the hardware specific code.

Representing Hardware User Interaction

The designer must first consider the translation of each element into messages that the game engine understands. This translation enables us to retain a semblance of abstraction away from the constraints of the platform.

By way of examples that have meaning in the real world, we will base our message handling around the following (which is borrowed from the way in which Microsoft Windows deals with similar interaction):

KEY_UP identifier repetition when

KEY_DOWN identifier repetition when

In this simple representation, the *identifier* is a value detailing the exact action that has been taken, the *repetition* value indicates how many times the action has occurred within a given time period, and *when* indicates the time at which the event occurred.

It is feasible that *repetition* is greater than 1 in cases where the system has not had the time to make multiple messages for user actions. In such cases, *when* may indicate the time of the first or last action, depending on the implementation.

The actual value for *when* can be represented in terms of game-time or real time; that is, it could be the time in play, or time of day in the real world. The latter is dangerous, since there is no way of knowing when the game will be played. If it is used, it should usually only be used to measure time differences, and not discrete values.

NOTE

Time-of-Day Seeding

Some operating systems, such as Microsoft Windows, offer a function that returns the number of time units since the current session was started.

Such functions come with the same reservations as using the time of day; it will never be the same time of day for a given point in the game on separate occasions.

However, this type of function comes into its own when trying to calculate game-time, since it is a simpler value to deal with, being measured in milliseconds, or seconds.

Time of day as defined by the ANSI C library is measured in milliseconds since 1970, making the values extremely large when calculations to retrieve game-time are concerned.

As long as the designer and programmer are consistent and aware of the consequences of using one or the other, the choice is arbitrary. The resolution of *when* is another matter; if game-time is chosen, it might make sense to represent *when* in terms of seconds or even milliseconds, depending on the pace of the game.

The message is sent to the core Game Engine by the hardware entity responsible for monitoring the relevant piece of hardware when the player releases the joystick or moves the mouse, or presses/releases/hammers a key or button. Table 8.1 lists the values for the *identifier* that could be processed in order to seed events based on the appropriate instance of user interaction.

TABLE 8.1 Simple Message Translations

NORTH	UpArrow or Mouse/Stick Forward
EAST	RightArrow or Mouse/Stick Right
SOUTH	DownArrow or Mouse/Stick Backwards
WEST	LeftArrow or Mouse/Stick Left
A	Return or LeftButton (Fire)
B	Shift or RightButton (Select)

If the user were to move the joystick up (or press the Up-Arrow key), hold it there for two seconds, and move it back to the center, the entity responsible for user input might generate a sequence of messages as in Table 8.2.

Now that we have defined how the user interaction is going to be represented, we shall turn our attention to how the Game Engine can use this information in the terms of our universe. We have four parts to each message that fall into two groups: action, and time of action (or simply, time).

TABLE 8.2 Message Sequence Example

Message	Identifier	Repetitions	When
KEY_UP	NORTH	1	5
KEY_DOWN	NORTH	1	7
KEY_UP	SOUTH	1	7
KEY_DOWN	SOUTH	1	7

If we are programming in C or C++, or a similar language, we will probably have attached numerical definitions to the *message* and *identifier* actions. This might look similar to:

CODE SAMPLE 8.1 Message representation.

```
// Message Types
#define KEY_UP      1
#define KEY_DOWN    2
// Message Identifiers
#define NORTH       100
#define EAST        101
#define SOUTH       102
#define WEST        103
#define FIRE        104
#define SELECT      105
```

This is the *action* group of message components. The *time* of action group contains values that are already numerical in nature. Once we have numerical values attached to each group, we can use them to create seed values.

APPLICATION OF HARDWARE USER INTERACTION

We shall consider the application of hardware user interaction in terms of the *action* and *time* groups, defined in the preceding section. In general, *action* events are discrete, and are only useful when dealing with discrete game objects. *Time* is continuous, and can be used in a way that is subtly different for scheduling multiple objects and game events. The difference will become clearer as we progress.

In defining how the various values can be used, we are assuming that the algorithm to which they provide input generates output that is in some way meaningful. Exactly how it can be meaningful is discussed in later chapters, but the discussion here is complex enough without trying to incorporate that into the theme presented herein.

One of the conclusions that we came to in Part One was that seeds work best if they are large and varied—that is, they contain a set of bits that are odd and even—to generate a sequence of numbers that is patternless. Our numbers presented previously do not fulfil these criteria, and we have two

choices. The first is to insert numbers in the code that fulfill the criteria, and the second is to somehow define an algorithm to create the numbers in real time.

If performance is an issue, the recommended solution is to insert numbers in the source code that can be used with very little preprocessing. In cases where performance is less important (the nonaction sequences of games, for example), we can use either. To arrive at these numbers, a pseudorandom number generator should be used, which generates a sequence of values with a repetition period that is at least as large as the required number of elements. Part One examines this aspect in more detail. The following code segment shows a possible revision of the code required to implement this.

CODE SAMPLE 8.2 Revised message representation.

```
/* Message Types
   Generated using the Lauwerier
   Algorithm with a seed of 98765
*/
#define KEY_UP    9753
#define KEY_DOWN  9506
/* Message Identifiers
   Generated using the Lauwerier
   Algorithm with a seed of 54321
*/
#define NORTH     864
#define EAST      1728
#define SOUTH     3456
#define WEST      6912
#define FIRE      3824
#define SELECT    7648
```

This is a clear example of a technique described in Chapter 4, using a pseudorandom number generator to create seed values that will be used as input to one used in real time.

These values can then be fed into the real-time algorithm, which produces a repeatable sequence of numbers that we can use to change the properties of a game object in response to an action carried out by the user. In its most simple terms, this is merely an example of an action/reac-

tion relationship, which does not necessarily need to be implemented in this way (as we stated at the beginning of the chapter).

The power of this technique becomes apparent only when we consider what happens next. We discussed a simple action game in the section above "Seeding on User Interaction," loosely based on a game called *R-Type* written initially for the Nintendo 8-bit games console.

Revisiting this example, let us consider one of the creatures that appears in *R-Type*. A simple version of this beast is depicted in Figure 8.2.

As can be seen in Figure 8.2, the creature resembles a kind of tail, anchored to the wall. It has some freedom of movement, and touching it is lethal. Other than that, it is quite benign. Like the ghosts in *Pac-Man*, it moves in a way that has pattern when the player is not close to it. Once the player approaches, however, it moves in a somewhat erratic way.

One other quality that this beast has is that, as the *Pac-Man* ghosts, it is continually moving. Each movement could be described in a way that is based on a sequence of pseudorandom numbers. This being the case, we could also base the movement on a series of numbers generated using the player's actions as a seed.

By extending the action/reaction philosophy of game design, using sequences of generated numbers, we need only store the characteristics of the creature, and leave the movement definition to be provided for in real time. Simple action/reaction dictates that if the player stops moving, then the creature will, too. This is not very realistic in the majority of cases, and by using this new technique, the realism can be retained, since even if the player ceases to move, the sequence of numbers can continue to be generated.

```
########
######
######                   0000
####          0000 0000 0000
######0000 0000              0000 0000
######0000                       0000
####
########
########
####
######
```

FIGURE 8.2 Plain-text representation of an *R-Type* style character.

Astute readers will have spotted the one problem that must be solved before this technique is ready for the real world. If the player performs the same move twice, the sequence of numbers that dictates the movement of the creature will be "reset," since an identical seed will be created and fed to the movement algorithm.

The danger is that if the player continually moves, the beast will remain static, unless steps are taken to prevent the same seed being continually fed to the algorithm that generates the movement of the creature. A simple way to avoid this is to retain the seed, and only reseed if the new seed is different. Another way will be seen later in this chapter, and more complex approaches are detailed in Chapter 11, "Plot Sequencing."

The actual seed value that is to be used can be arrived at by a simple addition of the numbers representing the message type and identifier. Using our revised code segment, a movement by the player results in the following message:

Message Type	Identifier	Repetitions	When
KEY_UP	NORTH	1	5
9753	864		

(The two numerical values are taken from the representation code segment.)

This would result in the *action* segment being represented by the single number 10617. Using this as the seed to a Lauwerier algorithm implementation (from Chapter 1) would yield the following sequence of numbers:

10617, 1234, 2468, 4936, 9872, 9744, 9488, 8976, 7592, 5184, 0368 …

To tie up this first discussion, we shall assume that our beast moves in a way that is defined by two numbers; one referring to the segment that is to move, and one referring to the movement the segment is to perform. If our beast has five segments, each of which may move up or down, or not move, we can generate the sequence of numbers listed in Table 8.3.

In this table, *segment* is arrived at by a modulo operation by 5, and *movement* by adding *value* to *segment* and performing modulo operation by 3 on the result. While this approach has limitations, it is a good starting point for any aspiring games programmer to enter the world of infinite variations on a given theme.

TABLE 8.3 Generated Movement Table

Value	Segment	Movement
1234	4	2
2468	3	2
4936	1	2
9872	2	1
9744	4	1
9488	3	2
8976	1	1
7592	2	1
5184	4	0
0368	3	2

The final aspect of *action*-based interaction is to consider sequences of keystrokes, combinations of user events to produce similar effects. Thus, if a user decides to try and "confuse" the beast by making rapid movements, we can limit the effect of rapid reseeding of the movement algorithm, and provide a better flow of events at the same time.

Using our *R-Type* variant example, we might assume that a player moves rapidly from side to side, hoping that the beast will attempt to move in an obstructive way such that it becomes predictable. This would be based on observing the reactions of the beast to discrete left and right movements made by the player in the past.

We have two possible approaches to avoid the unwanted effects of repeatedly reseeding the movement algorithm: ignore the player's movement for a certain number of iterations, or use the sequences of player actions to reseed the algorithm so that the beast exhibits different behavior.

The choice depends on the application. In some cases, we might wish to apply the sequence reseeding technique only in more advanced stages of the game. It is left to the programmers and designers to decide which of the possible approaches should be taken. Mathematically speaking, there are two ways to apply the sequence reseeding approach.

In the first instance, we could just add together the values arrived at by the action sequence. There are a few aspects to avoid, such as the value being too high to calculate a meaningful value. In order to avoid these unwanted effects, we could keep a running total of each action, and use this

total to seed the algorithm and reset it to zero. In this way, we also avoid repeated reseeding.

On the other hand, we could calculate a running average that is used to reseed the algorithm periodically. This also avoids the unwanted effects we mentioned. Again, choosing which approach to use is up to the designer and programmer. It is very likely that different approaches work best for different applications. The general flow of control, however, remains the same:

1. Seed movement based upon player's current (last) action
2. Calculate running value
3. If target value hit, reseed algorithm
4. Perform game actions
5. Go to step 2

In this way, we ensure that the movement algorithm is seeded properly in the first instance, and that it is reseeded appropriately.

TIME-BASED INTERACTION

So far, we have dealt only with *action*-based interaction. The other group that we mentioned previously is *time*-based interaction. That is, in addition to using the discrete actions of the player to seed variations in the Game Universe, we can also use the time at which an event occurred, with relation to other aspects of the Game Universe.

In general, *time* is a continuous thread running throughout the playing session; it is therefore useful in two ways. The first is in measuring the time difference between two actions, otherwise known as the *reaction time* of the player. The second is to seed on discrete time values with relation to the state of the Game Universe. The latter is discussed in the section entitled "Software User Interaction."

When using time to seed algorithms, we must perform a certain amount of *event tracking*. In essence, this means that we must have a series of checkpoints defined for certain actions, detailing the action and when it occurred. These checkpoints should always be defined with respect to the object that provides the basis for the checkpoint. There are a few instances where *global event tracking* is required; again, these are discussed in the next section.

Event tracking is best applied in a Game Engine that is message based. In our examples in this section, we have defined a number of messages that can be fed from the control devices to the Game Engine, so we have already assumed that we will be taking this approach.

In the message-based environment, we can post messages to objects, and they can post messages to the core Game Engine. In this way, we have a high level of communication between the different game objects and the universe. Without this communication, it becomes necessary to introduce measures for examining game objects explicitly. This reduces the transparency of game objects, and increases the complexity of the application.

Therefore, not only is the message-based approach good for event tracking, it is also a good all-around technique for reducing complexity and increasing reliability and ease of programming. The majority of the time, however, the programming of a game will involve a mixture of messages and object examination. This is simply a question of performance; a message-based architecture is very resource intensive.

This discussion aside, we will assume that for the movement and control of the game objects in real time, the message-based approach is being used. Even with a well-defined architecture, there is a choice to be made regarding the specific application of movement algorithms. In the end, it can be condensed to a simple question of responsibility: does the Game Engine take responsibility for dictating movements to the game objects, or does it just feed messages to them and leave them to inform it of any reactions?

Whichever is chosen, the theory remains the same. An object performs an action, and the time is noted. The user performs an action, and the time is noted. If the user's action is considered to be a reaction to whatever the object did, the difference between the two is calculated. The resulting value is then used as a seed to an algorithm that dictates some aspect of the object's future movements.

These future movements may also have possible player reactions associated with them, and consequently, more seeding may take place based on future reactions of the player. In this way, a sequence of events unfolds, each based on the other. It is even possible to introduce the actual actions that the player performed into the equation.

It is the incorporation of the timing and sequencing of actions and reactions that lead us to the next section.

SOFTWARE USER INTERACTION

In the preceding section, we dealt only with the actual actions that the user performed, and when they were performed. In the fabric of a Game Universe, however, these actions may not make sense in isolation. In other words, there will be cases where the action itself does not tell us enough about the state of play to make a decision about how to alter the Game Universe.

This can be illustrated by considering the movement of the player's vehicle to the left. The user presses the left arrow key (or moves the joystick to the left). This is the action. A message arrives at the Game Engine, informing it that the player wants to move to the left. The Game Engine does not have enough information from this alone to give the command to move the craft on the screen one unit to the left; there could be a wall in the way.

In the same way that the Game Engine must consult a number of different objects and their states before making a decision that will affect the Game Universe, there are also cases in which an algorithm using the User Interaction information in this way should perform similar consultations.

The aim of software user interaction is to consider what direct effect the player has had on the Game Universe because of an action, and translate this into an abstract effect. This abstract effect can then be used to generate other abstract effects that are then translated into direct effects on the Game Universe.

One way to look at this is to consider the effect that the player of an adventure game has by picking up a lamp. The direct action is that the user picks up the object. A number of indirect (or abstract) effects result from this action. The first is that the character representing the player gains weight; the weight of the object. The second might be that the character's backpack enlarges slightly.

Further effects might be that the lamp turns out to contain a genie, which might be a good or bad thing depending on other user actions. These latter results might be generated from the abstract effects that certain player actions have had on the Game Universe. Indeed, it is not simply the act of picking up the lamp that is used to generate other abstract effects, but a combination of this and other direct actions that all have indirect effects on the Game Universe.

The generated abstract effects are then translated into direct effects on the Game Universe. Bad genies might perform evil abstract actions that re-

sult in direct actions such as roofs falling on the character's head, floors falling away, or other deeds that have direct effects on the character such as injury, or falling into caves below the castle.

This might sound complex, but it is a question of representation. If each object is defined discretely, each having its own set of properties, actions, and reactions, the technique becomes easier to appreciate.

We will look at the action portions of game objects in Chapter 11. For now, let us consider the effect of the interaction between objects in the Game Universe.

The first point to note is that in order to keep the possible interactions between objects predictable, we fix the possible properties and values at design time. Put another way, we introduce limits to the mathematical algorithms that define each object so that we can always be sure that the objects exhibit the correct appearance.

Software user interaction, then, begins with the instantiation of the game objects. During this phase of determining the immediate part of the Game Universe in which the players find themselves, we generate and present the objects that surround the player.

These objects may be generated with reference to some properties that are exhibited by the state of the player object, or by the state of the surrounding nonplayer objects. We will discuss this in detail in Chapter 9, "Serialization Techniques." For now, let us just concentrate on the theory, that the seed choice is made with respect to the initialized location of the Game Object within the Universe.

DESIGN NOTE 8.1 THE THREE PHASES OF USER INTERACTION

In general, the user can interact with the Game Universe in a discrete number of ways.

Instantiation occurs when the Game Universe (or portion closest to the player) needs to be generated for the first time.

In the *action* phase, the user may cause direct or indirect changes to the Universe.

Following the action phase, there may be a period of *reaction*, where any effects on other objects not directly affected by the action phase are generated.

While the action of the player may be unpredictable, we should always use mathematical techniques that ensure that the effect that the player has on the universe is predictable, by limiting the effect that the player has.

Once the game is in play, various action phases might affect the Game Universe, and Objects within. Each Object will have a set of properties that might be altered during the Object's life span by the player. We will discuss this side in Chapter 11, "Plot Sequencing."

In action phases, the choice of seed may be related to the new position of the Object, if it has moved, or any properties that have been altered by the player. These are direct consequences of the player's intervention in the Universe.

Finally, once the player has had an effect on the Universe, there is a period of reaction. Seeding from this requires examining the indirect effects of the player's action. Again, we deal with this in detail in Chapter 11.

In this final phase, seeding takes place using a number of inputs, ranging from placement to the effect of the properties of involved objects and their possible actions.

Now that we have considered how we might choose seeds from the ways in which the user might interact with the universe, it is time to see how the universe itself provides seed material.

SEEDING FROM THE UNIVERSE

In the same way in which the user interacts with the Game Universe can be used to set up values for the various objects, the objects themselves can provide input into their generation. In other words, even before the player is allowed to have an effect on the universe, the universe can be generated.

This commonly occurs only once in a given game session, although it may happen more than once if the player performs an action that causes the immediate portion of the Game Universe to become irrelevant. By way of example, players could transport themselves from one planet to another using some form of hyperspace or teleport device.

Care should be taken, however, when using this latter technique, since there may be logical effects on other game objects as a result of the player's action. Some of these objects will be part of the portion of the universe to which the player is moving. Realism dictates that such effects not be overlooked.

One of the sources of seed material that the universe provides itself is game-time. There are a number of ways to represent game-time. The first is by direct relation to real time. This would mean that, give or take, game-time resembles real time in format, resolution, and structure.

Game-time might be equivalent to real time, or it might be offset by a certain amount. Either way, there are specific pitfalls to note when using this form of time as a seed value. The first is that predictability will be affected. Unless we can ensure that the player is always at the same place at the same time, the numbers that we generate from the game-time value will be different each time the game is played.

Because of this, they cannot be used to seed immovable game objects; that is, objects that the player will always expect to be in the same place every time they are encountered, regardless of when they are encountered. Realism dictates that, except in exceptional circumstances, the universe does not change; this has been one of our key premises throughout the book.

However, when seeding from the universe, there is a difference between an object being in the same relative place, and moving in a discrete way. Planets in *Elite II: Frontier*, the sequel to Braben and Bell's *Elite*, subscribe to this quality. They move in orbit around a specific point. In comparison to the universe, they do not move, but in relation to the player, they move in a controlled way.

One might assume that some complicated celestial mechanics are at work that dictate the movement of the planet around the star. However, it is quite possible to assign a few qualities to the object, and use the appropriate game-time to seed the position of the planet as the user approaches.

A simple linear algorithm might state that the object orbits around a star every 12 hours. Thus, after also assigning its distance from the sun, we can calculate its position at a given game-time. This can be used as a seed for other values; which will always be the same at that point in orbit, although the actual game-time might be different.

Another variety of game-time is time in play. This is associated more with action games, which might be over in a matter of hours, rather than days. In fact, a simulation-strategy game such as *Elite* might also use time in play in action sequences.

One might consider that an event might occur after a certain period of time had elapsed. This event would always occur, no matter what the player was doing at that point in time. While not immediately obvious, this technique is very powerful.

It is easy enough to imagine one key action occurring at a given point in time. Where this technique becomes more useful is if there is a discrete set of possible events, or even a generated sequence of possible events, that occur at given points in the game. If these events are key to the plot, then

they should occur at the same time. Rather than constantly checking to see if an event should be triggered, we can merely use a seed value derived from the game-time to seed an event (or lack of event).

Besides seeding on game-time, there are other qualities pertaining to the Game Universe that might provide good seed values, such as properties of objects, or properties of the player with respect to other objects.

Now that we have examined how various seeds might be derived from the universe, it is time to see in detail what the actual input numbers mean, and how they can be used. We shall start with object placement otherwise known as *serialization*, and move on to plot sequencing in Chapter 11. During these discussions, the contents of this chapter should be kept in mind at all times.

SERIALIZATION TECHNIQUES

In the preceding chapter, we saw how the Game Universe can be seen as a collection of objects, each with its own set of rules and qualities. All games can be reduced to a collection of interacting Objects, which are set against a Backdrop.

When creating either Backdrops or Objects, we may choose to set their properties according to their situation or position within the Game Universe. Additionally, there may be other factors that may affect their exact nature when they are created. It is usual for Objects to be set up according to their position with respect to the Backdrop against which they exist, and

DEFINITION NOTE 9.1 OBJECTS VS. BACKDROPS

Generally speaking, Backdrops are static, and Objects are dynamic.

This difference is applicable in both programming terms and in logical terms.

The Backdrop is usually created and instantiated at a specific time and does not change during its lifetime; after which, it is destroyed.

Objects can be created and destroyed at will, and may change during their lifetime.

As a final note, Backdrops can contain Objects; Objects can be used to represent parts of the Backdrop that might change.

Objects, however, cannot contain Backdrops.

for Backdrops to be created with respect to each other in terms of the Game Universe.

To take a simple example, consider the game *Elite*, which is a classic example of this in action. The Backdrop consists of a series of galaxies, each containing a number of stars. Orbiting each star is a planet, and orbiting each planet is a space station in which the player may dock.

Each star has a set of properties pertaining to the inhabitants of the planet, along with information about imports and exports, political bias, and relative stability. These properties are held static: the galaxy, and the stars and planets within, are the Backdrop.

Each space station Object, however, is defined by properties relating to the type of goods that are for sale, and their prices, along with what weapons and spacecraft-enhancing objects (such as shields, etc.) are available. These are all properties that may change.

Other objects that are created during the playing session are opposing spacecraft that may attack the player. These objects, and their temperament, are also variable.

We could choose to instantiate each Backdrop (star) in terms of its position within the galaxy, and each space station could be generated in line with the properties generated from the characteristics of the star. By the same note, when a player arrives near a given star, spacecraft objects could be generated (or not) depending on the current state of play and properties relating to the player and the space station.

A player could arrive at a poor star that has been reduced into anarchy, carrying precious metals, and be fairly sure of being attacked by pirates. By a similar token, a player who has killed a number of police craft might arrive at a well-policed system and also be sure of receiving a visit from the local police, as a result of previous misdeeds.

All of the preceding relies on *serialization*, the positioning and properties of Backdrops and Objects within the Game Universe. Before we discuss this in detail, the reader should be aware that because we are concentrating on generating objects based on certain properties, there is no limit to the number of objects that can be created. Our Game Universe will be very close to infinite in dimension.

Algorithms for setting advanced properties of objects such as their appearance are discussed in Parts Three and Four of this book. The discussion here is on how to arrive at numbers and number sequences that can be used as starting points, or seeds, for those algorithms.

THE BACKDROP

As we discussed in the introduction to this chapter, the Backdrop is the setting against which the action of the game takes place. Once created, it remains static for the duration of its lifetime. The backdrop is usually seen as a collection of objects that have a variety of properties that are initialized at the start of their life and do not change.

Traditionally, the backdrop has been stored on the distribution media, in expanded form. By *expanded form*, we mean that the entire collection of objects is stored, along with their properties, and all that is required is to read them into memory at the appropriate time. Games that rely on this are generally action games or ladder- and level-style games such as *Doom*, *Manic Miner, Repton,* and *Quake.*

These are all excellent games, and have one thing in common: a start, middle, and end. That is, they all contain a number of levels of increasing difficulty, in which the last level is the hardest and guarded by a truly awesome end-of-level boss.

At the other end of the spectrum, we have games such as *Elite*, where every aspect of the backdrop is generated as the player progresses; as each object comes into scope, it is generated from a generic version; and the properties are set according to the outcome of a seeded algorithm.

In between, we have games such as *Worms*, in which the numbers required to generate the levels are stored along with the game executable as part of the distribution media.

Surprisingly, the techniques in this book can be applied to all kinds of games; the roles that the techniques play change according to their use. One would expect that in a book dealing with Infinite Universes, we would only be concerned with the application of such techniques with respect to near-infinite games.

However, we have noted in the past, and will note again, that infinity works in two directions. That is, we have infinity as applied to a number of objects, and applied to the detail of those objects.

This minor digression leads us to the conclusion that we can use serialization techniques to create an infinite number of game objects, each with differing properties. We can also use serialization to instantiate objects that have been referred to on the distribution media.

There is still a place, even in the Infinite Universe, for level files, but we would like to minimize the quantity of information that it should contain, especially in an age when limited resource environments such as consoles

and handheld units are coming into their own. Even more applicable with the prevalence of the Internet is that many games will be aimed at the download market, where every additional second of online time results in an increase in cost for the player.

REFERENCE COORDINATES

Serialization techniques revolve around the reference coordinates of a given Object in the Game Universe to determine what properties it should have. Simply put, it is the Object's position at the time that it is to be instantiated that is used to give it a set of properties that dictate its appearance and behavior within the Game Universe.

If we consider as an example of a Game Universe a simple two-dimensional grid consisting of tiles that are predefined, and rendered accordingly for display, we can state that each one can be expressed in terms of its position on the grid. From this position, we can determine what tile should be present at that particular game coordinate.

We might have a tile representing each of the following:

- Grass
- Water
- Mountain

The choice of which tile to use for a given position within our grid might be the result of an algorithm designed to take as input the x and y position of the tile on our grid, which is assumed to wrap around like a torus (or donut) in each direction. For a grid that runs from 1 to 10 in each direction, we therefore have 100 possible tiles to place.

For each tile, we have a possible choice of three properties (grass, water, or mountain) that we can assign to that tile. We have two choices as to how

IMPLEMENTATION NOTE 9.1 POSITION DEFINES PROPERTIES

If the properties of an Object are defined by its position in the Game Universe, then it also follows that the same Object in a different position will have different properties—it will appear and behave in a different way.

This is one of the reasons why Backdrop objects do not move, and one of the reasons why Infinite Game Universes are possible.

we populate our grid. A game in the style of *Elite* will create each tile as it is encountered. On the other hand, a *Doom*-style game will probably store the properties of each tile in a level file.

Whichever way is chosen, this technique can be applied. The only difference is that the grid is either generated in real time, or generated and stored. One advantage with generating and storing is that we can tweak the generated grid by hand so that it takes on a more realistic appearance.

In real time, we have very little control over how it will appear. There are, of course, a number of techniques for dealing with this aspect, which you will see in Parts Three, Four, and Five. For now, we will just assume that we can deal with a completely random distribution of properties.

Now that we have come this far, it should be obvious that we will be using a pseudorandom number generation technique like those discussed in Part One to create our properties. Equally obvious is that every time we generate the grid, we would like it to be the same. The same Backdrop should not change every time the game is played!

In this case, the Backdrop is our 10 × 10 grid, of which each tile has a property that can be set to water, grass, or mountain. This property allows the Game Engine to render the tile accordingly. As always, we have a number of choices as to how we implement this. The first, and simplest, is to generate 100 tiles, using a sequence of 100 pseudorandom numbers.

The crux of the matter here is that we need to seed the pseudorandom number generator. The choice of seed is relatively simple. Applying the principles that we have dealt with up to now, we know that it should be at least four-digits long, with a varied bit sequence. We cannot seed based on game-time, or user interaction (see Chapter 8, "Introduction to Seeding"), since this grid must be the same whenever the game is played.

Instead, we will use the principle discussed as being particular to the game *Worms*, using a previously defined number, which generates a grid that we can approve. This number is read from the storage media, and could be "9352." Using the Lauwerier algorithm, with a multiplier of 2, and four-digit length, we would arrive at the values listed in Table 9.1.

The values in Table 9.1 were created by the FASTGEN program, which is available on the accompanying CD-ROM. A quick analysis shows that rather than storing 100 numbers, we store only five, a savings of 95 percent. Assuming we are able to assign tiles to the numbers in a meaningful way, we have generated our Backdrop, from a starting value, in a very simple fashion.

TABLE 9.1 10 × 10 Grid of Lauwerier Values (Seed 9352; Multiplier 2; four digits)

	1	2	3	4	5	6	7	8	9	10
1	4816	9632	9264	8528	7056	4112	8224	6448	2896	5792
2	1584	3168	6336	2672	5344	0688	1376	2752	5504	1008
3	2016	4032	8064	6128	2256	4512	9024	8048	6096	2192
4	4384	8768	7536	5072	0144	0288	0576	1152	2304	4608
5	9216	8432	6864	3728	7456	4912	9824	9648	9296	8592
6	7184	4368	8736	7472	4944	9888	9776	9552	9104	8208
7	6416	2832	5664	1328	2656	5312	0624	1248	2496	4992
8	9984	9968	9936	9872	9744	9488	8976	7952	5904	1808
9	3616	7232	4464	8928	7856	5712	1424	2848	5696	1392
10	2784	5568	1136	2272	4544	9088	8176	6352	2704	5408

The power of this technique becomes apparent when we consider that this set of 100 tiles is a corner of a world populated by 100 such sets of tiles. That is, it is (10 × 10) × (10 × 10) tiles in size. One thousand numbers would be required to store each tile individually. We can achieve the same effect using generation from a set of 100 numbers; a savings of 90 percent.

This may not seem particularly startling at first sight; the implications, however, are quite startling. Suppose each tile is one-mile square. If we have designated a particular tile to have the property "grass," defined by our algorithm, within this we could generate a set of subtiles, each one-tenth of a square mile in size. We now have another grid of 10 × 10 tiles.

For each of these subtiles, we might decide that each could have a property logically derived from "grass," such as "marsh," "copse," or "meadow." From the grid in Table 9.1, we pick an arbitrary tile: 3,7 with a value of "5664," which we assume to be "grass."

Using this as a starting value, we can generate values, as in Table 9.2.

Again, these values were generated using FASTGEN, but this time with a multiplier of 3 and using three digits as a maximum length. The Game Universe would begin to become a little cumbersome at this point if we had to store all of these values in a level file. We have a set of values some (10 × 10) × (10 × 10) × (10 × 10), or 1 million tiles in size, which we can generate from a mere 100 numbers.

This is more impressive. Granted, one has to have a good algorithm for deciding how to allocate properties in a realistic fashion, but at least in

TABLE 9.2 10 × 10 Grid of Lauwerier Values (Seed 5664; Multiplier 3; Three Digits)

	1	2	3	4	5	6	7	8	9	10
1	0699	0097	0291	0873	0619	0857	0571	0713	0139	0417
2	0251	0753	0259	0777	0331	0993	0979	0937	0811	0433
3	0299	0897	0691	0073	0219	0657	0971	0913	0739	0217
4	0651	0953	0859	0577	0731	0193	0579	0737	0211	0633
5	0899	0697	0091	0273	0819	0457	0371	0113	0339	0017
6	0051	0153	0459	0377	0131	0393	0179	0537	0611	0833
7	0499	0497	0491	0473	0419	0257	0771	0313	0939	0817
8	0451	0353	0059	0177	0531	0593	0779	0337	0011	0033
9	0099	0297	0891	0673	0019	0057	0171	0513	0539	0617
10	0851	0553	0659	0977	0931	0793	0379	0137	0411	0233

principle we can realize big savings in resources by simply generating starting points at will. In fact, as a bonus, this technique works equally well in both directions. By way of example, consider that, with a good enough property allocation algorithm, we need only one value to generate our entire Backdrop.

However, generating the value for one subtile requires a lot of processing. This is especially important if it is the subtile that is displayed to the player at a given time. We have to step down through three grids in order to arrive at the value for the current subtile. To see what effect this is going to have, let us assume that we want to know the value for the subtile that is at position [0,0][3,7][9,8]. The steps we need to go through are:

1. Read seed value for grid [0,0] "9352" 1 operation
2. Generate values up to grid [3,7] "5664" 3 × 7 operations = 21
3. Generate values up to grid [9,8] "0011" 9 × 8 operations = 72

To get one tile, we have had to make 93 operations and one disk access. The alternative is to store all the values in memory, requiring 1 million bytes of storage space. Actually, there is a third option, in which only one operation needs to be made.

We have stated that Backdrop objects do not move, they always start in the same place, and always have the same properties. Since each object is located at a discrete place in the universe, we can use its position information

to seed the algorithm that determines its properties. We do, however, need to be careful when doing this, because there is a certain pattern in using grid references.

Taking our previous example, where we would like a value for the tile at the position [0,0][3,7][9,8], there are a number of ways in which we can arrive at a seeding value. Some readers might ask themselves if it is possible just to create a number from the location coordinates and then use that to determine the property value.

The answer is a small digression, but worth explaining. Consider a very small 5 × 5 grid, in which the tiles can either be land (black) or sea (gray). We assign the number 1 to land, and the number 2 to sea.

The simplest way to allocate values to the grid is to assign a number to each, as in Table 9.3.

TABLE 9.3 Simple Grid Numbering

1	2	3	4	5
6	7	8	9	10
11	12	13	14	15
16	17	18	19	20
21	22	23	24	25

Arriving at these values in real time requires a very simple calculation:

square_number = xPosition + ((yPosition-1) * width)

$$\text{Cell numbering.} \qquad (9.1)$$

To arrive at the square number for cell at position (4, 3) we put values into the equation, thus:

square_number = 4 + (2 * 5) = 14

However we try to use these numbers to arrive at a value between 1 and 2 (although it could be any range, the result is always the same), we get an effect known as the "Checkerboard" shown in Table 9.4.

This was simply created using a modulo operation ((square number % 2) + 1), but due to the self-similarity of the grid, there is no way in which

TABLE 9.4 The Checkerboard Effect

1	2	1	2	1
2	1	2	1	2
1	2	1	2	1
2	1	2	1	2
1	2	1	2	1

we can proceed without modifying the numbering before we attempt to assign a final value to each square.

The preceding digression has at least yielded a good technique for arriving at a reliable cell-numbering scheme. The way we will proceed is to use the numbers arrived at using Equation 9.1 to seed a pseudorandom number generator on demand. This will avoid needing to generate the entire grid using the feedback technique discussed prior to the digression, and also in Part One.

Using the grid in Table 9.3 to provide seed material for a pseudorandom generator, such as the Lauwerier algorithm, would seem an easy task. However, these algorithms work best with large numbers, as we saw in Part One. Following our recommendations from Part One, we see that the Lauwerier algorithm would not be a good choice in this case. There are several good reasons for this.

The first is that it uses a multiplication, which is inherently a pattern-forming operation, as we saw. In fact, however hard one tries to come up with a good scheme for using the Lauwerier technique, we can never escape the fact that we are trying to destroy an inherent pattern with the application of another.

This is best experimented with so that the failings become apparent. We might choose, for example, to apply the Lauwerier algorithm on the numbers as they stand. We might assume that using the calculation in Equation 9.2 should work.

value = (cell_number * 2)

$$\text{Lauwerier-Style calculation on cell numbers. (9.2)}$$

We might then go on to assume that we can remove head and tail digits until only one remains, and then modulo that by 2 (and add 1) to get our final value. The grid in Table 9.5 shows the application of this.

TABLE 9.5 Simple Lauwerier-Style Calculation
on Cell Numbers

2	4	6	8	0
2	4	6	8	0
2	4	6	8	0
2	4	6	8	0
2	4	6	8	0

Of course, as we have already noted, big numbers work best, and Table 9.5 proves this observation. However, we are left with the problem of how to build up these big numbers. If we assume that a four-digit number is large enough, we are left with the problem of how to build up such a number from the smaller ones in the table.

There are many ways to do this, of course, but we arbitrarily decide to subtract the cell value from 9999. The result of this is shown in Tables 9.6a (before Lauwerier) and 9.6b, after the multiplication and digit removal has taken place.

Clearly, this was not the best approach. In fact, there are some good ways to produce reliable values—that is, values that produce a patternless enough effect—but these require so much processing that they are of little use for real-time applications. (To give ambitious readers a hint, they in-

TABLE 9.6a Before Lauwerier.

9998	9997	9996	9995	9994
9993	9992	9991	9990	9989
9988	9987	9986	9985	9984
9983	9982	9981	9980	9979
9978	9977	9976	9975	9974

TABLE 9.6b After Lauwerier.

9996	9994	9992	9990	9988
9986	9984	9982	9980	9978
9976	9974	9972	9970	9968
9966	9964	9962	9960	9958
9956	9954	9952	9950	9948

volve repositioning digits, combined with an addition or subtraction until a four-digit number is obtained.)

Taking our findings from Part One as a guide, we will observe one of the key conclusions raised: quite often it is best to find a reliable algorithm, with input values that work well, and hold them constant. You may have realized by now that we will be using the Dewdney algorithm, and experimentation with the DISTRIBUT software from the CD-ROM ON THE CD yields the numbers 9876 and 2758 as being reliable values for *m* and *k*. Equation 9.3 shows the calculation that we will be performing.

value = ((cell_number * 9876) + 2758) % 9999

Dewdney-style calculation on cell numbers. (9.3)

The application of this is shown in Table 9.7, which is taken from the sample output of the SEQGEN software supplied on the companion CD.

TABLE 9.7 Dewdney (9876, 2758, 9999) Applied to Cell Numbering

2635	2512	2389	3559	3436
3313	6354	6231	6108	7278
7155	7032	0074	9950	9827
9704	0875	0752	0629	3670
3547	3424	4594	4471	4348

Let us take a little breather at this point, and take stock of how far we have come. We stated that our Backdrop Objects in this case consisted of tiles representing mountains, grass, and water. Since then, we generated values using the Lauwerier algorithm that could be used to make reliable, although totally random, terrains, using these three tiles (the problem of making the terrain realistic will be dealt with in Part Five of the book).

IMPLEMENTATION NOTE 9.2 AVOIDING REPETITION

To further avoid effects of repetition involving even and odd numbers always ending up as the result, one should also rebase the result using a suitable modulo (i.e., 99), as we did for the coin- toss simulation in Chapter 2, "Simple Random Number Generation Techniques."

These static terrains are good for games that require only a limited number of terrains, from which the best can be picked and tweaked for distribution. To deal with larger games, we set about deriving a cell numbering scheme and combining it with the Dewdney technique to arrive at a table of reasonably random numbers.

MACRO- AND MICRO-RESOLUTION REVISITED

As we saw at the beginning of the book, larger does not necessarily mean the same in this context as others. Indeed, the grid referencing technique that we saw previously comes into its own, when more detail is required.

Imagine that we start from a single, discrete Backdrop Object, which in this case is a universe of galaxies; the dimensions of the universe being known at design time. Within each galaxy, are a number of stars. This number is in proportion to the size of the galaxy, which dimension is a property based on the reference coordinate arrived at by way of the technique described previously.

The stars can also be considered Backdrop Objects, since they do not move. Their characteristics can be determined by the same reference coordinate algorithm as the galaxy. We can add as much resolution as we require; from star to planet, to continent, to country, and eventually arrive at a terrain.

Since each unit is arrived at by calculation, using the predictable nature of pseudorandom numbers, we can go beyond the terrain and consider individual tiles of terrain, which may contain all manners of individual Backdrops or other Objects.

The important point to note is that as long as we can generate a reliable and useful starting point, there is no limit to the resolution that we can apply, as long as there is a representation for each calculated piece.

All that we have stored is the algorithm that defines the Backdrop, plus the representations of the numbers that this algorithm generates. If we want to add another universe, for example, we only need to change its seed reference. By a similar note, the player may, in the course of playing the game, find objects or situations that the designers did not explicitly design into the fabric of the game.

It is the predictable nature of the algorithms that allow us to be sure that we do not break the rules of the game, and also that each and every piece that should be in the same place throughout the game remains in that

place. These are powerful techniques for creating a realistically infinite Backdrop against which to set a game.

GAME OBJECTS

We have now found a scheme whereby we can generate Backdrop Objects using their position in the Game Universe to decide upon their properties. We stated also that Backdrops can contain bona fide Objects. Having established that we can assign properties to Backdrops based on their location in the Universe, can we also generate Object information based on the Backdrop?

In fact, our current scheme provides a very good starting point, since we have generated a number that is ideal for passing back through the algorithm that generated it. This, however, is not a good idea, since there is a very real risk that duplication of numbers will occur.

To avoid this, we should use a modification of the original algorithm, or a new algorithm to generate the values that will define the Objects contained within the Backdrop. In fact, while using the Reference Coordinate system detailed previously is a good approach for generating Backdrops, it is less wise to use it for generating game objects.

DESIGN NOTE 9.1 WASTEFULNESS IN ALGORITHMS

Reference Coordinates can be used in two ways.

In the preceding section, we used them to generate information about the Backdrop on a square-by-square basis. In this way, we can determine, using the application of a specific pseudorandom number generator, whether there is an object at co-ordinate x,y and what its specific properties are.

Consider, however, the amount of redundant information that is stored: we must apply the algorithm for every square, sometimes only to find out that it is empty.

There are a number of good reasons to do this for Backdrops; the fact that the player may move to any position, and also that it is usually the case that even the empty squares may serve a purpose.

On the other hand, when we consider objects that might move, the real Game Objects, it is less wasteful to follow a different scheme—to generate their

coordinates based on an algorithm, usually seeded by the properties of the Backdrop Object that contains them.

The reason that this method cannot be used for Backdrop Objects, is that to find the "empty" space would require generating the entire Backdrop, object by object. Since Backdrop Objects often contain more elements, the Game Object method described here is not appropriate.

Game Objects as discrete from Backdrop Objects are moveable, dynamic entities, as we saw earlier in this chapter. Due to their nature, there is a different method that we can use to determine their properties, both at the time that they are created and at a given point in the play session.

Of course, there may be a number of reasons why a specific Game Object might have properties different from those that they were given at the time of creation (see Chapter 8, "Introduction to Seeding"), so here we will deal only with their creation parameters.

The exact nature of all the parameters, or properties, will vary from one game design to another, but here are a few techniques for determining some numbers that can be used to specify what those properties should be.

SPECIFYING LOCATION

As with Backdrop Objects, Game Objects have to live somewhere. They are usually contained within a Backdrop Object, and their position is normally expressed with relation to their parent. Taking an easy-to-visualize example, let us assume that our Backdrop Object is a galaxy, and we want to specify a number of Game Objects, being stars.

In this case, we can make the stars Game Objects, and not Backdrops, because they may change; this is a design decision specific to this example. Among their other properties is their location within the galaxy Backdrop Object.

In order to arrive at their location, we would like a Cartesian coordinate, containing an x and y number specifying the horizontal and vertical distance from the origin. Of course, we could also introduce a z coordinate to give a true 3D reference, but this is left as an exercise for the reader.

The first step is to establish how many Objects we require. For each Object, we have to perform a number of steps. These steps depend on the de-

IMPLEMENTATION NOTE 9.3 OBJECTS AND CLASSES

For those familiar with object-oriented design techniques, it will be obvious that only one definition is required for each type of Object, and that each Object is an instance of that class.

However, what might be less obvious is that they should be stored in a linked list.

One might be tempted to use an array, but this would require knowing how many objects might be required at a given time; the techniques in this book preclude that knowledge.

sign, but for this implementation, we want to ensure a good spread, with no two Objects in the same row or column. Of course, we must also ensure that in trying to follow these guidelines, the process does not enter an infinite loop.

So, the process becomes:

1. Choose x coordinate.

2. Choose y coordinate.

3. Check coordinates against previous object.

4. If x or y match, regenerate these coordinates a maximum of 10 times.

The limit of 10 iterations was fixed arbitrarily; the programmer is free to choose a number that fits the time constraints of the system.

Actually choosing the numbers that specify the x and y coordinates can be done by any of the pseudorandom number techniques that we have looked at here. As for choosing the seed, there are a number of options.

The chosen generator can simply be seeded with a set value, and then simply used repeatedly, choosing numbers by feeding the output back as the seed. This could be dangerous in certain circumstances, because one may not be sure that the generator has not been called or reinitialized in the middle of generating the Objects. To avoid this, we would need multiple generator objects, which is wasteful.

Following the theme of this part of the book, we have a useful trick that we can use that is based on the predictability of the algorithms. When we need a set of objects, that may or may not be generated in sequence, we should always use known numbers to reseed the chosen algorithm.

To do this, we need only store one number, which we shall call the *master seed*. From this master seed, we generate the first object. The chances are good that at this point we need to go and do some other processing, such as responding to user input, or repainting the screen. The result of this is that the pseudorandom number generator may have become altered.

Since we are using predictable generators, we should now reseed the generator on a known value to generate the next object. Of course, due to the predictable nature of the generator, we cannot use the master seed. We can, however, use the value of the last object, and we can use the technique detailed in the previous section for Backdrop Objects to derive a seed value from the coordinates of the preceding object.

We can continue to follow this chain of selection until we have as many objects as we require. The final object can then be used to create the master seed for the next time that we need to create a set of objects.

One final note: pseudorandom number generators work best with large numbers, and the output is usually a large number. These should be re-based to arrive at a useful value. A simple modulo operation may not remove the problem of sequentially generating only even or odd numbers.

OTHER VALUES

A value for any property can be arrived at using this method. All that we need to be sure of is that we base the generation on a known value. All such known values will be derived from the master seed. For instance, to generate the size of a star (referring to our earlier example), we might choose to generate a seed from the coordinates using the technique explained previously.

This seed becomes the master seed for the object, and can be used to generate all other values. Of course, some of the values will be a direct consequence of one or more generated values. We might say, for example, that the number of planets is related to the size of the star, and that the chances of one of the planets supporting life is related to the size of the star and the position of the planet.

We must be careful when using the master seed approach based on coordinates for those objects that might move. Stars are an easy example, because they do not move. It is likely, though, that in a given game, there are objects that will move. In this case, if the coordinates change, the master seed changes, which is not a good consequence.

We will deal with this shortcoming presently. Let us first consider the last of the objects.

THE PLAYER OBJECT

This is a special kind of object. It is a Backdrop Object that moves and changes. We specify it as a Backdrop Object because it can contain other types of objects, both real and backdrop. It is persistent; after all, once its lifetime ends, the play session also ends. In multiplayer games, this is also the case; once the player object is destroyed, the object can no longer have an effect on the Game Universe.

The Player Object's position is a special type of master seed. It changes constantly, but is also completely predictable. That is, there is a limit within which the player can move in the Game Universe; a discrete number of co-ordinates that the player can inhabit. Even in an Infinite Universe, we know that because of our coordinate system, the player's position can be uniquely identified.

Due to this special nature of the Player Object, we can use the master seed derived from the coordinates of the player in our serialization.

The predictable nature of our random number generators means that every time a player arrives at coordinates x,y, we can generate a series of numbers, each seeding the other, and recreate the objects in the vicinity of the player faithfully every time.

In our previous example, we might consider that the player is at the galaxy that is referenced by x and y (and possibly z) coordinates. We update the relevant location part of the Player Object; and in doing so establish a master seed, which we can use to generate the stars that are present in the galaxy.

In this way, each time the player visits this galaxy, it will have the same number of stars, each of which having the same number of planets with the same properties and in the same places. To achieve all this, we have stored only a coordinate system within which the player may move.

This can even be applied at several levels—the Player Object could have coordinates specifying the position within several Backdrop Objects at the same time. For truly infinite Game Universes, where the periodicity of the chosen algorithm might be a problem, this is often the best approach.

The reason for this last is that using a generator with a modulo of 9999 in it, or specifying a four-digit result, means that there is a limit of 9999

possible values that can be generated. To avoid this becoming a problem, we can either increase the number or avoid using the same master seed for each object sequence.

Referencing Objects

The final approach to serialization is to allocate reference numbers (or serial numbers) to the objects. This value may then be used as a master seed for the object's properties. It can also be used to derive the seed for the object next in the generation sequence. This solves the problem that we saw in our discussion of master seeding on object coordinates.

Another use for the serial number is to be able to identify a moving object. Identification is important in locating, checking, or simply managing a given object.

Determining the serial number is not an easy task. The cell numbering that we saw earlier is one way to determine a serial number for the squares of a grid. The serial numbers derived in this way are sequential, and we went to great pains to establish a system whereby this sequential property could be removed so that useful seed values were derived from them.

It is important to keep the coordinate system for grid references, as the grid reference is the best approach for situations where a grid exists. However, it is less important for Game Objects that do not stay in the same place.

When we require a series of objects that are not referenced by their coordinates, we are free to devise a serial numbering scheme that naturally lends itself to being a seed without any of the processing that was required for techniques using the reference coordinate system.

The important point to note is that for objects of a given class (type), the references given to each one must be unique. The predictability property of the algorithms we have discussed here is a double-edged sword. On the one hand, it means that for the same seed value, we can be sure that the properties arrived at will always be the same.

On the other hand, it does mean that if two objects of the same type have the same serial number, they will end up with the same properties. In addition, there will be no way to discern one from the other. Following from this, if we have two objects that exist in two different places at different times, but have the same serial number, then they will have the same features, which is not necessarily a good thing.

Having pointed out the possible pitfalls, we should now try to establish some principles that we can use to avoid them. Sadly, unless we want to spend many computational cycles attempting to assign a unique number—by checking all the numbers that have already been selected using a given algorithm—we can not perform this in real time. Therefore, we must spend time in the design process.

A good technique is to establish different input values for the pseudo-random number algorithms depending on the object class. If we know how many objects can be present in the immediate Game Universe at a given moment in time, we can quickly find a combination of input values that do not lead to a repetitive sequence of numbers.

Further to this, we can even use a combination of the coordinates of the object with an algorithm that can attach a serial number in real time. One such approach could be to use the time of creation: it is unlikely that the same object will be created at the same time in two or more different sessions.

The drawback to using this approach is that we will arrive at different values that cannot be used as seeds. If this is not a problem, then this approach is the best; indeed, if two objects are created at the same time, we might want them to have the same properties, but if they are created at different times, we might want those properties to change.

The final solution is a good introduction to Chapter 10, "Using Sequences as Seeds." More accurately, we might like to have a pool of predetermined sequences that we know do not repeat, and yet are random enough to provide a basis for establishing values in the real-time Infinite Game Universe.

USING SEQUENCES AS SEEDS

We have already seen one example of pregenerated sequences in Chapter 9, "Serialization Techniques," where we assigned a table of Lauwerier values to a grid representing objects in a Game Universe. In that case, we used them as discrete numbers upon which we based a tile-selection algorithm.

In fact, we could just as well store a sequence of numbers to be used as seeds. In Part One, we encountered the Fibonacci generator, which is commonly used to create a table of values to be used as seeds in other pseudo-random number generators. These tables are stored on the same media as the game—they are static.

The reason we use techniques such as the one just discussed is to save processor cycles while the game is in motion. If we did not do this, there is always the danger that a particular algorithm will take so much execution time that the game will become less playable.

THE BENEFITS OF PREGENERATED SEQUENCES

We saw one benefit in the introduction to this chapter; saving valuable processor time. Since the aim of this book is to remove the reliance on distribution media and other storage requirements in the real-time environment, we should at this point state that it is only a starting point. After the initial sequence, we hope to be able to generate a near-infinite sequence that is large enough to give the illusion of infinity within the scope of the Game Universe.

This means that the sequences that are stored need only be as big as required; hopefully, this is much smaller than the space required to store all

the possible elements that could populate the Game Universe. What it does not mean is that true macro-infinity will be realized without the complementary techniques that we will in due course be considering.

Bearing these shortcomings in mind, there are some very positive effects that stem from the use of pregenerated seed sequences.

IMPLEMENTATION NOTE 10.1 USING PREGENERATED SEQUENCES

We have spent much time in Part Two considering the benefits of using predictable random number generators. When attempting to use pregenerated sequences of these so-called pseudorandom numbers, we have to bear in mind that if we use the same algorithm to generate sequences of numbers from the pregenerated seed, we will overlap the original pregenerated sequence.

The reason for this is that these numbers naturally follow each other, as we saw in Part One. When we first encountered this, we stated that to avoid repetition, we could determine the maximum number of values required, and create sets of values.

Therefore, to implement the use of the pregenerated sequence, we should take care to remember that a different algorithm should be used to make use of the seeds. In this way, we avoid the problems associated with the predictability of the sequence.

The first key benefit of pregenerating a fixed set of numbers is that we can avoid repetition within the sequence. We can simply remove any duplicates and regenerate a series of replacements. Since this is done offline (i.e., before the game is finally shipped), we do not need to worry about the length of time that will be required to do this.

However, it is altogether possible that it will prove difficult to find an algorithm that does not repeat itself at some point. Indeed, most algorithms, apart from Fibonacci sequences, do. Bearing this in mind, we should choose an appropriate algorithm; or at least serialization techniques choose a large enough periodicity that we can achieve the required number of values without danger of pattern-based repetition.

As Dewdney notes (*The Armchair Universe*, p. 225), when discussing his algorithm:

> "Sooner or later, however, resulting sequence must repeat itself because there are only p possible remainders."

We can also perform some other processing that we could not do in the real-time environment to ensure that the sequence is distributed in a way that is fair. For this, we can use the naked eye and look at a graph similar to those produced by the DISTRIB application that appears on the companion CD, and the graphs we first encountered in Part One.

ON THE CD

This analysis is the key reason why we cannot do this in real time. Although the spread of results can be altered manually offline, for very large numbers of values, even this might prove to be more time-intensive than the benefit of having performed this analysis.

Therefore, to counteract this, we can introduce a second process, whereby the results are shuffled using the technique outlined at the end of Part One. We could do this in the real-time environment, but would lose the ability to rectify any errors manually.

Having noted the benefits, and established that pregenerating seeds has a place in the implementation of a near-infinite Game Universe, let us examine the various ways in which the sequences might be applied.

Serialization and Seed Sequences

If we can arrive at an upper limit for the number of game objects that are to populate the Game Universe, then we can use the seed sequences to provide serial numbers for the instances of such objects. This is in part a solution to the problem first encountered in the last chapter.

All of the benefits that we saw in the preceding section are passed on to the initialization of game objects in real time. That is, we have no danger of encountering duplicates, and we can ensure a rich and varied number of master seeds, should that be required.

To use the pregenerated sequences, we need to know how many objects are required. We can, however, use the technique by applying the principle of master seeding. By doing this, we assume that we can identify a discrete number of object classes. For each class, we assign a value from the pregenerated seed sequence and then use it to generate a series of objects.

Combining Sequences with Infinite Techniques

As we said in the section "Benefits of Pregenerated Seeds," in order to achieve true macro-infinity, the seed sequences that have been discussed

here must be combined with other techniques. Since the sequence is finite, one might assume that this is a fairly tall order—and indeed, it is.

In fact, the only way in which we can hope to arrive at our goal is to combine the values in the sequence with an algorithm that is not constrained in any way by that sequence. In terms of finding such an algorithm, there is only one that is reliable: time.

We had almost rejected time as a suitable contender for generating sequences of reliable, predictable pseudorandom numbers due to the unpredictability of the player. That is, the player may not necessarily arrive at the same place at the same time, meaning that if the arrival time was to be used as a master seed, the universe would be represented in a different way in each play session.

This is clearly not a good effect for a game in which the backdrop is supposed to remain the same at all times. For this reason, when we choose to use time, we need to do so by using the same thread of time to generate pieces of the Game Universe.

We therefore consider time from an abstract point of view, not from the discrete point of view of the player. Since the player may arrive at different places at different times, we consider the game time as being the predictable but infinite basis upon which to vary our finite sequence of numbers.

This can be done in a variety of ways, and only experimentation will enable the designer to find the best combination. There are a few pointers to consider, however.

The first is to use an algorithm in which one part can be varied, and in which one can be seeded from the store of pregenerated seed sequences. Since we vary one part of the algorithm, we can be quite sure that a near-infinite sequence of numbers can be generated. They will also be predictable from a design point of view, since the game-time thread is constant, even between play sessions.

PLOT SEQUENCING

A number of possible meanings can be attached to the term *plot* in the context of games programming. In its most simple form, the plot is merely a constrained sequence of events that may or may not follow a pattern. The most abstract meaning that can be attached to the term *plot* is the main theme, or story line behind a game.

Usually, we take the plot to be a series of two or more connected events. They are usually, but not always, connected by the actions of the player with relation to the Game Universe. The player may have a direct or indirect influence on the plot of a game.

Action games generally have a very simple plot, comprised mainly of a journey through a maze or similar, shooting anything that moves. Real-time strategy or simulation-style games may have a plot that is more intricate and based on an indirect relationship between the player and Game Universe.

In this chapter, we will be considering how both types of plots can be controlled by introducing pseudorandom elements into the Game Universe. By a similar token, we shall see how a static plot can manifest itself in a controlled, but unpredictable way, depending on both the actions of the player and the use of pseudorandom number generators.

PLOT SEQUENCING AND GAME RULES

All games have rules, otherwise known as a set of allowed actions. The rules of a universe should apply equally to the player and objects and characters that the player might encounter. This may sound reasonably straightforward; if something shoots the player's character, and it becomes injured,

the player reasonably expects that if he or she shoots something, then it will become injured also.

This simple sequence of events is a very small example of a plot in an action game. The rules are that both parties have a loaded gun, and that they can see each other well enough to aim and fire the weapon. Once fired, they reasonably expect the projectile to hit the opponent and cause damage.

There are, however, a number of possible ways in which the expected outcome of the plot can be altered. Either party could run out of ammunition. One party could have a gun of significantly more power than the other has. Either of them could be endowed with an armor-plated suit; the other could have supernatural reactions and dodge the projectile.

These plot twists could themselves be the results of other plots that have chained together to produce the new plot. Some of these "other" plots could be totally independent of the player's actions, and take place for the only reason that it was the time at which they should take place.

Thus, we have our first simple premise: the plot is the application of game rules on the objects that inhabit the universe.

We usually determine the game rules at the time of designing the game. In special cases, we can allow game rules to evolve naturally of their own accord, but this is usually a result of the convergence of predetermined plot lines.

Our second premise, therefore, is that plots start with an event, be it predetermined or evolutionary. The flow of the plot is dictated by the game rules (our first premise). In addition, a plot can be a sequence of predetermined events, chained together by the application of game rules at separate intervals.

A plot can be seen as a set of conditions that are established at a given moment in time, with a threshold, or target set of conditions to be reached

DEFINITION 11.1 EVENTS AND PLOTS

For the purpose of this discussion, an event is an entirely abstract proposition.

It manifests itself in the change of state of a given Object, possibly as a result of an action that that Object may perform.

Similarly, a plot is just a given sequence of events. Again, it is an abstract concept, only noticed by the effect that it has on the flow of events.

at some point in the future. The way in which these conditions are arrived at is defined by the behavior of the Game Objects involved.

The target conditions may also have a time limit, after which a different set of conditions may be established. The exact nature of the conditions, and involved parties, depends entirely on the game rules.

PREGENERATED PLOT SEQUENCING

Assuming this relationship between plots and events, we can look at a first example of plot sequencing, that which is determined at design time: pregenerated.

As we saw in Chapter 10, "Using Sequences as Seeds," pregenerating seeds is a technique used to save processing time when the game is in play. It also means that the seeds are guaranteed to be perfect before the game begins.

We previously encountered a form of pregenerated plot sequencing in Chapter 8, "Introduction to Seeding," where we looked at using the various properties of Game Objects to seed the properties of other, related objects. This is an abstract form of plot sequencing, where the plot runs in a way that is implied. That is, objects have an effect on each other (they interact), which yields a form of plot reflected in the changes observed.

It can be said to be pregenerated in that each object has a distinct set of properties that are fixed at design time, and vary within a set of values that are also fixed at design time. Pregenerated plots are controlled by the positioning of Game Objects within the portion of the universe they inhabit, with a given set of properties that define their behavior.

Before we continue, let us consider a simple example. In the game of *Pac-Man*, the plot is simple. The little yellow creature that represents the player should travel around the maze, eating dots and avoiding ghosts. There is one ghost in each corner of the maze. Also in the corner of each maze is a special pill that, when eaten, allows the yellow creature to eat the ghosts.

The plot manifests itself in a sequence of controlled events in which the ghosts move around the maze in a certain pattern (which is predefined) for a certain length of time. After a while, they begin to converge on the player, with just enough intelligence to trap an unwary player, at which point the player is eaten.

Therefore, the plot is entirely pregenerated; that is, there is nothing the player can do to alter the plot. It is controlled—and the player is also,

if unwittingly, controlled—by the behavior pattern of the ghosts, which is also predetermined.

Even if a pregenerated sequence of seeds is used to control the plot, variations are possible by combining them with the outcomes of events in which the player has had an effect. Subsequent detail can therefore be generated using this interaction as a seed.

PLOT SEQUENCING AND EVENT CHAINS

Until now, we have looked at event chains (some infinite) as ways in which the plot is controlled. In fact, this is only partially true. Event chains and plots are closely related, complementary techniques.

Considering the *Pac-Man* example in the previous section, the main plot can be broken up into subplots, and each subplot can be activated as the result of a sequence, or chain of events. The ghosts, for example, have three behavioral plots: benign, evasive, and aggressive.

DEFINITION 11.2 PLOT STYLES

A plot is not merely a sequence of events, be it abstract or concrete. There are a number of different types of plots:

- **Behavioral.** Objects exhibiting a certain pattern of actions
- **Theme.** Evolution of a story line involving many objects

The behavioral plots that are exhibited by the ghosts are the sum total of the plot lines in *Pac-Man*, and are generally triggered by event chains. In fact, different event chains will trigger different plots, and at different points.

By way of example, one tactic of *Pac-Man* players is to ignore the special pills, concentrating on the normal ones, until the ghosts change from benign to aggressive. As they converge on the player, the player makes for a special pill.

If the event chains have all been well timed, the player can eat the special pill and all the ghosts before they turn back to normal. Of course, once the special pill has been eaten, the ghosts become evasive, a behavioral plot designed to avoid being eaten.

Figure 11.1 shows the relationship between event chains and plots.

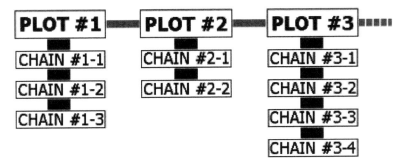

FIGURE 11.1 Sample relationship between event chains and plots.

In Figure 11.1, the plots are defined as containing a sequence of event chains, linked by specific events or sequences of events. The seed is used to start a plot, and from this plot, events can be chained, the outcome of each one providing information for generating the next event. Each generated event may give rise to another plot.

It is important to note that event chains can only be predicted up to a point, because the player has an unpredictable effect on each chain. The plots, however, are entirely predictable, since they are triggered by specific events or event chains.

The sequencing of the plots, however, depends on the event chains, so even if the plots are pregenerated, there is the very real possibility that they might be executed in an order different from what was originally envisaged by the designer.

PRACTICAL APPLICATION

Having discussed the theory, it is now time to discuss their application. Exactly how the techniques are applied will depend on the game design. Different game rules will call for different representations, and the variations are endless. We already saw in Chapter 8 how user interaction can be used to affect the behavior of Game Objects, using a simple action game example.

This time, however, we will discuss a simple *Pac-Man* clone, *EATEM*. The code and executable for the *EATEM* game appears on the companion CD-ROM. The maze that is used is a simple one, depicted in Figure 11.2.

There are four ghosts, each inhabiting its own corner of the maze. The rules are very simple: the player must avoid the ghosts and eat all the dots.

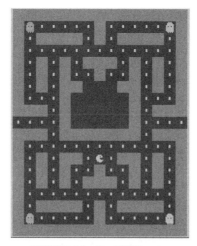

FIGURE 11.2 The *EATEM* maze.

(There is no concept of the power-pill, so the ghosts are immortal). Each Game Object may move up, down, left, or right.

The behavior of each ghost can be defined in terms of a chain of events for each mode of behavior that we require. There are only two: benign and attacking.

In the first mode, we can set no target, but in the second mode, we can target the ghosts on the player's position. The first mode is an example of an event chain. It links into a plot, which is the second mode, in response to a certain sequence of events.

The plot sequence can be determined by a start point and an end point. The start point is where the player has eaten 75 percent of the available dots. This figure is chosen arbitrarily; it could be higher or lower. It could even diminish level by level, thereby increasing the difficulty.

The event sequence that describes the benign mode is not a plot sequence, since we cannot define a target. It is an event chain, where one object state leads to another.

Now that we have defined, in abstract terms, the rules of the game, we must attach some concrete values to them before we are able to implement the final code. Starting with the movement of each object, we can define a series of values that dictate how the object is moving, in terms of the change in position.

Left $x - 1$
Right $x + 1$
Up $y - 1$
Down $y + 1$

The event chains will be defined in terms of the current movement, and possible movement. They can be encoded as a series of finite-state machines. A finite-state machine is one in which the current state is analyzed and a new state is defined. If we take one ghost as an example, we might say that if it is moving right, then the next state is down, if that is allowed.

Subsequently we might state that if it is moving down, the next state should be moving left. This can be easily represented, and is a sequence of events, or event chain.

The plot sequence must be defined in terms of the target (to be in the same place as the player), following a separate sequence of events. These other events can also be defined in terms of finite-state machines: if the ghost is above the player, it should move down; if it is to the right, it must move left.

Although simplistic, this is a good example of how event chains and plot sequences go together. The logical mathematics that manage the finite-state machines are just one possible way in which they can be implemented.

PROBABILITY AND EXTRAPOLATION

In this part of the book, we will be examining what the various mathematical techniques are that can be applied to the existing world to give rise to encoding and storage algorithms so that examples of the real world can be generated at will to populate the Game Universe.

In addition, we will also see how to go beyond simply generating possible examples, and create new entities for the game universe.

In the course of our discussions, we will also attempt to gauge the best solution for a given situation. To do this, we examine the impact and requirements of various techniques, in terms of their efficiency and storage needs.

INTRODUCTION

Probability techniques revolve around the study of the characteristics of a possible Game Universe, or an existing close relative. For example, if one considers using treelike objects in the Game Universe, then the study of actual existing trees would give rise to a mathematical representation of a probable tree.

The derived figures can be used with other techniques to extrapolate other probable trees that can be used to populate the Game Universe. Similarly, a possible game universe can be generated that contains examples of the various objects that form it, and these can also be examined mathematically to produce a generalization that can then be used to generate other examples of each object.

This part of the book takes the two techniques of probability analysis and extrapolation as a natural progression by way of examples to observe how the two can be used in conjunction with the pseudorandom techniques explored in Parts One and Two to produce game universes in real time, with little or no data storage.

EXAMPLE USING LETTER ADJACENCIES TO GENERATE WORDS

A s an introduction to the two techniques outlined in the introduction, we will consider the generation of words to be used as names for Game Objects. These names should be natural in appearance; as close to "regular" language as possible, so that the effect is of possible words that do not detract from the atmosphere generated by the game.

In the course of this discussion, we are touching on every aspect of the use of probability in games programming; sampling the data, storing it, and applying the stored data to achieve a given result. Since these techniques are of paramount importance when attempting to use mathematical techniques in generating Game Universes, the three main techniques that can be used to achieve this are presented and compared.

The comparison is made possible by evaluating the amount of code and data required to achieve the desired result. Although the discussion might at first sight seem out of place, it is easiest to appreciate when a concrete example can be examined, which is why it appears here.

OBJECT ADJACENCY THEORY

In order to fully appreciate the technique, we should first consider the effect of generating, entirely at random, sequences of letters to form words. The program NAMEGEN, included on the companion CD-ROM generated the list in Table 12.1, using the Lauwerier algorithm.

TABLE 12.1 Random Words

kvqhyh
onabc
ppodq
rjcf
kvqhy
hpod
qrsl
wdgx
ejcp
etwd

The example in Table 12.1 might serve for a very simplistic, primitive game; however, it would not be appreciated by the game players in today's market. So, how might we increase the quality of the generated words? The next few sections show how this can be achieved using the very simple medium of letter combinations. The theories that we will be expanding on, however, can work for a variety of different applications in games programming, as we shall see.

It is important that the aspiring developer understand the application to words that we are about to present before continuing onto other applications, since the majority of the rest of the chapter uses these basic building blocks.

The theory itself is quite simple: To improve upon the quality of letter combinations, it is necessary to manipulate the letters used to build the words. We might like to briefly think about basic letter combinations taken from the list in Table 12.1 to determine exactly how it is that they do not form natural words.

From simply trying to pronounce the words in Table 12.1, we have a hint as to why the words are not natural; they are difficult to get one's tongue around at best, impossible at worst. Take for, example, the strange combinations in Table 12.2.

TABLE 12.2 Unpronounceable Letter Combinations

kvq	odq	dgx	twd	jcf	rsl

Together with the word list in Table 12.1, we can begin to present a few statements as to why the words do not appear natural. First, there are a limited number of adjacent consonants that are pronounceable, and "dq," "wd," "cf," and "kv"are not among them (at least using English and the Latin alphabet). Second, and related, most consonants require that they are followed by a vowel, or appear at the end of a word. Last, there are relatively few letters that can actually appear at the end of a word, and the choice depends on the preceding letters.

So we begin to see that in order to generate words, we need to take heed of a few rules that govern the placement of the letters in the alphabet. There are several ways that we could approach this, but at the root of each would be the need to examine real-world examples in order to see how letters are combined to produce words in the real world.

Our theory, therefore, would be to examine consecutive pairs of letters in real words and investigate how they are placed together, so we could create a table of probability showing the likely pairs. We could then extrapolate by choosing pairs at random and placing them together to form words. By doing this, we hope that, at the very least, we might avoid some of the problems that we saw by generating purely random words.

The preceding is the basic theory, and can be applied to other problems that games programmers need to solve, such as terrain generation. The first step in attempting to apply this theory is, as we saw earlier, in isolating the elements that are used in combination with each other to produce the final effect. This might be, for terrain generation, the placement of mo
untains, plains, and lakes, for example.

COMPARISON OF TECHNIQUES

Now that we have our basic theory, let us examine exactly why it is beneficial to use it in a game programming context. We will be examining it with reference to building words that are on average six letters in length, and comparing the storage space required. We have three points of comparison:

- Storing hard-coded words and retrieving them at will
- Storing a letter adjacency table and building words from it
- Coding the rules derived from a letter adjacency table to build words

In order to make our comparison, we should try to establish a break-even point, at which it becomes beneficial to use one of the preceding three techniques. Before we put hard figures to this, we must consider that from a qualitative point of view, being able to generate words is superior in that it is scalable. By scalable, we mean that the algorithm can support multiple objects, almost without limit. The second and third techniques are scalable, and the first technique clearly is not.

CODE-DATA DYNAMICS

In performing these comparisons, we run into the slightly peculiar area that we might like to call code-data dynamics. We can say that in order to store 100 names, which we can choose from at will, we might require 100 × 6 bytes of storage space, or 600 bytes. The selection of a given name depends on the implementation slightly, but if we assume a simple array:

```
typedef szWord char[6];
typedef szWordArray szWord[100];
```

we can access it directly:

```
sprintf ( object.szName, "%s", szWordArray[x] )
```

where *object* is a given universe element that requires a name, referenced by the integer *x*. Not only do we need to consider the 600 bytes that are needed to store the data, we also have a code overhead both in storage and in execution. The exact mix of data and code, to give the most efficient result, with reference to performance and physical storage is what we mean when we refer to the code-data dynamics of a given technique. Be warned, however, that although the data portion is easily calculable, working out how much the code affects the end result varies from difficult to impossible.

In the preceding example, we need to include the code required to:

- Retrieve the data
- Choose the relevant portion
- Attach the data to the object

To complete this brief digression, we can say that attaching the data to the object can be disregarded in this case simply because it applies to each

of the techniques that we wish to compare, and therefore we do not need to consider its impact.

Returning to the main plot of this section, we are ready to begin our analysis of the size of code and data that will be required for each technique. The starting point when performing an analysis of this kind is to begin with the data; defining how the data will be stored has an impact on the eventual complexity of the code required to access it.

TECHNIQUE 1 : HARD-CODED ELEMENTS

To most programmers, the simplest format for storing a fixed number of elements is the array. We have already considered this in the code extract in the preceding section, namely an array that contains storage space for 100 items, each of 6 bytes in length, requiring 600 bytes. This is our data storage overhead.

For more complex data objects, more complex data representations can be required, but it is recommended that a simple array of objects be used since this requires the lowest code overhead. Other ways of storing the data are possible, such as creating a linear array, and reserving one byte for each entry to indicate the number of bytes occupied by the data that follows.

What is immediately obvious is that the choice of data representation has a direct effect on both the code overhead required and the efficiency of data retrieval. In terms of operations, for object number n, we see that in the case of the array, data access requires three distinct parts, with pseudo-C code equivalents as shown in Table 12.3.

Therefore, we could hazard that the effective code-data dynamics (purely a quantitative measure) is approximately 603. This is based on the assumption that there are three logically separate operations.

Before we proceed with analyzing the remaining techniques, we should build some form of scalability factor into the evaluation. This will give us an idea about how scalable the technique is; in other words, how applicable it is for large numbers of individual objects.

Table 12.3 Code Overhead for Simple Data Access

Lower-bound check	if (n < 0) return error_handler;
Upper-bound check	if (n > 99) return error_handler;
Retrieval	return DataArray[n];

The code overhead will not change appreciably; the data portion, however, is much more susceptible. If we wish, by way of example, to double our storage requirements, we can say that 200×6 bytes would be required, which is 1200 bytes total. The code-data dynamic is therefore 1203. Dividing the second figure by the first gives a coefficient of 1.995, a figure that we might choose to term the efficiency of the algorithm. Our total code-data dynamic for this technique could then be expressed as:

$$1203 / 603 = 1.995 \quad \text{(for a population scaling factor of 2)}$$

This is all very well, but what exactly does it mean in real terms? It is the ratio of code to data for a given scaling factor for a given algorithm. We would like this value to be as close to 1 as possible, indicating that the data-to-code efficiency is sufficiently high that an increase in scale does not result in an increase in storage space. Hence, our figure of 1.995 indicates that the algorithm relies heavily on data that are potentially wasted resources.

TECHNIQUE 2 : THE ADJACENCY TABLE

As before, we will assume a static array that is as large as required, and commence with determining the data storage requirements associated with the algorithm. Please note that the full description of how the table is to be built, along with details as to why the algorithm works and what results can be gained by using it, appear later in this chapter. For now, let us just assume that it is desirable to use the algorithm.

Again, we require names for 100 objects, each with a length of six characters at most. Our data storage overhead is clearly more complex than before. This time, however, the 100-object requirement has no effect in determining the actual data storage that is needed.

Therefore, this component is determined by assuming that a grid is created in memory, as shown in Table 12.4.

The gray squares in the 26×26 grid will be filled with a number, which indicates whether one letter may be followed by another. This is discussed in more detail later in the chapter, but for now, let us assume that if there is a 1 in the gray square referenced by the letter D along the x-axis, and R on the y-axis, then the combination DR is allowed.

TABLE 12.4 Letter Adjacency Table

	A	B	C	D	E	...	X	Y	Z
A									
B									
C									
D									
E									
.									
.									
.									
X									
Y									
Z									

Thus, we require $26 \times 26 \times 1$ bytes of storage to house this data. This amounts to 676 bytes of storage. In addition, we require one array of 6 bytes to store the letters that we generate.

So far, so good. Now for the code dynamic calculation. Here, it becomes a little more complex, since it is governed by the type of algorithm used to build the word. Since we have not yet discussed this technique in detail, we will now lay some building blocks upon which we can later expand.

In essence, we can perform the following steps to build a word of six letters:

1. Generate the starting letter x.
2. If its column of following letters is set to zeros, repeat step 1.
3. Select a row at random in column x.
4. If it is zero, repeat 3.
5. Set letter n to x, and increment n.
6. If n is 6, stop; otherwise, go to step 2, using the new letter.

Before the programmers point it out, we should admit that this is for illustration only, and that if an inspired individual were to implement the process as is, the chances are very good that sooner or later it will get caught in an endless loop, if it fails to find a letter. Another point to note is that

step 6 really does jump to step 2, and not step 1. This is because we wish to chain the letters together, and only regenerate if we find ourselves in a position where the letter we want may not be followed by anything.

For the sake of simplicity, we can assume that the random number generator is shared code, used by other parts of the application software, and therefore we do not need to consider its overhead here. This also sidesteps the question of how different algorithms affect the code-data dynamics of the technique. Avid readers will remember that we made a good stab at answering the various reliability and efficiency coefficients of various random number generators in Chapter 1, "The Nature of Random Numbers."

The pseudocode in Table 12.5 can be generated by which we can attempt to estimate the code portion of the code data dynamics for this technique.

Purists will no doubt forgive the use of labels in Table 12.5. The idea is to be as efficient as possible, with as little overhead. With today's compilers, there is no real excuse for using labels instead of object-oriented and function-based techniques; however, for short examples like ours, it makes more sense to try and keep things as basic as we can.

In Table 12.5, there are roughly 10 operations per letter, which evaluates to about 60 operations total. Therefore, our code data dynamic is 736. This is an extreme figure—some words may not be six letters long, but for comparison purposes, it is more than adequate.

TABLE 12.5 Code Overhead for Letter Adjacency

Generate the starting letter x.	GenerateLetter: x = Random(25);
If its column of following letters is set to zeros, repeat 1.	ColumnCheck: z = 0 for (y = 0; y < 25; y++) z = z + LetterTable[y][x] if (z == 0) goto GenerateLetter;
Select a row at random in column x.	SelectRow: y = Random(25);
If it is zero, repeat 3.	if (LetterTable[y][x] == 0) goto SelectRow:
Set letter n to x, and increment n.	Word[n] = x n = n + 1;
If n is 6, stop; otherwise, go to step 2, using the new letter	If (n < 6) goto ColumnCheck;

The algorithm is therefore heavier than the one presented in Technique 1, by a factor of 1.22. In order to determine the comparative efficiency, it is necessary to perform one final step: the scalability coefficient. In fact, this works out at exactly 1. That is, to generate a single word from a possible 200 takes no more resources than to generate one from a possible 100. The scalability efficiency of this technique is therefore clearly higher than before.

TECHNIQUE 3 : DERIVED RULES

Finally, we should examine the last technique, that which revolves around creating a series of conditional statements derived from the table created in preparation for Technique 2. The first point to note is that the data requirement is effectively zero.

One would expect that the code requirement would therefore increase; if not proportionally, then at least in a linear fashion with respect to the other techniques. The complexity of the algorithm certainly increases, and we will tackle this one step at a time. First, to generate the first pair of letters, we can establish the following necessary steps:

1. Generate letter x.
2. Generate letter y.
3. Verify that y may follow x.
4. If not, begin again with step 1.

In actual fact, there is another, possibly more efficient way to achieve the same effect:

1. Generate letter x.
2. For each letter y that may follow x, generate a number between 1 and 100, n.
3. If n is less than 50, begin again with step 1.

This second solution runs a very real risk of entering an infinite loop, as was the problem with Technique 2. Here, we can say that if we err on the side of caution, we should disregard this second solution. The first also runs a smaller risk of entering into an infinite loop, but we can say that it is negligible, as we did in Technique 2. Since we have chosen to disregard

the inefficiency in both cases, the code required to remove this problem is probably comparably complex and therefore will not have an untoward effect on the resulting comparison of the code-data dynamics of the techniques.

In terms of the segment of code that determines whether the letter y may follow the letter x, we can say that it exhibits some characteristics that will allow us to gauge the maximum code overhead required.

First, we assume that for each letter, we have a simple C case statement, as in Table 12.6.

From this admittedly lengthy code snippet, we can see that there is a total of 26 comparisons involving letter x, and for each of those, a total of

TABLE 12.6 Letter Selection Rules

```
switch (x):
{
        case 'A':
                if (y == 'A') then return -1;
                .
                .
                .
                if (y == 'Z') then return 1;
                return 0;
        break;
        .
        .
        .
        case 'Z':
                if (y == 'A') then return 1;
                .
                .
                .
                if (y == 'Z') then return 1;
                return 0;
        break;
}
```

26 comparisons involving letter y. The maximum inefficiency of the algorithm for letter selection is therefore a staggering 26×26 operations, or 676. However, this is identical to the data storage requirement (assuming 1 byte is equal to one operation) identified for Technique 2.

We have made a big assumption here by stating that one operation involving a comparison of two constants is identical in impact to the storage in memory during execution time of 1 byte of data. The reader is free to evaluate this as he or she wishes and adjust our conclusions accordingly, but experience has shown that the effect of storing and managing 1 byte of data may very well have this impact in terms of overall execution time.

It follows that a table similar to those constructed in the evaluation of Techniques 1 and 2 can be arrived at with the C pseudocode (Table 12.7).

TABLE 12.7 Code Overhead for Letter Selection

Generate letter x.	GenerateLetter: $x = Random(25)$;
Generate letter y.	$y = Random(25)$;
Verify that y may follow x.	$n = LetterSelection(x, y)$ [26 operations]
If not, begin again with step 1.	If ($n \neq 1$) goto GenerateLetter;

With reference to Table 12.7, we can now calculate the expected code dynamic for this technique to be 30. Therefore, the total code-data dynamic would be, for a six-letter word out of a possible 100, 180. This technique also scales nicely with a coefficient of exactly 1, as in Technique 2.

SUMMARY

Thus, we have arrived at a very rough guide for the efficiency and scalability of three techniques: the first relying on data storage, the second on a combination, and the third on pure code. The final step that we would want to perform in order to choose one of the techniques would be to consider the total effect of each if we needed to generate an entire universe.

So far, we have neglected the other 99 word choices in all techniques (or 199 if we need 200). Let us remedy this now. The key to providing figures for this final stage is to be aware of any changes in data or code dynamics due to this new requirement. As regards to the data, there are no

changes for any of the techniques. This will not always be the case, so it must be considered.

As for the code dynamics, this will change by virtue of the number of times that the selection process needs to be carried out. In Technique 1, this is arrived at by simply multiplying the number of operations arrived at as a result of Table 12.3 (3) by the number of words required. This gives us 3×100 (300 operations) and 3×200 (600 operations).

Performing a similar operation for Technique 2 gives us a value of 60×100 (6000 operations) and 60×200 (12,000 operations). Technique 3 is by far the most operation intensive, with 180×100 (18,000 operations) and 180×200 (36,000 operations).

THE EFFICIENCY QUOTIENT

Putting all these numbers in a table (Table 12.8) may help us to come to some conclusions based on the bewildering array of numbers that we now have.

TABLE 12.8 Code-Data Dynamics Comparison

| | Number of Data Elements | | | | | |
| | 1 | | 100 | | 200 | |
	Data	Code	Data	Code	Data	Code
Technique 1	6	3	600	300	1200	600
Technique 2	676	60	676	6000	676	12000
Technique 3	0	180	0	18000	0	36000

While this might not seem to be helpful at a first glance, we can perform a few further calculations, based on Table 12.8. These are aimed at deciding upon which technique is most suited to our requirements. Equation 12.1 indicates the theory.

$$Q = (data + code) / elements \qquad \text{The efficiency quotient.} \quad (12.1)$$

In Equation 12.1, Q shows the relationship between the code-data dynamics and desired population; it is a measure of the overall efficiency of each technique. Table 12.9 shows the various values of Q for the measures shown in Equation 12.1.

TABLE 12.9 Comparison of Efficiency Quotients

	Quotient per Number of Elements		
	1	*100*	*200*
Technique 1	9	9	9
Technique 2	736	67	63
Technique 3	180	180	180

Although not immediately obvious, we are now making progress toward our goal. What should be obvious is that for the two extremes (data- and code-intensive) represented by Techniques 1 and 3, Q is constant. This indicates that the number of elements that need to be generated does not have an effect on the efficiency of the algorithm employed. However, for the combination Technique 2, the efficiency increases depending on the number of elements, shown by a falling Q value.

This leads us to two conclusions. The first is that for smaller numbers of elements, Technique 1 should be chosen. Technique 3 has no real practical use in this case since the code overhead is far too heavy, unless storage space is at a premium—unlike Technique 1, the total space required remains constant. This latter measure was considered early on, as in Table 12.8.

The second conclusion is that there should be a point at which it becomes, on a per-element basis, more efficient to use Technique 2. This is coupled with the fact that the values are generated as required, meaning that the data storage change is zero. In addition, it is limitless in scalability; there is no need to know the values beforehand, thus the resolution in either direction is infinite. We can, in fact, have infinite object detail, and an infinite number of objects. It is clearly the most powerful of the techniques for our purpose. On the other hand, going through the steps presented earlier will enable programmers to make that decision for themselves.

To wrap up this section, we should just perform the final comparison. That is, how many elements must we consider as our population before Technique 2 rivals Technique 1 in terms of per-object efficiency; in other words, how many elements must be considered before Q closes on 9?

Those with a modicum of mathematical knowledge will quickly ascertain that the answer is that Q will never be lower than 60, since the latter part of the following equation (that which multiplies by 60) prohibits it:

$$Q = (676 + (60 \times n)) / n \qquad \text{Efficiency of Technique 2.} \qquad (12.2)$$

Indeed, it would seem that in Equation 12.2 we have failed in our quest. On the other hand, no appreciable overhead change is evident when we scale the number of elements (n) by factors of 10. That is, roughly the same overhead is required for 1000, 10,000, 100,000 and even 1,000,000 elements. Readers are welcome to calculate the intermediate values for Technique 1; the final memory requirement is somewhere around 6 million bytes!

Admittedly, it is possible that when designing a game, having a million planet names to choose from is not very high on our list. Remember, however, that realism dictates that there will be many times when generation is far superior to storage, especially in resource-limited environments. Furthermore, although the actual real-time generation technique may seem overkill for a particular set of circumstances, there is no rule that dictates that the required elements cannot be generated ahead of time and stored for later use.

CONCLUSION

We have learned much in this section of the book. We now know how three different techniques for recreating our Game Universe compare. In addition, we have seen how to perform a lengthy but complete comparison on the three styles outlined earlier.

To conclude this section, there is one final note that should always be borne in mind: a blend of techniques is usually the best compromise, but the motions must be borne out to ascertain exactly what the mix should be.

Bearing this in mind, we will now proceed to apply this knowledge to the magical world of probabilities, where we shall see just how much can be done to ensure that the overhead of generating a rich and varied Game Universe can be reduced using simple mathematical principles.

PROBABILITY TECHNIQUES IN GAME DESIGN

In the end, all programming comes down to the processing, storage, and representation of numbers. Not only does the process end with it (all machines use numbers to describe the operations required), but frequently the process may begin with the manipulation of data.

By using probabilities to describe and represent potential, real, or possible universes, we are using a set of empirical data (measurements) to represent qualitative values. That is to say, we wish to store and manipulate, through numbers, that which cannot naturally be expressed numerically.

Words, for example, have distinct qualitative properties that we have already encountered, such as unpronounceable letter pairs. These can, again, be expressed numerically. However, how do we arrive at these numbers? Furthermore, how best can we organize these numbers so that the best possible effect is arrived at: that which is most natural, or is an example of the exact mix of qualitative components that makes it realistic?

FROM QUALITATIVE TO QUANTITATIVE

By way of illustration, let us turn our attention to the mythical generic tree that we first encountered before our voyage into the comparison of techniques. As an exercise, we will attempt to describe such a tree using mathematical notation. The simplest tree that we might like to consider is an archetypal Christmas tree, or pine. A simple sketch as that shown in Figure 13.1 might suffice to elaborate on this vision.

FIGURE 13.1 A simplistic pine tree.

Although simplistic, the tree is recognizable for what it is. To describe it using mathematical notation requires that we express it in terms of lines, as in the sketch in Figure 13.2.

From this, we can establish a variety of mathematical relationships between the various discrete elements that make up the tree. The branches, for example, can be seen to have a length that is directly linked to their height—they get shorter, at a steeper angle, the further they are up the central trunk.

Once this relationship is expressed in code, along with other attributes of the tree such as a variable trunk length, it becomes possible to express a number of possible trees, with differing heights, and therefore number of

FIGURE 13.2 Line art simplistic pine tree.

branches, each with varying branch lengths, and angles with relation to the central trunk.

In order to find the limits within which we can generate the pine trees, we must take a sample of possible trees. In this way, we transfer the qualitative data that the human eye reconciles with the concept of a tree to quantitative information, allowing us to choose a representation of a tree that can then be displayed in a recognizable format. In doing this, we have used numerical data to achieve results that cannot usually be represented numerically.

The analysis of qualitative data in this way allows us to represent generic objects given a set of possible examples from which we can build specific instances. The examination of possible trees will remove the element of chance that may, if unchecked, lead to undesirable effects; trees that are no longer recognizable in the worst case.

Suppose, however, that we do not wish to create only pine trees, but instead, other forms of trees. A simple analysis of the tree domain leads us to believe that the angle of branches (for example) varies from between $+x$ and $-x$ degrees, using a 90-degree angle relative to the tree trunk as a base. In order to generate other kinds of trees, we may choose to add an analysis of other trees to our database, and thus extrapolate new types of trees based on this additional data.

We have so far glibly spoken of branch lengths, angles, and trunk sizes without once considering how this information might be stored. Indeed, the encoding of our real-world objects will have a very real effect on the resulting objects that we might generate. The reality is that while we might find a generic approach feasible, in order to achieve results of the highest possible quality, we should choose a storage encoding that is as close to the quality of object that we wish to store.

This slightly convoluted statement simply means that if a line-art representation fits, using lengths and angles to represent the object, then we can use it; however, we should always remember that some objects will not benefit from this form of representation.

Imagine, for example, trying to encode the average face using line lengths and angles. Clearly, we will be at odds with reality in attempting to use such a simplistic technique. In fact, many objects cannot be accurately encoded in this way. Therefore, we would need another approach that was able to accurately convey the various qualities that we attach to a face.

In fact, the common approach, as discussed by Dewdney (*The Armchair Universe*, p. 95), is but a variation on our pine tree storage. In this

approach, points are determined based on a set of faces, which connect lines, which in turn allow us to render a photograph of the face in line fashion. Encoding these lines merely requires that we store pairs of x,y coordinates that determine the start and end points of the lines that make up the face.

This technique has been used to great effect by a variety of researchers in averaging together the encoded faces of a large population of female faces in order to arrive at the perfectly average face. The technique can be used for a variety of objects, from teapots to bananas, and provides us with a second way to encode our generic objects.

A final approach that is used to great effect by artificial intelligence experts is to encode the object as a series of cells in two dimensions, which depict the shadow of the object. Clearly, this is specifically tailored to applications where the object is viewed in two dimensions. The other approaches have the advantage that they can be easily translated and rotated.

The last two methods are generic; that is, they can be applied across a wide variety of everyday objects, from faces to cats. The first is specific to pine trees and other basic semigeometric shapes, where the image is strictly composed of lines that intersect each other at definite angles or angle ranges.

DEGREES OF RESOLUTION

We have spoken so far only of one degree of resolution, the entire object. During the playing of a game, however, it is very likely that other degrees of resolution will be required. We have shown how we can achieve macroinfinite resolution by being able to generate multiple variations on a given object, but we have not touched upon the other extreme—that of being able to provide micro-infinite resolution, zooming into the detail of an object.

In order to illustrate this, let us return to our example of the creation of new words with which we began the chapter (see Table 13.1).

Embarking on a descriptive analysis of Table 13.1, we might say that, were the player to enter a library, he or she might choose a book at random. That book would contain pages of paragraphs, which in turn would be made up of sentences. Each sentence would consist of words, made up of letter combinations. Each letter has a unique and individual form, which may or may not be an alphabet that the player recognizes.

TABLE 13.1 Resolution of Letters

Micro-Infinite	The shapes of letters	More Detail
	Letter-pair combinations	↑
	Individual words	
	Word-pair combinations	
	Sentences	
	Paragraphs	
	Books	↓
Macro-Infinite	Libraries	Less Detail

It is hoped by now that the reader has spotted that we do not actually need to store a library in order to be able to produce a book for the player to read. At least in theory, we can merely store a generic set of letter combinations, sentences, paragraphs, and books that we can use to recreate, at will, whole libraries of books. In fact, the preceding example is deliberately over-detailed to give an idea of what is theoretically possible. In reality, we will probably either want to generate phrases or words—paragraphs, possibly. The notion of generating an entire book of elf-runes, however, is probably laughable; nonetheless, it is important to remember that it is possible.

QUANTITATIVE ANALYSIS TECHNIQUES

Having delved into the theory, it is now time to examine how it can be put into practice. We will use mathematical notations on each of our three approaches in turn. To recap:

- Object adjacency
- Line-art representation
- Coordinate representation

The first of these is dual purpose. We can apply it equally to storing letter adjacencies or cell adjacencies. Although the encoding is the same, the application will be slightly different, as we shall see. The steps that we need to follow, however, are the same for all approaches.

1. Examine the target population.
2. Encode each object with respect to the encoding mechanism.
3. Combine the encoded object with an encoding of all previous objects.
4. Generate objects using the stored encoding.

OBJECT ADJACENCY

The technique hinges around the ability to record the chances (probability) of two objects being located next to each other. For this, we will use an object adjacency table. The dimensions of the table are arbitrary. We saw earlier that in order to store letter pairs, it must be 26×26 bytes; let us refine this to say that it must be 28×28 bytes. The 0th and 27th byte will be used to store occasions where a letter may be preceded (it begins a word) or followed by a space character (it is at the end of a word).

To represent combinations of words (phrases), we would need a table that is large enough to accommodate the total number of words (to which we assign n) in the sample, plus two that we use to determine whether the nth word may begin or end a phrase.

We can also assume that we need an additional z number of bytes to store the words themselves, since we are referring to each by way of a number. This template can also be applied to shadow picture representations of objects. We simply ensure that we construct a grid as large as the largest object of the type that we are examining. It is important to note that we can only represent objects of the same type.

If, for example, we wish to store images of trees, and also images of houses, it makes no sense to combine representations of each in the same table. It might, however, make sense to combine various varieties of trees in the same table, as long as we do not mind losing the ability to build a tree of a specific type.

So, now we have a grid that is large enough to accommodate the data. Our next stage is to examine each object in turn and encode its attributes in the table. The code in Code Sample 13.1 is a very simplistic way of encoding a given word.

CODE SAMPLE 13.1 Letter adjacency table encoding.

```
typedef char * word;
typedef  row * int;
```

```
void EncodeWord ( word szWord, row * szTable )
{
  int x;
  n = WordLength( szWord );
  for ( x = 0; x < n; x++ )
  {
    if ( x == 0 )
    {
      szTable[0][szWord[x] — ('A' + 1)]++;
    }
    if ( x == n—1)
    {
      szTable[27][szWord[x] — ('A' + 1)]++;
      continue;
    }
    szTable[szWord[x+1] — ('A' + 1)][szWord[x] — ('A' + 1)]++;
  }
}
```

Applying this to the entire population of words will yield a table in which each cell x,y will contain a number. This number indicates the number of times that the letter in row x has been followed by the letter in row y. Should either x or y be equal to 0 or 27, then that letter may either begin or end a word, respectively.

So far, we have achieved the first three steps that we outlined earlier; we have examined the population, encoded each in a way that we can store efficiently, and created a table showing the relationship between the attributes of each object. So simple is this approach that we have achieved this in one short piece of code.

Storage of the resulting table is trivial, requiring only 28×28 bytes of space. We have one final task that is required to complete this technique. We should devise a way in which we can generate words, based on specific input data. We saw the basic algorithm for doing this in our discussion of code-data dynamics. However, it was not especially mathematical, so we will enrich it now.

Besides the letter table that we have built, we actually need to store some other information about the population before we are able to apply this first technique. In the case of words, these are:

- Frequency of word lengths
- Frequency of starting letters
- Frequency of ending letters

What follows can be applied to any discrete properties, or attributes of objects that need to be described in a way that leads to accurate generation of a given example of the population. It is up to the game designer to decide how these are arrived at, and at what resolution they should be defined. In all probability, several levels of resolution will need to be defined, since most objects are made up of multiple discrete elements, each of which has its own set of discrete attributes.

Attributes and Resolution

To keep this discussion simple, we will assume one level of resolution: words comprised of letters. Each of the pieces of information that we previously described as properties of a word uses the term *frequency*. In mathematics, this is described more commonly as the *frequency of observation*. It amounts to observing the population and noting the number of times a given attribute occurs.

It should be noted that, following mathematics texts:

"The frequencies are not the data, they tell us something about the distribution of the data."

—Discovering Advanced Mathematics: AS Mathematics
John Berry, et al; Harper Collins Publishers, 2000

This is exactly what we need, knowledge about how the various frequencies we have isolated are distributed so that we may follow the rules that result from them. In essence, what we want to achieve is the generation of a set of possible examples based on the population, such that each example would fit within the mathematical rules that define it.

Since we are not concerned with the fact that the samples we generate are actually examples of individual items that exist within the population, merely that they look as if they might come from it, we can use the strictness of mathematics in a paradoxically vague way.

The first attribute, that of word lengths, can be expressed in two ways: a set of discrete values, or a set of continuous ones. The second is more general, but requires less space. Consider that words in the sample might vary from one letter in length to 20, we would need 20 bytes of storage. If we

were to encode the frequencies in sets of five letters (5, 10, 15, 20), we would need only 4 bytes. The decision in this case is fairly easy: we take the most accurate, since it does not require significantly more storage space. The game designer must be aware, however, of the impact of the decision for other objects' attributes.

Clearly, the other two, frequencies of starting and ending letters, are discrete values, and can be derived from the table, since we specifically stored these values. Hence, they require (in this case) no extra storage space. We might also like to consider the frequencies of starting and ending letters based on word lengths, if it seems likely that this will have an impact. Again, it is the decision of the game designer, when looking at a population of objects, whether any inter-attribute relationships exist, and how they might be encoded.

In encoding these additional values, grids similar to those in Table 13.2 might suffice.

These tables can be populated in a way similar to the code in Code Sample 13.1, using the same data set.

We now have all our object adjacencies encoded appropriately, and can begin to apply some mathematical principles in generating possible objects. It should be noted that all of the preprocessing is performed prior to and separate from the game itself; it is not code that will be shipped, only the data will appear alongside the code for the game. Therefore, we need only concern ourselves that the data portion is not too great; in this case, it totals 1824 bytes, which is none too great.

TABLE 13.2 Additional Encoding Techniques for Object Adjacency

	Starting Letters					Ending Letters				
	1	2	...	19	20	1	2	...	19	20
A										
B										
.										
.										
.										
X										
Y										
Z										

Clearly, the code first encountered in Chapter 12 (Table 12.5) should be our starting point for any discussions as to how the data can be applied in real time to create individual objects (in this case, words), since the representation is almost the same. However, we have refined our data set a little since then, and so are able to devise more complex and realistic algorithms.

The first point to note is that we are attempting to create a possible set of objects, based on the data gathered from a given population. Thus, we would expect that if we were to reapply our population analysis algorithms to the new, generated population, that the tables resulting from doing so would be similar to those generated from the original population. We might also expect that if we were to analyze an identical number of objects from each population, the distribution of the various attributes would be almost identical, assuming that the samples were comparable.

With this in mind, let us apply the knowledge that we have gleaned from creating the tables to the problem of generating possible objects.

Our general algorithm might look something like this:

1. Choose a possible starting letter.
2. Choose a possible following letter.
3. May this letter be also an ending letter? If yes, and if the word length is roughly within the bounds allowed by the starting letter, then stop. If not, go to step 2.

In the preceding algorithm, we have used some words that may seem vague, but to which we can attach specific mathematical meanings: "possible" and "roughly."

Each choice of letter that is made, whether it be following another, or as a starting or ending letter, is chosen in the same way. In each case, we must consider the frequency of each possibility, and choose one based on chance. Before we elaborate on this further, let us speculate a little on what we want to achieve. In essence, we want to be sure that if we were to generate x starting letters, that the proportions of each will follow, as nearly as possible, the distributions arrived at by analysis of the example population.

In order to reduce this to simple terms, consider the following well-known phrase:

"The quick brown fox jumped over the lazy dog."

We would encode this as in Table 13.3.

TABLE 13.3 Letter Adjacency Example

| | A | B | C | D | E | F | G | H | I | J | K | L | M | N | O | P | Q | R | S | T | U | V | W | X | Y | Z | sp |
|---|
| | | 1 | | 1 | | 1 | | | | 1 | | 1 | | | 1 | | 1 | | | 2 | | | | | | | |
| A | 1 | |
| B | | | | | | | | | | | | | | | | | | 1 | | | | | | | | | |
| C | | | | | | | | | | | 1 | | | | | | | | | | | | | | | | |
| D | | | | | | | | | | | | | | | 1 | | | | | | | | | | | | 1 |
| E | | | | 1 | | | | | | | | | | | | | | 1 | | | | | | | | | 2 |
| F | | | | | | | | | | | | | | | 1 | | | | | | | | | | | | |
| G | 1 |
| H | | | | | 2 |
| I | | | 1 |
| J | 1 | | | | | | |
| K | 1 |
| L | 1 |
| M | | | | | | | | | | | | | | | | 1 | | | | | | | | | | | |
| N | 1 |
| O | | | | | | | 1 | | | | | | | | | | | | | | | 1 | 1 | 1 | | | |
| P | | | | | 1 |
| Q | 1 | | | | | | |
| R | | | | | | | | | | | | | | | 1 | | | | | | | | | | | | 1 |
| S |
| T | | | | | | | | 2 |
| U | | | | | | | | | 1 | | | | 1 | | | | | | | | | | | | | | |
| V | | | | | 1 |
| W | | | | | | | | | | | | | | 1 | | | | | | | | | | | | | |
| X | 1 |
| Y | 1 |
| Z | 1 | | |

Since every letter in the English alphabet is found within the sample phrase, there is at least one entry in every row and column in Table 13.3. There is not enough of a population to make it worthwhile generating the two grids in Table 13.3, but we should state that the average word length is

four (36 / 9), and that words may vary between three and six letters in length.

In mathematical terms, these are known as the average, calculated thus:

Number of letters in sentence / Number of words

And the range, defined as:

The highest value–The lowest value

Before we formally define an algorithm for creating a word, let us consider the steps that are required using plain English. First, we must choose our target word length. Arbitrarily, we choose the average of four. Next, we should pick a letter that may begin our word. Looking at Table 13.3, we can isolate eight contenders: B, D, F, J, L, O, Q, and T.

These letters have certain properties within the scope of our discussion regarding mathematics that are worth looking at. First, they each occur as starting letters once, with the exception of T, which occurs twice.

This is important, because when we select a starting letter, we should be aware of the distribution of possibilities. This is true for any pair of letters, or letter and space, because we wish to follow the distribution of the parent population.

From a mathematical standpoint, we can reduce this information to show the probability, or chance, of a given letter being chosen. We do this by summing the number of observations, and then dividing each number of observations in turn by the total as seen in Table 13.4.

TABLE 13. 4 Observation Probabilities

B	1	1/9	= 0.11	0.11
D	1	1/9	= 0.11	0.22
F	1	1/9	= 0.11	0.33
J	1	1/9	= 0.11	0.44
L	1	1/9	= 0.11	0.55
0	1	1/9	= 0.11	0.66
Q	1	1/9	= 0.11	0.77
T	2	2/9	= 0.22	0.99
TOTAL	9	9/9	= 0.99	

It is a simple step from this data to be able to say that the letter T is more likely to be chosen than the others, since the proportion of times it occurs is higher. How, though, should we decide which to choose? Imagine for a moment that we have a 10-sided die. If we roll it, the number 4 might be face up. If we divide this by 100 so that it becomes a number between 0 and 1, we arrive at 0.4, which we can use to index into Table 13.4.

This is done by adding together the frequencies until they exceed the number we have just calculated. This gives us the letter J (at 0.44). Now assume that we were to perform the same operation until a letter appears twice. This letter would then be the one that we choose to begin the word. We would hope that T would come up more often than the others would, since it has two chances of being chosen, whereas the others only have 1. A value of 10 (1.0) we must take as being T, since accuracy dictates that the recurring values that result from each calculation be rounded.

This technique will be used each time we need to choose a letter, and results in a fair way of choosing each letter. Therefore, assuming that the letter O was chosen, we can proceed to build our word. An examination of the table yields the letters G, V, W, and X, each occurring with equal chance. Arbitrarily, we choose V.

Following a similar course until we arrive at our target number of letters, four, we build the word:

OVED

which is not an English word, but is at the very least pronounceable, and would almost make a good name for a person, place, thing, or part of a verb. Incidentally, D may end a word, but we need a way of possibly ending a word prematurely if no candidate can be found that is allowed to end our word.

Using this technique, we have passed from the qualitative, through the quantitative, and back to qualitative to arrive at something that a computer has generated largely by itself, and yet which a human can vouch for. This is the cornerstone of games programming: reality.

Abstract objects that are easily recognizable from their shadows may also be combined in this way to create new objects. Imagine a set of geometric shapes, superimposed on a grid as depicted in Figure 13.3.

If we count each square that is filled in as a value "1," and each that is not as a value "0," we can build a series of adjacency grids, much as we did with the letter tables shown earlier. Following the same theory as before, we

FIGURE 13.3 Simple geometric shapes.

can combine the grids to produce a grid that represents all possible combinations of adjacencies, with rising values where grids with filled-in squares overlap.

With some creative color-coding, we might produce grids that look akin to those in Figure 13.4. The far right figures in each series show what the table values might look like once all the shapes have been superimposed.

From this it is quite easy to see what the likely shapes are that can be created from the superimposed grids. Indeed, were we to create shapes at random, using the same theory stated previously, some interesting "new" shapes can be produced. However, they are far from perfect; some additional techniques are required in order to be able to create realistic shapes. This technique by itself is really only suited to abstract objects.

FIGURE 13.4 Superimposed simple geometric shapes.

LINE ART

The more concrete the objects become, the more aware we have to be of the mathematical relationships between the various pieces. Looking at the shapes in Figure 13.4, we have paid no attention whatsoever to the ways in which the lines are connected together, nor the shading in the filled shapes.

In our pursuit of realism, we cannot afford to ignore these relationships, because to do so will yield unnatural results. Occasionally, we may require results that are not strictly comparable to the population that we are examining, but they must still adhere to the principles of the population.

Stated another way, we might like to create alien trees at random. In order to provide a basis for the trees, we might examine renderings of a multitude of Earth trees and create a representation that is to be used to create instances of possible trees.

These trees may not be recognizable as Earth species—after all, this is the aim of the exercise. However, it is unlikely that we would want to create objects so far removed from the Earth tree that it is not recognizable as a treelike object.

Using the adjacency table technique, it is possible that trees might be created that bear no resemblance to what we know as a tree. This is because we have paid no attention to the ways in which the lines connect together—only the existence of the lines on a grid.

It is interesting to note that the less abstract we become in our definitions of objects, the more complex become the ways in which we must examine them. It is no longer enough simply to think in terms of a grid; now, we must attempt to describe the object in terms of lines.

A simple reason for this is that when we examine an object in terms of a grid, we ignore the connections of lines. These connections define either enclosed areas (in the case of geometric objects) or features (in the case of abstract shapes, such as trees). Let us first turn our attention to enclosed shapes.

The easiest way to think of objects in terms of lines is to consider them in terms of length, direction, and angle. There is a simple language proposed by a team from the MIT Media Lab in the 1970s called Logo in which an object called a Pen is controlled by a series of simple commands, of which a subset could be defined as in Table 13.5.

TABLE 13.5 Simple *LOGO* Commands

PenUp	Stop drawing
PenDown	Start drawing
Left *x*	Turn left by *x* degrees
Right *x*	Turn right by *x* degrees
Forward *n*	Go forward *n* spaces

We might use this simple language to define a square of side *n* as follows:

PenDown

Right 90

Forward *n*

Right 90

Forward *n*

Right 90

Forward *n*

Right 90

Forward *n*

This simple piece of pseudocode will yield a perfect square. Similarly, we might define a triangle as follows:

PenDown

Right 120

Forward *n*

Right 120

Forward *n*

Right 120

Forward *n*

These two sets of pseudocode have more in common than is immediately apparent. To highlight this, Table 13.6 shows the pseudocode for each of the objects in Figure 13.3.

TABLE 13.6 *LOGO* Pseudocode for Simple Geometric Shapes

PenDown	PenDown	PenDown
Repeat 4 times	Repeat 3 times	Repeat 8 times
Right 90	Right 120	Right 45
Forward *n*	Forward *n*	Forward *n*

The relationship between each of the objects is quite clear; since they all begin and end in the same place, we can say that the angle to be turned through each time is:

Angle = 360 / Number of Sides

How can we use this information to generate objects? Regular objects pose no problem whatsoever, since we need only choose an angle to turn through, or a number of sides. The number of repetitions or angle to turn through per repetition can be easily derived as:

Repetitions = 360 / *angle* where *angle* is chosen at random
Or angle = 360 / *repetitions* where *repetitions* is chosen at random

With this in hand, we can generate any regular shape at random. Smaller examples can be created by reducing the side length; larger ones by increasing it.

Irregular shapes, usually combinations of two or more regular shapes, prove to be more of a problem. These may be broken down into several categories, depending on the reflective symmetry that they exhibit. Some have reflective symmetry about their midpoint on a given axis, be it horizontal or vertical. Others have reflective symmetry along a diagonal. Finally, they may have no reflective symmetry at all.

Ignoring for a moment that we might want to generate an object that falls into a specific category, let us concentrate on how we might generate an example of a possible object based on the examination of the three simple geometric objects with which we have been working.

In the previous section, we saw how it is possible to infer relationships between specific features by analyzing a given population and tabulating the results on a grid. Further to this, we also investigated the way in which

the grid can be converted into a series of values that influence the choice of value.

These two techniques are abstractions of the observed features of the population. That is, we choose to attach mathematically meaningful values to the frequency of occurrence of the features exhibited by the population. When we apply these values to an algorithm that leads to new sequences being generated, we need to convert the abstraction back into something that would be meaningful in terms of the observed population.

Clearly, while the exact techniques are not applicable for the current technique, we have applied the same principles and reduced our observed population to a series of mathematically meaningful values. What we now need to do is to analyze the relationships between these values in such a way as to produce a complete abstraction of the population.

Taking as our population the set of shapes that have between 2 and 10 sides, we can derive a relationship in terms of angles to turn through for each side, as we expressed with the previous equations. This leads to the set of figures in Table 13. 7.

TABLE 13.7 Relationship between Angle and Number of Sides

2	3	4	5	6	7	8	9	10
180	120	90	72	60	51.43	45	40	36

From this, we can see that for a shape with a given number of sides, if we trace the outline from start to end, we will have turned through 360 degrees. Therefore, any closed shape that we wish to generate should adhere to this principle.

Storage of the object properties shown in Table 13.7 is more complex than with the object adjacency technique. At the same time, it seems that the overhead is smaller. For each line, we need only store two pieces of information: the length of the line that we should draw, and the angle through which we should turn prior to drawing it.

Put another way, if we wish to represent a square that is five units to a side, we need only store 10 pieces of information: two for each side. To store the same object using the object adjacency technique, we need to store a grid of 5 × 5 numbers (25 pieces of information), of which most will be redundant.

This redundancy is due to the fact that we are obliged to store values where there is no meaningful information stored. If there is white space, then we have to store a relationship between each square within that white space. With line-art encoding, this white space is not stored.

However, in order to store a complex shape, we must be aware that it might take a large number of polygons to represent the shape. In such cases, an object adjacency representation might be more applicable.

This can be rectified to a certain extent by storing each object in terms of the number of sides and the total angle through which to turn. In this case, only two pieces of information per object need to be stored. A square would be stored as two numbers: 4 and 360.

Breaking down a complex object into a set of simple geometric shapes is best done by a human being. The reader may find a good way of doing this automatically. As a guideline, a matching process may be devised whereby the object to be encoded is placed on a grid, and each feature matched to an object of increasing complexity.

In this way, we might begin with an object that has three sides, and attempt to match all the triangular parts of the image to representations of various triangles. Next, we would do the same with a series of squares, matching the remaining features as required.

Usually, the process will end here, with a significant loss of detail. This loss of detail comes about because, while a complex object can usually be broken down into triangles and squares, there will inevitably be cases where the final representation falls short.

In the final analysis, then, we must store four numbers per geometric representation: the starting coordinates, length of lines, and angle through which to turn. The human brain is best suited to performing the best fit of the simple objects to the complex one.

At the beginning of this section, we isolated four steps that are needed to use this technique to its fullest: examine, encode, combine, and generate. We have so far established how to examine and encode a given object. We break it down into a series of geometric shapes, and store the relationship between them.

We mentioned triangles and squares for complex shapes, but for our simplistic pine tree, we can use lines. The encoding is similar; a starting position, line length, and angle (4 numbers) are all that is required. Taking the pine tree in Figure 13.5, we note that there is a center trunk, and three branches on each side.

FIGURE 13.5 Line-art pine tree.

We might choose to encode this as per Table 13.8.

TABLE 13.8 Simple Pine Tree Encoding

Feature	Coordinate	Angle	Length
Trunk	0,0	0	3
Left Lower Branch	0,1	−45	0.75
Right Lower Branch	0,1	45	0.75
Left Middle Branch	0,2	−45	0.5
Right Middle Branch	0,2	45	0.5
Left Upper Branch	0,3	−45	0.25
Right Upper Branch	0,3	45	0.25

This can be reduced, in turn, to a single trunk of three units, plus an encoding for the left and right branches. Each branch is set at the same angle, with a regularly shortening branch length. In the same way that we derived a generic algorithm for the simple geometric shapes that we identified earlier, we can also derive an algorithm for the pine tree.

To do this, we simply note that the number of branches on a given side is proportional to the trunk length, and so we can form the first equation:

Number_of_branches = *trunk_length / spacing*

Pine tree branches. (13.1)

The *spacing* value in Equation 13.1 for this tree is 1. Following this, we can also arrive at an equation for the position of a given branch set (left and right):

Branch_y_position(branch_number) = *spacing * branch_number*
Pine tree branch position. (13.2)

All that is missing from Equation 13.2 is the *x coordinate* of the branch, which, from Table 13.8, is always 0. Finally, we need only establish the length of branch as follows:

Branch_length(branch_number) = spacing - ((spacing / (trunk_length+1)) * branch_number)
Pine tree branch length. (13.3)

In Equation 13.1, *spacing* was chosen as the "standard" branch length for convenience, and is derived from Table 13.8. By a similar token, the branch angle is always 45 degrees (or –45 degrees).

Analysis of other pine trees from the population will yield differing values, which can be combined with these mathematically. All of the variables in italics in the preceding equations can be varied depending on the properties exhibited by the sample population.

The final step, then, is to generate example trees, using the equations shown previously. At this point, we see that the algorithm, while being a little simpler in some respects, is slightly more mathematical. In some ways, the discussion so far has been more abstract than the object adjacency technique.

IMPLEMENTATION NOTE 13.1 PROPORTIONALITY

In order to fit into the models described, it will be necessary to create encodings of the population that fit into the equations.

In doing this, one will lose a certain amount of fluctuation that exists in the natural world.

For example, it is rare that the spacing between branches will be exactly the same, and that there is the same number of branches on each side.

This can be seen as a shortcoming of this technique; nevertheless, it does make for a practical and efficient way of mathematically encoding the objects.

Although we are not about to change the nature of the discussion now, it should be obvious that in order to generate examples of the abstract representations of the pine trees that we have defined using the previous three equations, all we need to do is apply the pseudorandom generators to determine numbers to put into them. All of the variables in *italics* can be replaced with generated numbers to create examples of the objects.

This brings us to the final technique: the coordinate system.

COORDINATE

The third and final discrete way in which we can define a set of objects is in terms of the coordinates of their connecting lines. We have already examined the concept of connecting lines in the previous section, where we examined closed shapes in terms of the angle separating each line. Here, however, we are dealing with objects that have features that may or may not be in themselves closed shapes.

Before we move on to complex shapes, let us first treat our simple geometric objects using this technique. Each line is encoded as a starting set of coordinates and an ending set. They can be tabulated as shown in Table 13.9.

As with the line-art technique, it will probably be best if a human performs the preprocessing; in this case, matching the lines that make up a complex object to the coordinate system. Again, we can break down the entire process into examine, encode, combine, and generate.

TABLE 13.9 Coordinate Representations of Simple Shapes

Square	Triangle	Octagon
0,0 – 4,0	0,0 – 2,4	1,0 – 0,1
4,0 – 4,4	2,4 – 4,0	0,1 – 0,3
4,4 – 0,4	4,0 – 0,0	0,3 – 1,4
0,4 – 0,0		1,4 – 3,4
		3,4 – 4,3
		4,3 – 4,1
		4,1 – 3,0
		3,0 – 1,0

The examination and encoding requires only that we break down the image into lines, each with a starting and ending coordinate as we described earlier. This technique makes it very difficult to actually combine sets of coordinates; shapes will rarely have the same number of coordinates.

The first step if we want to perform this type of analysis is to ensure that we can break down the images to be combined into sets of matching coordinates. We can then calculate the difference between each set, to arrive at a value that defines each coordinate.

Once the combinations have taken place, we arrive at an image that is the sum of the differences between the sets of coordinates. Figure 13.6 shows a square and a diamond. Both have the same number of coordinates (four), which can then be tabulated.

FIGURE 13.6 Square and diamond representations.

To calculate the coordinates of the lines making up the sides, we use the center of each figure as the reference point. From Figure 13.6, we can derive the coordinates shown in Table 13.10.

Once we have the sets of matching coordinates, we need to calculate the combination of the two figures. Calculating the difference between the

TABLE 13.10 Coordinate Encoding for the Square and Diamond

Figure	Side	Coordinates
Square	1	−1, 1 to 1, 1
	2	1, 1 to 1, −1
	3	1, −1 to −1, −1
	4	−1, −1 to 1, 1
Diamond	1	0, 1 to 1, 0
	2	1, 0 to 0, −1
	3	0, −1 to −1, 0
	4	−1, 0 to 0, 1

coordinates can be done in one of two ways. Simple subtraction will yield a different result than averaging will. Either may be used, depending on the desired result.

Table 13.11 shows the result of each of the two options.

TABLE 13.11 Difference Calculation Results

Side	Subtraction	Averaging
1	−1, 0 to 0, 1	−0.5, 1 to 1, 0.5
2	0, 1 to 1, 1	1, 0.5 to 0.5, −1
3	1, 0 to 0, 1	−0.5, −1 to −1, −0.5
4	−2, −1 to −1, 0	−1, −0.5 to −0.5, 1

Once all the shapes have been treated in this way, we are left with a table representing the average shape. From here, we can generate examples of the average shape in much the same way as we did with the line-art system.

This type of technique will be explored further in Chapter 15, "Probability and Extrapolation," where we propagate the coordinate model.

PROBABILITY AS A COMPRESSION TECHNIQUE

In essence, all of the techniques we discussed earlier are exercises in compression. That is, they all take a large population and reduce it to a discrete set of data and algorithms from which a similar population can be generated. This, however, is not acceptable for true compression, where we require that the resulting population is *identical* to the original.

REDUCING THE SAMPLE POPULATION

Take the letter adjacency table we used in Chapter 13, "Probability Techniques in Game Design." In producing such a table, we reduce the sample population of words to a 26 × 26 grid of values. We have compressed it; at least, as long as the sample population was greater than 676 bytes, we can be sure that the table is smaller than the sample. We can use that table to generate "possible" words. We cannot, however, use the table to regenerate the sample population.

Remaining with this example, we obviously require some way in which we can statistically examine the population, such that the properties of the original population are not lost in the reduction. We therefore need to store specific pieces of information that we can use in conjunction with the table in order to regenerate our original sample.

The information that we require is the same information that we use to generate words; namely, the starting letter and a value indicating the offset

into the column represented by the current letter. In order to establish whether this is valid as a compression technique, we must determine if we have saved any space by using it.

Before we proceed, something needs to be made clear. Until now, we have seen that we can generate a far larger "possible" population using these methods than would be possible using storage alone. Chance dictates the exact nature of the objects we generate. There are times when this is not reliable enough and we need to regenerate the exact population. It is possible that the two aims will go hand in hand for a specific application; namely, that the storage will be used for both "random generation" and "regeneration."

STORAGE REQUIREMENTS

Bearing this in mind, we can calculate the storage requirements for the following phrase:

"The quick brown fox jumps over the lazy dog"

as being 43 bytes. Analysis of the phrase leads to a letter adjacency table that is 676 bytes in size, but which can be reused (see my earlier comment). If we wish to use the table to regenerate the phrase, we first need to store the numbers representing the starting letters of each word:

21 18 3 7 11 16 21 13 5 9 bytes

We then need to store enough information to enable us to regenerate each word, which amounts to a number specifying the offset into the probabilities that can be generated for each column. To refresh, we can generate the possibilities from the table by summing all the occurrences in a row, and representing each call value as a percentage of the total. To generate a letter, we pick a number between 1 and 100 and add up the cell values until the chosen number is equaled or exceeded.

Referring to Table 13.3 in Chapter 13, we can create Table 14.1.

The total amount of data required is 36 bytes, a savings of 16 percent. Expressed differently, we require roughly 0.83 bytes per byte of storage. This may not seem on the face of it to be an enormous amount of saving, especially when we consider that in order to benefit, we need to make back

TABLE 14.1 Generation Data for a Phrase

21	18	3	7	11	16	21	13	5
100	100	100	100	100	50	100	100	100
100	50	50	100	100	100	100	100	25
	100	100		100	100		100	
	100	100		100				
				50				

the 676 bytes we need for the table, as well as the code required to generate the words. For the table alone, we would need to "compress" 4225 bytes of text in order to have saved the 676 required by the table.

RUN LENGTH ENCODING

To improve on the efficiency, we need to reduce the amount of data that we need to store even further. One way to do this is to use another type of sampling of the population called *run length encoding*, or RLE. The technique is much like our adjacency one in that it concentrates on reducing series of numbers to pairs of information.

Before we examine the RLE algorithm in detail, we must state that in doing so we only reduce the permanent storage requirements; that is, the table can be encoded using RLE to remove sequences of bytes that repeat themselves, but before we can use the table, we need to expand the RLE encoded chains. This working storage is important in memory restricted environments such as consoles and handheld units.

The way in which RLE works is very simple. If we choose the sequence from the first row of Table 14.1, thus:

100 100 100 100 100 50 100 100 100

viewed as a sequence of numbers, we see that the number 100 is repeated many times. We could reencode this sequence of numbers as a number series of pairs. The first value would indicate the value, and the second the number of times it should be repeated. Thus, the sequence becomes:

100 5 50 1 100 3

Calculating the saving, we see that we required 26 bytes originally, replaced with 13, which is a space savings of 50 percent. This is more acceptable than the 16 percent we managed earlier. Since the two are compounded, we are now entering savings of around 60 percent over the original requirement.

In all this, we have said very little about the preprocessing and postprocessing required to encode all of these algorithms. It is quite clear that an enormous amount of work is required in sampling the data, building the table and then using the table to generate words. A further refinement is to replace the values in the table with percentages that represent the values that are required.

Finally, there will probably be cases in which there are zero values. These add no information to the table for this application and can be removed. The OBJADJ source code on the companion CD-ROM uses a simple linked list in place of an array. This approach means that only significant data is stored.

CONCLUSION

The preceding example shows how various sequences of properties (letters forming words, adjacent bitmap values) can be used to build compressed versions of the original. The exact way in which we choose to apply the principles and algorithms is dictated by the choice of properties exhibited by the population that we choose to sample.

In the case of simple geometric objects, we saw how it is not enough to simply apply the adjacency technique, except after we have reduced the bitmap to something that lends itself to being sampled in this way. Words, seen as letter sequences, or pairs, lend themselves to this technique.

The application of probabilities to the sampled data allows us to expand the compressed data into something that resembles the original. In doing so, however, we lose the "exactness" that would be required to completely render the original population. To overcome this, we may choose how the "new" objects are rendered, such that we need only find a starting point for the object that we need to render in order to recreate it.

Leaving this latter point aside for the time being, we can say that if we were to apply the principles in Part One to the sampled data, we can create an infinite number of possible objects that bear a good resemblance to selected subjects from the sampled population.

In addition, in order to prepare objects that are truly representative of the entire population, we must choose a sample that is similarly representative. Mathematically speaking, we need to choose a set of the original population, such that all the possibilities that exist in the whole population are present in the sample.

This is an ideal case; it is unlikely that we are able to be selective enough in choosing our sample that we can capture every nuance exhibited by the starting population. To give an example that can be expressed clearly, suppose that we wish to generate a set of names that sound natural. We might sample a number of names, one for each letter of the alphabet.

In doing so, we would be fairly certain that the resulting generated names would sound natural within the confines of our sample. However, we cannot be sure that every possible name has been captured, or that we have achieved a situation in which the proportions of possible names are adequately represented. There are, for example, not as many names beginning with "X," "Z," or "Q" as there are names starting with other letters.

In addition, we may have more male-sounding names than female, or more that have their roots in Latin than Scandinavian or Germanic tongues. This means that we need to expand our sample accordingly.

In essence, the sample needs to be "big enough," but will probably be constrained by practical terms such as time and processing power when applied in the real world. This is true for any sample that we wish to take where the entire population is rich and varied.

The core mathematical techniques at work in this part of the book so far have been:

- Sampling
- Statistical analysis
- Probability
- Propagation

The last of these is simply using the information gleaned by the other three to make decisions about which facet, or property, of the sample to use from a limited set. The combinations of properties are also a result of the analysis and representation of the data.

We might say that the techniques combine to produce *lossy* compression. This is a form of compression where the overall flavor of the sampled population has been retained, at the expense of losing some of the detail. In

graphical terms, an image that has been compressed using lossy compression expands to reveal a recognizable version of the original, but close inspection reveals shortcomings in the representation.

Applying this to a sample of words, the shortcomings become much more marked, since language in itself is understandable only if a large proportion of the detail is present. The only way to achieve lossless compression using this technique is if we are able to encode enough of the detail to arrive at a representation that can be expanded without losing a significant proportion of the original.

If we are not concerned with the eventual shape of the result, merely that there is a significant amount of detail, we can fabricate that detail ourselves. We can use a technique we will call *extrapolation* to achieve this. Extrapolation does not ignore detail; it merely recreates detail that is plausible, if not identical.

An in-between method, which we might like to call *propagation*, is the subject of the next chapter, laying the foundation for the final technique of extrapolation.

Now that we have seen how the techniques combine so that we are able to generate examples of the sample population, we turn our attention to the final technique that can be used to populate a universe: extrapolation.

PROBABILITY AND EXTRAPOLATION

Everything that we have stated to date has been in some way connected with probability and the application of probability in generating figures that are representative of the sample population. An object created in this way could well come directly from the sample population, at least in terms of probability. It is quite likely that the object is not actually a member of the population, but the important concept is that it could be.

This is a simple example of extrapolation. Unlike strict replication, which is required when probability is used as a lossless compression technique, extrapolation relies on the concept of sameness, or similarity. At its simplest, extrapolation merely requires that we combine a set of features observed in the sample population to produce a possible variant.

We have used this form of extrapolation in each of the techniques in Chapter 12, "Example Using Letter Adjacencies to Generate Words," when we tested the theories by building sample objects. It can, however, be taken further. Indeed, the only extrapolation that we have encountered to date has been purely with respect to the sample population.

We shall call this type of extrapolation *propagation*. That is, propagation is the means by which we can generate a set of possible objects from a sample of real objects. These objects may or may not be part of the sample, and by the same token, they exhibit enough of the properties that are common to the sample that they could have been taken from it.

Bearing these definitions in mind, we can say that of the three techniques discussed here, (adjacency analysis, line art and coordinate) they can all be propagated to produce possible examples of the data set, and they

can also all be extrapolated to produce variations that are definitely not part of the sample.

EXTRAPOLATION

In extrapolating a population, we hope to exaggerate relationships between the characteristics that we have sampled. The effect of this extrapolation depends on the scheme that we have used to sample and store the data.

Of the three schemes, (object adjacency, line art and coordinate), only the latter two work well in isolation. That is to say, object adjacency tends only to give good results when used in combination with other techniques, or over several classes of object.

Where object adjacency comes into its own is for analyzing groups of other objects that may be expressed using either of the other two schemes. Techniques for using it in this way will be examined later on in this chapter.

Of the two latter schemes, the coordinate system is the easiest to extrapolate, so it is here that we will begin.

THE COORDINATE SYSTEM

When we implement this scheme, we store the start and end points of a number of lines, which combine to give shape to the image. As we saw in the preceding chapter, we can merge several sets of points together to produce variations. These variations take their form directly from the input data to yield new instances.

These new instances will be recognizable as being combinations of two sets of points, especially if the two sets of points are shown. It is easy to see how one can "become" the other. The core of extrapolation takes this technique, known as *morphing*, one step further.

When we merge, or morph, two sets of points, we calculate the difference between two known sets of corresponding points. That is, we must link all the points from one image with all the points on the other image, and calculate the difference between the two.

The "in-between," or merged version is simply a version in which the differences between the sets of points are scaled down. We apply these differences to the points from the first of the two images, to arrive at an image that can be said to be a morphed version.

Of course, eventually, we will reach a point where the differences are such that when applied to the points of the first image, we arrive at the second. In this way, we can morph one image into the other.

Now, let us consider what happens if we were to magnify the differences between the two sets of points. We could extrapolate an instance of the combined images that would be unrecognizable from the source images, yet retain enough similarity to these images that it would not look unreal, or impossible.

Therefore, in the first instance, extrapolation is an exaggeration of those features that set the two objects apart. The next step can be thought of in terms of self-similarity. This requires choosing a reference point, and determining the difference between this and the various coordinates that make up the resulting image.

We first encountered this approach in Chapters 12 and 13 of this part of the book. We used this to create a generic example of a set of similar objects. The extrapolation based on self-similarity requires only one example of the object. Our first step is to choose a reference point.

The center of the object is a good place to start. We need only calculate the difference between each point and the reference point, and apply a multiplication factor. In Figure 15.1, which shows a stylized face image, derived from the one we first mentioned in Chapter 2, we show the face on the left, and the coordinates as derived from their x and y differences from the center of the grid.

FIGURE 15.1 Two aspects of the stylized face.

FIGURE 15.2 Reduced stylized face.

Taking the coordinates derived from the right-hand side of Figure 15.1, we can apply a multiplication factor less than 1 (0.74, for example) to arrive at the smaller version shown in Figure 15.2.

The final step in this approach is to consider how to generate a number of different faces based on the same theory. Here we have several options, the simplest being longer faces or wider faces. These effects require only that we vary the component that leads to the shape of the face.

For example, to derive a longer than average face, we simply apply a multiplication factor greater than 1 to the difference between the horizontal center line and the y coordinate of each point. In Figure 15.3, we see an elongated face based on the image from Figure 15.1, with a multiplication factor of 1.2.

The same technique can be applied to the difference between the vertical centerline and the x coordinate of each point. Joining the dots gives us the image shown in Figure 15.4.

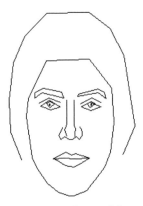

FIGURE 15.3 Elongated face.

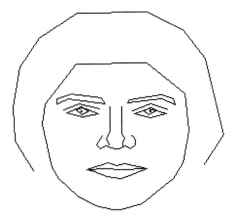

FIGURE 15.4 Wider face.

As a final note, and to give material for future experimentation, we should also state that it would add to the reality of each generated object if we varied the x and y multiplication factors independently from each other. If we want to populate an entire crowd of faces, we choose a maximum and minimum x and y multiplication factor for the crowd. We then generate a series of pseudorandom numbers that specify the extent of x and y multiplications that should be applied to each individual face.

ON THE CD The final result might look something like the output from the MULTIFACE software included on the companion CD-ROM, a sample of which appears in Figure 15.5.

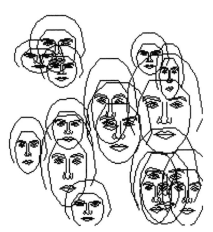

FIGURE 15.5 Sample "crowd."

THE LINE-ART SYSTEM

Running on similar lines to the coordinate system, the line-art technique can be used to generate objects from samples like the pine tree we explored in Chapter 13, "Probability Techniques in Game Design." We established that the tree can be represented by a set of equations, and that generation could be achieved by varying the input values.

When we propagated these objects, we did so only within the bounds defined by the examination of the sample population. To go one step further and extrapolate beyond the bounds defined by the sample population requires that we enhance random features. Again, this is much the same as with the coordinate system.

Taking our simple pine tree as an example, we should recap on the three equations that we derived for representing it:

Number_of_branches = *trunk_length / spacing*

Branch_y_position(branch_number) = *spacing* * branch_number

Branch_length(branch_number) = *spacing* - ((*spacing* / (*trunk_length*+1)) * branch_number)

In order to generate a given pine tree, we need to perform the following steps:

1. Choose trunk_length.
2. Calculate number of branches by dividing by *spacing*.
3. For each branch_number in branches:

 - Calculate y_position by multiplying *branch_number by spacing*.
 - Calculate branch length proportionally to the *branch_number*
 - The x_position is zero.
 - The angle is –45 for the left branch, 45 for the right branch.
 - Do the left-hand branch.
 - Do the right-hand branch.

This fairly involved sequence of steps will draw a pine tree of *trunk_length*, with a certain *spacing* between the branches.

Repositioning

The preceding example does not take into account that the trees will not be in the same position on the screen as assumed by the grid from which the equations were derived.

When actually coding this system, an x and y offset need to be added to each coordinate in order to ensure that the tree appears at the right position on the screen.

To extrapolate this simple representation in order to overstep the bounds set by the sample population, we need to do more than vary the *spacing* and *trunk_length* as stated in Chapter 13. Indeed, following the previous example set out by the coordinate system, we need to introduce differences at all stages.

For example, we stated that in reality, the branches are likely to vary in terms of length and angle. Therefore, we can introduce a little variation by using a pseudorandom number generator. Once we have chosen a seed, we can apply a generator to produce values that we can then rebase to allow changes in the branch length and angle for each branch.

The realism of extrapolation in this case will lie in applying just enough variation for the trees to be believable. If too much variation is allowed, the trees will not be realistic.

THE ROLE OF FEEDBACK

The final aspect of probability and extrapolation techniques to be considered is the role of feedback and feedforward in the game design and execution phase. So far, we have been dealing only with instances where the sample population actually exists.

However, in the game design stages, it is quite likely that we might want to create entirely new creatures, languages, musical pieces, or even behavior. Everything that can be analyzed to find relationships in the three ways that we have detailed in this part of the book can also yield entirely new examples that are not extrapolations.

Extrapolations usually bear more than a passing resemblance to the objects that were used as a reference sample. This is acceptable for cases where we do not want to deviate from the reality of the sample. However, for cases where there is no reference sample, we must turn our attention elsewhere.

Of course, if one uses a reference sample that contains humans, fish, and birds, then the result will be entirely new creatures. In the same way, if the extrapolation techniques used are applied for too long, then strange new life forms will take place.

They will, however, lose the reality that makes them believable. Feedback and feedforward techniques enable us to create startling new entities without the danger of losing realism in the process. As with all the techniques from this book, they can be applied at design time, where the best examples are taken further, or at run time, as long as they are constrained enough that the realism is not lost.

FEEDBACK

A feedback process is one in which the result of the previous iteration provides input to the next one. The pseudorandom number generators that we have been heavily involved with are all examples of feedback systems.

It is, however, not the same as seeding. Seeding is distinct in that a discrete value that may or may not be the result of the algorithm is fed as input to a new session of that algorithm. Therefore, while passing the value that has been generated directly back to the algorithm so that a new value can be generated is feedback, taking a previously generated value (generated by the same algorithm) and passing it as a seed is not.

The distinction is that feedback happens only when the exact value arrived at by a portion of an algorithm is fed into the next iteration.

FEEDFORWARD

Whereas a feedback system takes the result of an algorithm and uses it to provide input to the next iteration, a feedforward system can insert data arrived at during the execution of an algorithm and pass it to the next stage within that algorithm.

Self-seeding pseudorandom number generators are examples of this. In these cases, they provide information for the next iteration, but some of the information arrived at during the calculation process is also fed into either the next stage or, in some cases, the next iteration.

Feedforward can also have a role in passing information between two processes that are not otherwise related. It is this use with which we will be concerned.

APPLICATION OF FEEDBACK AND FEEDFORWARD

Some previous examples of Feedback and Feedforward appear in Chapter 15, "Probability and Extrapolation."

Extrapolation is a special kind of feeding, since it uses the source to provide input into possible targets. However, once we generate a set of possible objects, which are similar within a certain set of limits, as in Chapter 15, we can feed some of this information back into the generation algorithm.

Again, we are dealing with averages. We define an average object, and extrapolate it to arrive at a discrete number of examples. From these examples, we can define two extremes, and a new average object. Each of the two extremes can then be extrapolated with reference to the difference between them and the new average object.

If we apply this repeatedly, we arrive at a set of objects that are all similar, but not identical. This can be applied in two places in the development cycle of a game. The first is in the design stage, where we can create a myriad combination objects (banana–apple, for example) and choose those that are aesthetically pleasing.

The chosen objects can then be fed back into the algorithm for resampling. Using feedback/feedforward requires an additional step. The reason is that we no longer want only to store the average object, but also the specific extremes between which variation is allowed.

Therefore, we begin by storing two identical average examples, derived from the probability techniques that we looked at earlier in this chapter. Next, we generate a variety of objects, and select one that has a higher level of deviation than the average, and one lower. These are assigned to the average examples in place of the originals.

Next, we generate a range of objects that lie between the extremes, and select two that are at the fringes of aesthetic possibilities. We then either proportionally increase or reduce the differences between the extremes.

We perform this until we arrive at a situation where all of the generated objects are acceptable. At this point, we store the objects with the smallest and largest deviations. When the game is running, we can be sure that any object that is generated between the two extremes will be acceptable.

We have glibly spoken of generating in an abstract way until now. Depending on the technique chosen (line art or coordinate), the actual way in which the differences are calculated will vary. The theory, however, remains the same.

The first step is to identify the values that give shape to the object. We saw this in action in Chapter 15, where we saw that the coordinate system was geared to discrete coordinates that can be averaged together. The line-art system hinges on a set of equations that define the object.

Of the two, the coordinate system is more flexible, since the algorithm for storage and generation is generic. The line-art system relies on knowing for each object the discrete steps that are required to produce the final object. This is equally true for those objects based on geometric objects; we

need to know how many of each type build up the final object, along with their sizes and positions.

Once we know what values can be varied, we can generate new values using a random number generator. This is performed in real time, once the game is in progress, seeded on the position of the objects, using the techniques described in Part Two.

The second way in which feedback can be applied is based on the Game Universe in real time. Of course, this comes with the danger that we lose a certain amount of control over the appearance of the generated objects.

To generate objects based on the Game Universe, we choose two possible objects, and feed the results of generating one into the results of generating another. We can build up combination objects that have no close relative in the real world. Because there is no reference to which they can be compared, the resulting objects may take on an unrealistic form.

To avoid this, we should take pains to build in limits, beyond which the generation algorithm cannot be applied. In this way, we hope to avoid creating impossible examples of given combination objects. The exact limits that are to be used are left to the discretion of the designer—it is good to test all possibilities before the game is released.

This is made possible by applying the predictability qualities of pseudorandom numbers that we first saw in the previous parts of the book. Since we can establish the values between which the pseudorandom values can be generated, we can control the extent to which the combinations and extrapolations can occur.

FRACTAL
GENERATION

So far, we have examined a series of techniques for the analysis and processing of information that we can use to build a possible Game Universe. Fractals can be used as an extension to these techniques in a number of ways.

This part of the book deals with the fractal geometry that can be combined with the other techniques that we have already examined to generate the various aspects of an Infinite Universe. The techniques can be broken into two main themes: compression and regeneration, and generation from first principles.

We can apply the techniques at any of the levels of resolution that we define in this book, from looking out toward an infinite collection of objects, to examining the details of each object.

Essentially, techniques based on fractal theory are related to the techniques in Parts Two and Three in that they follow the same pattern of analysis, representation and storage, and, finally, regeneration. Moreover, because we are concerned with mapping one representation to another, fractal techniques can also be seen as an extension of those algorithms developed in Parts Two and Three.

The guiding property of fractals that makes them so useful to game developers is that they exhibit a great degree of self-similarity. In other words, as we examine the detail that makes up the fractal, we see that the smaller pieces are the same shape as the larger fractal, just diminished in size.

We can use this property of self-similarity to create micro-infinite resolution universes. We first thought of this as zooming in to the detail that is the property of a specific object. Using the example of landscape, we can

say that the metamorphosis of the examined section—from island to collection of hills and plains, to sections of rocky outcrop or grassland, right down to individual blades of grass or stones—is an example of micro-infinite resolution.

At the other extreme, we have macro-infinite resolution, which encompasses the realm of multiple objects, each with their own properties. Fractal techniques have their place here also, simply because the algorithms can be used to define the base properties for each object. We will examine the micro- and macro-resolution implications later in the book.

For now, we should recap on the underlying theory behind fractal mathematics that gives rise to these useful numerical properties.

MAPPING SYSTEMS

As we saw in Part Three, and to a certain extent in Part One, the essence of the Infinite Universe is the way in which it is represented. Representation is important because it has an impact on both the reliability and performance of the resulting algorithm. By way of example, we saw in Part One that in order to represent coin tosses reliably, we were forced to generate random numbers from 0 to 99, and then rebase them on the desired result set (heads or tails).

This, like all the other examples in this book, is a way of mapping the qualitative aspects of the Game Universe on to the quantitative representation that is mathematics. We found a purely mathematical way in which we could describe the data—or represent the universe.

We have seen adjacency tables, line art, and coordinate systems as ways of representing qualitative data (be it words, behavior, or images) in a mathematical way. In a real sense, fractals are a combination of all these techniques, since they borrow pieces from each.

Our goal, as it has been before, is to construct a system by which we can store a generic object representation in such a way that typical examples can be constructed based on a pseudorandom number generation routine. One might think that since we have already detailed some adequate ways of doing this in Part Three, we do not need to bother complicating the issue.

On the other hand, fractals occur so frequently in nature that to ignore them would close the door on a whole host of useful mathematical phenomena. Besides using them to encode objects that we have arrived at from the examination of a given population, we can use the properties they offer to construct objects from very simple inputs.

Put another way, fractal techniques can often be used to analyze and generate objects without considering every aspect of the source population.

MATHEMATICAL REPRESENTATION OF DATA

Before we begin detailing how fractal techniques can be used to represent real-world objects, we need to decide on the way in which we should represent the picture of the data. Note that the data does not necessarily need to be a picture; if other data are used, then a pictorial encoding can be used. We have the choice between a line-art or coordinate representation, or even a combination of the two.

The object adjacency technique is not appropriate in this situation due to the way in which fractals are built up. In fact, to encode the relationship between the objects in such a way as to be useful in fractal techniques, we would need to use a coordinate representation in addition to the adjacency representation in order to be able to adequately describe the relationships.

The reason for this will become clear when we discuss the actual technique in more detail; for now, all we need to consider is that fractal encoding requires that we are able to apply a series of transformations that describe the data. The object adjacency technique does not actually provide this information.

As before, we need to match the representation system to the source data set. That is, we need to choose a representation that closely resembles the pictorial description of the data.

This process must begin with the reduction of the abstract data to its associated pictorial representation. In the games programming world, there are several common sets of data, representing different aspects of the game. We have encountered some of them before, but here is a more complete list:

- Pictures: line art / coordinate / sprite
- Text and special characters

IMPLEMENTATION NOTE 17.1 DATA DESCRIPTION

It is easier to describe the data in a fashion that can be represented with a picture.

Even if the resulting picture is nothing more than a random series of points without a clear pattern, it is far easier to envisage the form of the data if we can associate it with a graphical representation.

This reduces the amount of abstraction required; most abstract concepts can be reduced to a pictorial representation.

- Sound effects
- Music
- Behavior

With the list in hand, we can now try to match encoding principles to the data types that we have identified.

PICTURES

Of these, the easiest to convert to a pictorial representation are the pictures (or graphics) that make up the visual elements of the game. Even here, though, the sequencing of such elements to provide animations can present a problem if we wish to reduce them to a pictorial representation.

There are two main types of animation to consider for encoding: static and generated. Each comes with its own caveats for implementation. Static encoding is usually associated with sprites, and requires that each possible picture is stored individually, and movement between stored images results in the required animation.

As an extension to this technique, one can reduce the amount of data that is needed to be stored by only defining the stored images in terms of the difference between the base image and the required animated images.

Generated animation is a logical progression from the preceding in which the relationship between the base image and the movement-oriented animations is stored in such a way as to be able to generate in real time the new image that is the result of an animation.

This technique is described in relation to 3D animations in the "Interpolated 3D Keyframe Animation" article by Herbert Marselas of Ensemble Studios (*Game Programming Gems*; Charles River Media, 2000). The article describes how two keyframes can be stored that represent the animation, and smooth animation can be introduced by calculating one or more in-between frames.

We can take this to its logical conclusion by defining the difference between the base image and each key frame, calculate the in-between frames to provide a smooth transition between them, and even use the differences between keyframes and the base image to calculate movements between keyframes. In this way, entire animations can be generated.

At the root of all these techniques lies the representation, in pictorial form, of the various images. The decision that needs to be made is whether this should be a line-art or coordinate system. In order to choose, we need

to think in terms of a sprite-based implementation (coordinate) or model-based (line art) implementation.

Of course, the designer is free to mix and match the various representations as best fits the required game style, but the aim is to encode the basic representation in one of the preceding ways prior to being able to follow through with the fractal techniques that form the basis for this part of the book.

TEXT AND SPECIAL CHARACTERS

We have already studied one way of describing textual data in a quasi-graphical way. The object adjacency system we first encountered in Part Two can be represented as a picture, and could look similar to Figure 17.1.

FIGURE 17.1 Pictorial representation of an object adjacency encoding.

In Figure 17.1, we have encoded a piece of text in terms of adjacent letters, ignoring all punctuation except spaces. Each cell on the 27 × 27 grid contains a character that indicates the number of times two objects have appeared adjacent to one another. These characters are as follows:

. Zero

o The smallest value

O Between the smallest value and the average value

Between the average value and the maximum value

If we wish to encode the entire ASCII character set, we would need to store an image of 255 × 255 bytes. This is sufficient for encoding words; entire sentences are more complex, and it is probably not worth attempting to provide a direct pictorial representation.

However, we can represent the building up of a sentence from predefined words using a network that is built up from analyzing a given text or texts. This network does require that individual words are recognized and stored in order that the example sentence networks can be built. Using our "quick brown fox…" example from Part Two, we can build up a network as in Figure 17.2.

```
the quick brown fox jumps over the lazy dog
 |    |    |    |    |    |    |    |    |
 pr  adj  adj   no   ve  prep  pr  adj   no
  \   |    |    /     \   |    |    |    /
    -noun--phrase-        --verb---phrase--
```

```
          Key
   pr          pronoun
   adj         adjective
   ve          verb
   prep        preposition
```

FIGURE 17.2 Sentence network.

The resulting network in Figure 17.2 shows how the sentence "S" can be built up from other parts of speech; in this case, a noun phrase and a verb phrase. Linguists might argue that the verb phrase in question also contains a noun phrase, but the level of detail that we introduced earlier suffices in this case to illustrate the point.

Thus, our sentence can be represented as follows:

$S = NP + VP$

We can then substitute using the network shown in Figure 17.2 to arrive at the following:

$S = (PR + ADJ + ADJ + NO) + (VE + PREP + PR + ADJ + NO)$

This sentence network that indicates all possible sequences of parts of speech may be best stored in a line-art representation. Getting from the abstraction back to the concrete sentence requires only that we reverse the algorithm.

Of course, if we choose to store each part of speech in its own memory "box" that can be accessed by a unique number, a graphical representation becomes very easy. A picture can be built up in which the intensity of a given point indicates the word that should be chosen. Each picture therefore represents a sentence.

SOUND EFFECTS

Sound (or noise) is easily represented by a computer-storable graphical notation by a technique known as *digitization*. To digitize a specific sound, it is sampled at regular intervals and the difference between silence (0 dB) and a given strength of the sound is stored. Typical sampling frequencies are 44 kHz (44 thousand times per second) for CD music, and 22 to 32 kHz for acceptable broadcast quality; radio, for example.

DESIGN NOTE 17.1 DIGITIZATION

Digitizing can also be applied to graphics, in which the color difference is stored between the sampled color and the most popular color on the picture to be digitized.

The sampling rate in this case will be equal to the number of pixels that need to be stored.

In Figure 17.3, we can clearly see the graphical representation of a sampled sound, such as those recorded by the Microsoft Sound Recorder application.

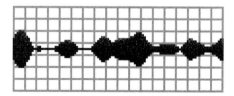

FIGURE 17.3 Typical graphical representation of a sound.

As a picture, it is easy to see that the best encoding will be a coordinate-based one, with the coordinates of the peaks and troughs stored.

MUSIC

In the same way that a sentence can be viewed as a sequence of words, music is simply a sequence of sounds played at different frequencies—the higher the frequency, the higher the resulting note. There are basically two types of music format that are commonly used in games programming.

The first is the MIDI format, in which each note is stored in an encoding that can be passed to the MIDI decoder to be played through the sound card. For each note, there is a value that represents the velocity (volume), instrument (piano, drum, guitar, etc.), note, and effects such as panning (left through right), slide (moving from left to right), and even tremolo effects (pitch change, providing a warbling sound). Of course, these can be combined.

The second format is related to the MIDI format in that it uses a representation that uses a special encoding for the various effects. The format is known as the MODule format, and differs from the MIDI format in that the designer stores a series of samples (as described earlier in the "Sound Effects section) that can be played at different frequencies to simulate the notes required.

Since both of these formats are based on a numerical abstraction, we can encode them in a picture relatively easily. In fact, we can use a technique that is very similar to the sentence encoding that we have already seen. We use a coordinate system, with an additional twist. The sentence encoding used the intensity of each point to indicate the precise word to be inserted.

Since we have more information that needs to be stored in order to represent a musical "phrase," we should use both the intensity and color to describe the exact nature of the note that needs to be played. If more information is required, we can even use several pictures, each one representing a different property of the note. Care should be taken, however, to preserve the relationship between the note and its properties when storing and retrieving the data.

BEHAVIOR

Strange though it may seem, many of the elements required to describe the behavior of an object can also be represented graphically. It is useful to do

this if we wish to manipulate, combine, or even generate different behavioral aspects for our Game Objects.

In Part Three, we saw one way of doing this, where we represented the behavioral aspects in terms of numbers that encoded the different movement possibilities. Further to this, we can use finite state transition methodologies to move from one to the other.

FSMs can be easily encoded in a coordinate system in much the same way as textual information and music. They all concentrate on sequences, or patterns.

As an aside, the reader might like to consider what would happen if we were to populate a behavioral grid at random, and launch the object on a journey through the Game Universe. Taking this one step further, we could even choose to change pieces of the grid in response to changes in the universe. This would allow us to implement rudimentary artificial intelligence. We will come back to this later.

DESIGN NOTE 17.2 FINITE STATE MACHINES

A Finite State Machine (FSM) is one whose behavior is defined by a series of states and the relationship between them.

As an example, consider a simple automaton with three states: (M)ove, (S)ense and (A)ttack.

If we consider that the automaton is Moving and it Senses something in its path, which it should then Attack, we have a series of three states M, S, and A, which are related by a simple algorithm that changes from one state to another.

SUMMARY

One might wonder why we are going to all this trouble to try to digitize (or encode) the data. The answer is that whatever we want to do with the information, it must be stored in a format that the computer can understand. Further to this, we also want to manipulate the information, and this is best done when it is encoded suitably.

Even more applicable in this case is the fact that we wish to apply mathematical transformations to the data in order to be in a position to create examples, in keeping with the theme of the book.

LIMITING THE DATA SET

While we need to ensure that we can store enough detail for the objects (whether they be graphical, textual, or behavioral) to be recognizable, there is no reason to store so much detail that the representation becomes too data-heavy.

By data-heavy, we mean that in line with our analysis in Part Two of the code-data dynamics, we would like to minimize the amount of data that we need to store in favor of using code as a replacement.

Thus, much of the work that fractals are going to be used for is to replace data with multiple-use algorithms. By multiple use (or generic), we mean that each algorithm we store should have more than one use. The input data may be used to tailor the result, but the underlying equation should be adaptable to different situations.

Algorithms should also be data-light; requiring a minimum input to achieve wide-ranging output. In fact, all of the algorithms in Parts One to Three adhere to this principle. This is especially true of the pseudorandom number generators, where often only one or two seed values yield entire sequences of undulating numbers.

In fact, the analysis of such generators has shown us that the way in which generic, data-light algorithms work is by feeding one or more output values back into the algorithm in order to help calculate the next value. We shall see that this is exactly how most fractal algorithms work also.

First, however, we must be sure that we can further encode the data set, once digitized, to remove redundant information that offers no substantial additional contribution to the encoded data set. We are not really going to remove the data, we are going to merely provide a mapping from one piece of data to another such that the second piece can be removed, and the relationship stored in its place.

This will become clearer as we progress through this chapter.

AFFINE TRANSFORMATIONS

If we have chosen a coordinate system to encode our data, we can consider the data set in terms of affine transformations. Affine transformations are:

"those which keep parallel lines parallel"
www.geog.ubc.ca/courses/klink/gis.notes/ncgia/toc.html#UNIT28,
Brian Klinkenberg, 1997

Each transformation is built up from one or more primitives that describe the relationship between two points. These points can either be two different points on the same graph (for encoding a picture, for example), or the same point on two different graphs (for encoding animations, for example).

Four primitives can be combined to make the transformation: translation, scaling, rotation, and reflection. Any transformation from a point x,y to a point a,b can be described using a combination of these four primitives. The order by which the primitives are used should be respected, since combinations of transformations cannot usually be reordered to achieve the same effect.

Before we consider how these primitives can be used to create data set encodings, we should look at what each one represents.

TRANSLATION

The mapping from x,y to a,b is effected by the addition or subtraction of j or k units. The following equations show this relationship.

A $X = a + j$ B $a = x - j$
C $Y = b + k$ D $b = y - k$ Translations (17.1a through 17.1d)

Equations 17.1a and 17.1b form a translation and a reversal about the x-axis, while Equations 17.1c and 17.1d form a similar pair for coordinates about the y-axis.

SCALING

The mapping from x,y to a,b is effected by a multiplication or division by c or d units. The following equations show this relationship.

A $x = a * c$ B $a = x / c$
C $y = b * d$ D $b = y / d$ Scaling (17.2a through 17.2d)

Again, Equations 17.2a and b, and Equations 17.2c and d form two pairs. One point to note is that if c and d are different, then the shape of the resulting object will change. Also, rather than using a division to effect the reverse transformation, a multiplication by 1/c or 1/d can also be used.

ROTATION

The mapping from x,y to a,b is effected by the application of equations derived from trigonometric theory. Without going into details, the following equations are used:

A $x = (a - (y * \sin(t))) / \cos(t)$ B $a = (x * \cos(t)) + (y * \sin(t))$
C $y = (b + (x \sin(t))) / \cos(t)$ D $b = (-x * \sin(t)) + (y * \cos(t))$

Rotation (17.3a through 17.3d)

In Equations 17.3a through d, t is the number of degrees (measured counterclockwise) through which the point x,y should be rotated so that it falls on a,b.

REFLECTION

The last of the affine transformation primitives, a reflection maps the point x,y to a,b by subtraction relative to a midpoint, u,v. The equations are as follows:

A $x = a + u$ B $a = b - u$
C $y = b + v$ D $b = v - y$ Reflection (17.4a through 17.4d)

These affine transformations can be used to describe virtually any coordinate-based representation of the data set that needs to be stored. Besides offering a certain degree of compression (since we only need to store a limited set of data), the fact that the data has been defined in terms of geometry makes it easier to manipulate when using the equations to generate examples of the object.

What we have not touched upon yet is how we go from object to representation and back to object again. The next two sections use the affine transformations shown previously to achieve this. Before we go into detail, however, it is useful to see the results that can be obtained. Without trying to understand the math too much, the reader is invited to grasp just the flavor of this example.

The equations that generated the example shown in Figure 17.4 look like this:

$w(x) = r * \cos(a) - s * \sin(b) + h$
$w(y) = r * \sin(a) + s * \cos(b) + k$

FIGURE 17.4 A fern generated with affine transformations.

These equations are derived from a translation by (h,k), a rotation using angles a and b, followed by a scaling by r and s. The actual values that need to be inserted in place of the variables h,k,a,b,r,s are broken down into the following four sets:

	Translation	Rotation	Scaling
	h,k	a,b	r,s
w1	0,0	0,0	0,0.16
w2	0,1.6	−2.5, 2.5	−0.85,0.85
w3	0,1.6	49,49	0.3,0.3
w4	0,0.44	120,−50	0.3,0.37

To generate the picture, one chooses a point x,y and calculates the point to be plotted using the values from w1. The result is then fed into w2, a point is plotted, and the result is plugged into w3. Finally, the next point is calculated, and the result is fed into w4, which is used to calculate the final point.

The result from w4 is then fed back into w1, and the process is repeated. In this way, the picture in Figure 17.4 is generated.

COLLAGE SYSTEMS

Figure 17.4 was created using the Collage Theorem. It is a simple-enough theory, but one that relies on the human eye to a certain extent. Software can be written to perform the operations that are required, but as we shall see, it is far from a trivial exercise.

The first step is to encode the shape using the coordinate system so that the desired level of detail is achieved. Once this has been done, we take a scaled-down copy of the image and position it so that it covers a portion of the source image. Any of the affine transformations discussed earlier can be used to manipulate the image so that it covers, as precisely as possible, a portion (the smaller, the better) of the original image.

This gives us w1, the first set of transformations that are used in the collage. To get w2 – w4, we transform consecutive copies of the original image using a set of affine transformations until the entire original image is covered with smaller copies of itself.

It is a good idea to minimize as far as possible the extent to which the smaller copies overlap each other, as overlaps result in a loss of detail. We have stated that for the fern in Figure 17.4, there are only four transformations required. Depending on the image, however, it may be necessary to use more or less to arrive at the final representation.

This is the theory behind making a Collage system work, and is obviously best done by the human eye, although a computer program could perform a large number of trial-and-error operations to try and fit smaller copies into the larger original.

Once the set of affine transformations has been defined, they can be stored for later use. When we need to generate an example of the shape that they define, we extract them and pass them through an *iterated function*.

ITERATED FUNCTION SYSTEMS

An Iterated Function System (IFS) is one that takes an input to generate an output, which is then passed back as the input to the next iteration. This is not a new concept to us, since we used a similar theory to generate a set of pseudorandom numbers.

However, we are going to use the theory in a slightly different way this time, as we have a number of equations that we can apply. We have two choices: we can either pass the output of each stage to the next, or we can take one point and apply four transformations to it to give the next set of points to be plotted.

A common approach to the problem of having multiple equations from which to choose is to use a probability model to decide which of the equations to use. For example, if we take the set of affine transformations shown previously, we see that we have w1, w2, w3, and w4. In order to decide which of the transformations to apply, we assign probabilities to each of the equations.

For the fern, probabilities for w1 through w4 are usually recommended to be .01, .85, .07, and .07. The reader will note that these add up to 1. We then choose a random number between 0 and 99, and divide by 100.

If the result falls between 0 and 1, we use transformation values for our general equation taken from w1. If the result falls between 1 and 86, we take the w2 values, between 86 and 93, w, and finally for 93 to 99, w4. In this way, we build up the shape.

The problem with IFS-based shapes is that usually a very large number of points need to be calculated before the image forms. The fern in Figure 17.4 uses about 100,000 individual points, or calculations. Clearly, this is not practical for real-time programming. However, the stored images can be put to good use as a basis for other data set applications.

L-SYSTEMS

An equivalent to the coordinate system in the fractal world is the L-System. Created by A. Lindenmayer in 1968, it is very similar to the line-art theory that we first saw in Part Two. We likened the line-art theory that Logo is a more correct computer language, and L-Systems also share some of the properties of Logo as well.

Also known as a string rewriting system, L-Systems begin with a simple set of characters, each of which identifies an operation that moves the Logo pen. Chris Byrd mentions the following set of symbols that can be used to draw many different shapes.

Symbol	Action
F	Draw forward one unit
f	Move forward one unit
+	Turn left
-	Turn right
\|	Turn 180 degrees
[Save state on stack
]	Pop state from stack

Each L-System that can be used to generate an image consists of one or more starting symbols and a set of rules, along with any additional information such as the number of degrees to turn through for left and right turns.

By way of example, let us consider a simple square. It can be defined in terms of the symbols just shown as a series of forward moves and angle turns; one set for each side of the square. The rules for this could be encoded as the following string:

F = F - - F - - F - - F

Our starting symbol is therefore F, and the angle is 45 degrees. After one iteration, we have drawn a square. The power of the L-System, however, lies in using the axioms and rules together to produce a string of symbols that can be converted to actions using the table just shown.

Byrd suggests that to build a plantlike picture like the following bush, the following rules can be used:

Starting string = +++++F
F = FF-[-F+F+F]+[+F-F-F]
Angle = 16

The key to the L-System approach is that the next action in the sequence is arrived at by substitution. That is, using the Starting String, each occurrence of the letter F is replaced by the string with which F is associated. It so happens that the F is also associated with a forward movement. Taking the preceding example, the action string can be built up as follows:

Step 1 – 5 +++++

Step 6 +++++FF-[-F+F+F]+[+F-F-F]

Step 7 +++++FF-[-F+F+F]+[+F-F-F] FF-[-F+F+F]+[+F-F-F]

Step 8 – 10 +++++FF-[-F+F+F]+[+F-F-F] FF-[-F+F+F]+[+F-F-F]-[-

Step 11 +++++ FF-[-F+F+F]+[+F-F-F] FF-[-F+F+F]+[+F-F-F]-
[- FF-[-F+F+F]+[+F-F-F]

The building up of the string from which the image is created, using this axiom-rule approach, is the reason why L-Systems fall into the category of rules known as *rewriting systems*. Of course, the basic theory can be extended to use multiple replacements, as long as the dual use nature of the symbols is respected.

In other words, this means that each rule must be represented by a symbol that also has meaning with respect to the actions that are required to build up the data image (be it a picture or a data representation). The limit to the number of rules is the number of symbols that make up the actions. It is not wise, however, to over-complicate the L-System beyond the traditional axiom-rule, as in the previous example.

DERIVING GENERIC FORMULAE

The three systems just discussed are all ways in which a data image can be processed and generic formulae for their description derived. The acts of creating these generic representation are important for the creation of Infinite Universes because they allow us to reduce a complex image to its component parts, each of which having its own set of variables.

These pieces can be combined, recombined, and the variables altered so that different instances of the data image can be built up. By altering a few key aspects of the data image generation formulae, many different variations on each individual data set can be generated in real time.

In order to harness the full power of fractal techniques that rely on affine transformations, it is important that the formulae derived for each type of transformation that provides a worthwhile mapping be retained in a database of transformation information. This database will be specific to the application; if it is a game in which many images of faces or bodies are to be stored, then the affine transformation database will be different from a game that centers on spacecraft.

There may be some question at this point as to what we mean when we say that we derive formulae. In fact, much of the work will be done by hand, as we have seen. However, with the application of the Collage system, we can build up formulae that represent the transformations required to map the object.

BREAKING DOWN THE DATA IMAGE

Standard L-System or IFS Collage-based techniques work well for quite complex images, as long as they contain a high degree of self-similarity. Ferns and bushes, trees, leaves, snowflakes, and even mountains are all examples of self-similar shapes that occur naturally.

Other data sets, such as musical representations and even the waves that make up the sound of individual notes and instruments, are also highly self-similar. Indeed, if one were to break down a piece of classical music into component parts, one would find that most are, if not perfect fractals, then fractal in style.

Of course, in order to be truly useful, we would like to be able to represent other images that might not be so self-similar. A building, for example, has many different facets, including doors, windows, and walls, and in the case of fantasy buildings, lava pits and other interesting features.

These additional features make the final object nonself-similar, but they may be self-similar in themselves. Even if they are not, they can probably be represented by one of the techniques that we have seen in this chapter.

The key to representing data sets that are a mixture of self-similar and nonself-similar pieces is to break down the data image into components that have a relationship that can be defined using an alternative algorithm. Taking a piece of background music, for example, it is possible that it can be represented by a series of points on a graph, or even a picture.

However, it is equally possible that this representation cannot easily be described using the various techniques that we saw earlier. In addition, we may wish to have enough control over the music that it follows key pieces of the plot. In other words, we might like to be able to move between variations in the music that follow the game play.

To do this, we would need first to break down the music into several parts. For example, we might have a medium-paced piece for exploration, and a fast-paced variation for fighting. These individual parts will contain

several different instruments, each of which will be performing notes that depend on the other.

Assuming that we can break down the pieces of music into phrases, each containing a certain number of notes, it is possible that we will be able to find a generic representation for each piece. Once we have found the magic formula that describes the music, we can store the representation for use in real time.

In this way, we have broken down a complex piece of information into smaller chunks, each of which can probably be defined using an algorithm. The way that these pieces can be connected is also likely to be able to be represented using an algorithm.

As an extension to this, one might like to consider a slightly different approach. Rather than trying to match an algorithm to the music, we could generate algorithms more or less at random, and pick one that sounds pleasing as the music. Perhaps a slightly long-winded approach, this technique will enable us to be sure that we can regenerate the music at will.

STANDARD MATHEMATICAL REPRESENTATIONS

One of the key principles that we have been involved with so far, the IFS affine transformation, relies on analyzing the data set and attempting to match transformations to the data. This is also a key principle behind using fractal techniques for compression.

However, there is a certain amount of fairly laborious trial and error involved in the practical application of this technique. Even more, the Collage theory, which is designed to help in finding appropriate transformation combinations, is only useful in certain circumstances.

For example, if we wish to analyze a fairly regular shape, such as a fern, or grass, in which the overall shape is easily matched to the parts that make up the leaves, the Collage theory comes into its own. What happens, though, if we wish to build up a set of transformations that match a complex shape, in which the larger shape cannot be matched to areas (or subshapes) of itself?

Such nonself-similar shapes, which we shall call *complex* shapes, cannot be easily processed using the Collage theory, so we have no easy way to determine the various transformations that make up the overall shape. Consider the average face from previous parts of this book, for example, or a piece of coastline. They are complex shapes that are entirely nonself-similar.

In *The Tinkertoy Computer*, Dewdney insists that a set of affine transformations can be found that can be used to recreate a photograph of the Monterey coastline fairly reliably (p.111). Even more, Alan D. Sloan, a mathematician from the Georgia Institute of Technology, has achieved video rate reconstruction of images as large as 512 × 512 pixels. Each separate frame takes three seconds to be analyzed and an IFS code for it found.

The technique that has been pioneered by the company that Sloan and Barnsley have formed, Iterated Systems, is a combination of the Collage theory and IFS. It relies on being able to analyze an image and break it up into areas of constant color.

The pieces of the resulting collage are then mapped to each other as closely as possible, using a library of standard affine transformations. Such standard transformations can be built up using trial and error, and once a library of them is available, rates of recreations can be achieved in excess of 30 frames per second.

Of course, all of the aforementioned can be based on some standard mathematical representations such as geometric objects, which are good starting points.

COMBINING STANDARD ELEMENTS

If we do not require a high level of resolution, it will be possible to generate objects that are recognizable using a set of transformations that are entirely derived from the standard two-dimensional geometric objects we call shapes.

Each shape can be represented by an affine transformation, or a series of L-System commands, or any other representation that has been chosen. The only aspect that needs to change each time is the value of the variables involved: the size of angle to turn through, the amount of scaling required, and so forth.

This does not mean, however, that the various elements be used in isolation; in fact, they can be combined. If we choose to combine, say, squares and triangles, shapes that are much more complex are possible than if we just used squares.

We can even take this further and combine encoding techniques, so that an L-System that represents a geometric object can be repeated starting from points that are defined by an affine transformation. Taking this further, we can even use a Collage technique, applied using not a reduction of

the actual image that we wish to encode, but a standard geometric object, such as a triangle.

By determining how the object can be covered by triangles, we will be able to build up an image that is fairly close to the original. The actual algorithm will not be covered here, but the general principle takes a shape and encompasses it entirely within a triangle, and that all affine transformations are derived from this large geometric object.

Thus, a Collage can be built up in reverse from the norm, using successive transformations to cover the image as nearly as possible. The original triangle (or closest-matching shape used) is, of course, discarded.

FRACTALS, PROBABILITY, AND EXTRAPOLATION: TYING IT ALL TOGETHER

Now that we know how we can represent data images using fractal-based algorithms, it is time to look at the input side of the equation. Until now, we have used data sets directly; either creating the data set manually, or taking existing pictures and attempting to map algorithms to them.

However, in Parts Two and Three of this book, we saw a different approach, using the analysis of multiple data sets to create generic data sets. This can also be applied in L-System and IFS Collage algorithms, especially for very abstract concepts such as music and behavior systems.

BASIC APPLICATIONS

The first way in which this theory can be applied is by using the probability techniques that we have seen previously to build the data image in a particular way. This could be an object adjacency, coordinate, or line-art model of the data that we would like to sample.

Once we have built up the model, we can then choose an appropriate representation using one of the fractal systems described here: an L-System or IFS Collage. As we begin to add to the model, to refine the data set so that an accurate representation is arrived at, we have new information that needs to be incorporated.

However, unlike previous examples in Parts Two and Three, we alter the fractal system based on the additional information, storing the differences

between the representations. The actual representation that we are going to use is different from the data collection set representations, making this technique an extension of those previously examined.

COORDINATE—COLLAGE MODEL

Since the coordinate representation scheme is based on the Cartesian system (which can be adequately manipulated using the affine transformation primitives seen earlier), it makes sense to use the Collage model to manipulate data sets based on the mapping between coordinates in the set and differences between sets.

In order to use the Collage model to encode, store, and generate data sets based on a coordinate representation, we have three operations that need to be carried out for each sample. Of course, if we only need to encode one set, we only need to use some of the steps.

Step 1 is to encode the data using the Cartesian grid. Usually associated with pictures (for example, the faces that we encoded in Part Two), any data can usually be represented in this fashion. However, it is recommended that this representation be used for data that has a natural graphical counterpart. Examples of good data sets for this system include pictures and sound waves; more abstract data sets (such as behavior) will be more difficult to describe using coordinates alone.

Step 2 requires that a series of affine transformations are found that can either map from the natural center of the image that represents the data set that we have encoded, or that maps each point to the next, if a graph style representation has been chosen.

REPRESENTATION NOTE 17.1 VISUAL EQUIVALENTS

When mapping a data set that may or may not have a visual equivalent using a coordinate system, it is important to choose axes that make the encoding easier.

For example, if the figure to be encoded has a natural center, it will make more sense to map the data set onto the axes in such a way that this natural center falls at 0,0 on the grid.

On the other hand, if we are mapping a sound wave, we would probably choose to map the wave with the lowest point at x,0 on the grid (where x is the sample point on the wave).

The final step (Step 3) is only required if multiple data sets are being encoded. It involves modifying the affine transformations such that one data set maps to the other.

Rather than map data points within the same data set, we need to be able to find a mapping from data points inside two different data sets. We could call this *mapping the difference* between the data sets. As in Step 2, we can either represent the data point transformations with respect to the natural center, or from point to point.

Once transformations have been found between the base data set and each required permutation, we only need to store the base image and the transformations in order to be able to generate the whole range of objects. In addition, we can alter the transformations if need be to produce endless permutations and variations on the base image.

Line-Art—L-System Model

Data sets that can be represented by Logo style commands that are self-similar in nature (some sound waves, for example) can be easily represented by an L-System-style encoding. The theory is similar to that used in the Collage system.

The first step is to find a wave that closely follows the original in peaks and troughs. This will give a general wave with a discrete number of peaks and troughs. The actual number of peaks and troughs that the wave encompasses depends entirely on the wave to be encoded.

In fact, the performance of this system relies on the variation that the wave exhibits. The larger the variation (number of maxima and minima; or peaks and troughs), the less "compressed" the L-System representation will be.

Subsequently, the initial wave is scaled down by a certain amount and superimposed on the original wave. The trick is to find a place in which it seems to "fit." To put it mathematically bluntly, we are looking for a series of waves that, when compared to the original wave, have a similar number of points above and below the average, and which maxima and minima vary according to the same amount.

What this means in terms of the sound is that we are looking for the closest possible match using multiple copies of an average representation of the original. As was noted earlier, this works best with self-similar waves, and less well with nonself-similar waves.

It is worth, at this point, giving an insight into what waves may be self-similar, and those waves that will never be self-similar enough to apply this theory.

Sound waves that represent a pure tone (such as those generated by wind instruments) will be very self-similar. Those waves that vary more in their undulations such as pianos and guitars (and the human voice) will be less self-similar and therefore less easily encoded using this technique, because the first wave will follow the original too closely to be an abstraction.

OBJECT ADJACENCY FRACTAL MODELING TECHNIQUE

This last is perhaps the most difficult of the techniques that we have encountered. This is not by virtue of the encoding technique, which the reader will recall was one of the easiest to grasp. Rather, it is by virtue of the way that the basic encoding can be enhanced using fractal techniques.

We recall that the basic encoding uses a two-dimensional grid, in which each cell contains a number that represents the strength of a relationship between a value represented on the x-axis and a value represented on the y-axis. In terms of letters, this amounts to the number of times that one letter follows another.

The resulting grid can be represented as an image. This image can be treated with any of the encoding techniques debated here. It can be treated using a series of affine transformations, mapping one series of points to another. The relationship between points could also be encoded using an L-System.

Following on from this, we could even choose to depict the grid as a series of geometric objects that are then mapped using L-Systems or another technique. There is, however, no real technique that maps directly to the grid itself.

CONCLUSION

In this Chapter we have discussed how a data set (whatever it may encode) can be mapped to a largely numerical representation. Once we have a numerical representation with which we have sets of numbers that can be manipulated, we are in a position to perform various mathematical operations on them.

Indeed, part of the representations that we have been defining here are in themselves an algorithmic representation of the numerical encoding (digitization) of a data set.

Following on from this, the next chapter will take these representations and place them in the context of games programming, such that the best use can be made of the data sets and their fractal qualities.

FRACTAL GEOMETRY
AND ITS ROLE
IN NATURE

A s we saw earlier, many of the images formed by IFS and L-Systems are vaguely plantlike in structure. This is largely due to the extreme self-similarity that is present in natural systems (like ferns, for example). As we noted, it is this self-similarity that is at the center of fractal systems.

Beyond this, we can also see fractal qualities in nature when we attempt to measure natural formations such as coastlines or mountains. Lewis Fry Richardson noted that the length of a coastline depends on the scale used to measure it. The smaller the scale used, the longer the coastline. This is because the smaller the scale that is used to measure it, the more detail that can be measured.

THE "NATURE" OF NUMBERS

The key difference between nature and mathematics in terms of numbers that can be used to represent features of both environments is that mathematically smooth lines simply do not occur in nature. Lauwerier (*Fractals* p. 31) notes that for a perfect circle, taking successively smaller scaled measurements has no effect on the true circumference of the figure, when plotted on a logarithmic graph, as in Figure 18.1.

We have plotted the measuring unit horizontally, and the measured length vertically, both using a logarithmic scale. The east coast of Britain is depicted, and the results show a line that is roughly straight. Richardson

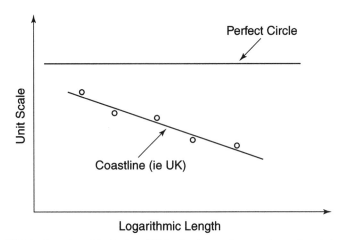

FIGURE 18.1 Logarithmic plot of Richardson's experiment and a perfect circle.

actually performed the experiment with several coasts and land frontiers and found that a roughly straight line results each time.

From the graph, we can derive Equation 18.1:

$$s = s_1 a^{-0.22} \quad \text{Derived coastline equation (UK east coast)} \quad (18.1)$$

where s is the length of the coastline, using a measurement unit of a. The line plotted for the circle has a slope that approximates zero, whereas Equation 18.1 shows a slope of 0.22. Interestingly, analysis of the South African coast shows that it exhibits a slope close to zero. This suggests that the coastline does not increase in complexity when the measurement scale decreases.

Either way, there is a clear relationship between the length of coast and resolution of the device used to measure it. The observation that the relationship is governed by an equation leading to a straight line in the case of almost every coastline suggests that we can draw mathematical conclusions from nature.

PATTERNS IN NATURE

Of course, much of mathematics is governed by observing numerical data that resolves itself into patterns. Each equation that yields a result or set of

results that has a use or theoretical application can be linked to a pattern, or patterns.

In nature, patterns abound; not just in terms of chance, but also by design. To explain: The use or evolution of a given piece of nature will yield a pattern. It could be a pattern of form or behavior, the way it looks, or the way in which it reacts to its surroundings.

Without descending too far into the realms of philosophy, we can see evidence of pattern in the simplest of botanical creations. In fact, the greatest evidences of pattern in form are in botanical and geographical formations—plants and rocks.

A fern, for example, is widely accepted to be constructed by a simple pattern. In fact, Dewdney gives a simple description of how iterated function system affine transformations can be used to construct the leaf of a black spleenwort fern. The key is in the fact that each leaf of a fern is broken up into smaller pieces, each of which has the same form as the leaf itself.

Even more interesting is that each of these pieces also has the same form as the original leaf—at least to an acceptable level of error. Dewdney describes this phenomenon in terms of a game that he terms "fractal tennis" (*The Tinkertoy Computer*; p.144).

In essence, fractal tennis is a way of explaining an iterated function system that consists of a set of affine transformations. Imagine a square tennis court, divided into four quadrants labeled A, B, C, and D. Each of these labeled quadrants contains a superb tennis player, whose accuracy and reaction times are perfect.

To begin the game, the umpire calls out a letter. The player who is in possession of the ball will serve it into the quadrant that corresponds to the letter called out by the umpire, in such a way that the ball is played to a point that has a specified relationship to the point at which it started.

All that this means is that if we imagine each of the quadrants to be further subdivided into subquadrants—labeled Aa, Ab, Ac, Ad, for example— and the ball begins in subquadrant Ad and is to be played to a point in quadrant B, then, depending on a predefined relationship, it should land in subquadrant Ba through Bd.

Each time the ball has been played, the umpire calls out another letter, and the player in possession plays the ball accordingly. Each time the ball is played, its position is noted. Gradually, the positions in which the ball has been played will converge to form a shape whose properties will depend on the equations used to determine where the ball should end up each time.

The relationship between the various ball positions can be represented by affine transformations. Each transformation will map one position to another. Thus, an image is comprised of affine transformations that each contribute to the overall shape.

We have seen that the number of actual transformations required to build up the fern shape is actually very small. In fact, just four were used in Chapter 17, "Mapping Systems," one of which was chosen at random to perform the current transformation.

This choice is the equivalent of the umpire in fractal tennis calling out a name. Thus, we can see how nature, or at least part of it, can be depicted by fractal mathematics. We will see many more examples of the way in which nature contains patterns that have relatively simple mathematical representations that, when combined, produce complex shapes.

FROM ANALYSIS TO FORMULAE

Once we have found a way to analyze the data set so that it falls in line with the natural representations that form the relationships between the elements of the data set, we must match mathematical formulae to this analysis.

We have seen already how a database, or library, of affine transformations and geometric shapes can be mapped to a shape. However, these are simply databases of values that can replace variables. Those fractals developed by Mandelbrot, Julia, et al, made famous by Mandelbrot's *Fractal Geometry of Nature*, rely on the formula itself, and not simply aspects of a static formula, such as an affine transformation.

Although in one sense, a fractal can be seen as being made up of a number of affine transformations, many fractals are built up using a single formula. This formula is used to calculate a series of values, each of which is fed back into the formula to arrive at the next value.

This is continued for a predetermined number of repetitions, or until the value tends to infinity. If the number of repetitions is reached before the value tends to infinity, the pixel relating to the value is colored white (on a black background).

Variations include coloring the pixel depending on how close to infinity the value calculated after the preset number of iterations is. This is, briefly, how a real-world representation of a fractal is built up. It is not actually the fractal, just a possible representation.

Of course, each calculation is not as simple as it seems. Most fractals exist in a rather strange mathematical place represented by a real and an imaginary part. Imaginary numbers are beyond the scope of this book; however, it is useful to know that each calculation involves a value that is in a real sense two values, such as 3 + 4i.

The mathematical operations that can be performed with such imaginary numbers are fairly simple, as described by both Mandelbrot and Lauwerier. The end results, however, are strange, often seemingly random, but usually generating an image that shows a pattern.

One aspect, however, remains undefined. We have seen how a fractal is formed, at least in general terms, but we have yet to see how an image that already exists can be mapped to a set of complex numbers that are governed by a formula.

In the end, it is not so much a question of finding actual formulae that map to specific images, but rather using well-researched formulae and formulae classes to produce sequences of values that are useful for the application in hand.

USING FRACTALS IN GAMES PROGRAMMING

One may wonder just why we have gone to such lengths to describe the relationship between fractals and natural formations. The key is in realizing the lengths to which the patterns that are present in nature can be mathematically represented by "magic" fractal-based formulae.

We say "magic" because it is not immediately obvious that the image of a fern can be replaced by a comparatively simple mathematical formula. Compared to the level of complexity that is present in a fern plant, the formula that can be found that expresses the computation of lines or points that make up the final fern shape is almost deceptively uncomplicated.

The reason behind this is the level to which the same shape can be repeated over and over again in diminishing scale and in a variety of orientations. Of course, the resulting shape will be a "perfect" fern. If we take a real fern and compare the two, we will find subtle differences. We lose a certain amount of detail in exchange for ease of representation, storage, and generation.

Using fractal-based mathematics in games programming could be the subject for an entire book by itself if we wanted to cover each way in which

it is possible to find a use for them. Here, though, we will only consider fractal technology as far as its use within the Infinite Universe concept.

In the previous chapter, we dealt with ways in which information of many kinds can be represented using fractal techniques, based on data sets. This is an abstract mapping of data to formulae. It makes little attempt to mimic the patterns found in nature. Instead, the mapping simply finds a way to bend the mathematical representations to the data set.

In fact, there are two ways in which we can use fractal representations in Infinite Universe Games Programming. The first is by using the mapping of data sets using fractal techniques. The second is by using preset formulae to generate a series of values in an "infinite" way.

RESAMPLING AND EXPANSION

Every technique that we have discussed so far embodies two principles. *Resampling* involves examining the data in such a way that we can easily represent it either algorithmically or in terms of a reduced data set. The data may or may not have been sampled to produce a digital picture of an analog data source; otherwise known as digitization.

Once the initial resampling has been applied, we are usually left with a reduced set of computationally malleable information. Such information can be further analyzed or treated in order to compress it, store it, or process it for further use.

When we arrive at a point at which we need to use it, we must perform some data *expansion* on the set of digitized information that has resulted from the digitization and resampling phases. This phase turns the data into a usable form. "Usable" in this case means that we have to turn the data into an expanded form for display or processing.

It is usual to perform the resampling phase before the target game is released; it is the resampled data that will be shipped with the final product. The time that the resampling takes, therefore, is not important in terms of the real-time game. Any combination of algorithms can be used to create the reduced data set, bearing in mind that the corresponding expansion will take place in real time.

When we consider that the expansion will be taking place in real time, we should examine how the performance of the final game will be affected by the act of expansion. Prior to deciding the exact resampling algorithm,

and therefore level to which the data is compressed or otherwise treated, an examination should be carried out as we saw in Part Two.

USE OF FRACTALS IN GAME AI

We have already seen how any data set can be represented and manipulated using fractal techniques; this can be extended to include behavioral models also. Representing behavior can take many forms.

Many behavioral models are also self-similar—the ghosts in *Pac-Man*, for example. Not only can the behavior of one ghost be applied to the others, requiring only that we store the basic movement algorithm, but also the intricacies can be ignored, since they are only a transformation of the basic behavior of a ghost object.

This alone does not constitute true game artificial intelligence, since the behavior is fairly static. Without embarking on a lengthy discussion of AI, one facet can be said to be the ability of the object in question to adapt its basic behavioral model depending on circumstances and previous experience.

If we examine the processes at work behind human reasoning, we see that this is indeed the case. To use a simple example to illustrate the way in which humans make links between past experience and current circumstances, we often say that if you put your foot in a fire and get burned, it is unlikely that you will choose to try the same experiment with your hand.

This also illustrates the self-similar nature of this aspect of intelligence. Although your hand is different from your foot, each can cause pain if placed in a fire.

OBJECT CLASS SIMILARITY

Another aspect of games programming lies in the analysis of the game objects that are to be represented one way or another within the game itself. We will see how each object and the techniques that are to be used to generate each object are arrived at in Part Five of this book, when we examine a real example.

However, the basic approach is to try to group classes of objects together that can have either a similar appearance or behavior. As we saw earlier, a

foot and a hand have very similar reactions to being placed in fire—they cause pain.

The similarity does not end there, however. Hands and feet are also similar in appearance, each with five protrusions—fingers in the case of hands, and toes in the case of feet. The toes and feet are also similar, in that they have joints and nails. The number of joints, however, is different between fingers and toes.

Therefore, while the objects are similar, they are not identical. They can all (hands, feet, toes, fingers) be represented by formulae that could be identical, but which variable parts can be filled with data varying enough to produce variations that enable one to distinguish between feet, hands, toes, and fingers.

CONCLUSION

This chapter puts fractal techniques into the context of games programming, and the Infinite Universe techniques that are at the core of this book. However, it is not intrinsically clear how the patterns and qualities can best be used to the advantage of a games programmer seeking to create a truly Infinite Game Universe against which the action can be set.

Chapter 19 will go some way to detailing exactly how the fractal techniques *could* be used to describe complex, variable, and constantly changing objects. It describes a number of theories; the implementation is largely left to the programmer. However, an expansion of one of the techniques is given in Chapter 20.

FRACTALS AND COMPLEX STRUCTURES

In the previous chapters, we concentrated on mapping simple structures mathematically. When we say "simple" in the context of data sets and Objects, we are not talking in terms of the data that makes up the Object. Considering the complexity of information that makes up a photograph or even a fern, we are clearly talking in other terms.

In fact, a complex structure in this context is one that is made up from many different sets of complex and noncomplex data. Thus, the concept of complexity as used here relates to the way in which the object is structured, not the actual data that makes up the detail.

Many prospective Game Objects can be better expressed in terms of complex structures, rather than, say, a photograph or graphical representation of the object. This is especially true of 3D objects, where the storage of information in terms of a complex structure is worth more than slicing up an example and storing a series of pictures.

A classic example of a complex structure in the games programming environment is a building. Buildings can contain windows, doors, passageways, even furniture, each of which can be represented by data sets or fractal transformations that give them shape and form. In isolation, these data sets do not make a building, but their combination in certain ways can be used to make multiple instances of possible buildings.

Additionally, this technique can be extended to cover complex structures made up of multiple data sets, each of which represents different aspects of the object. These aspects can be visual, or qualitative abstractions such as behavior, or variable aspects of the object's properties.

AFFINE ANALYSIS

We have already encountered affine analysis of data sets when we considered ways in which the data could be mapped to an abstract mathematical representation. However, now we need to go one step further and see how affine analysis relates to the complex structures described earlier in this chapter.

In a real sense, we are simply tying together all of our thoughts regarding fractal techniques, since we already have much of the theory that we require to make the step from pure affine analysis to complex structures.

The parts of the theory that we do have relate to combining various techniques with a view to achieving more with the combination than would be possible with one of the techniques on their own. We might, for example, choose to combine an affine transformation collage system with an L-System designed around geometric polygons.

The result is a collage system that uses polygons to build up the required image. Even the polygons might be allowed to have a bearing on the affine transformations used to build up the resulting picture, data set, or other representation.

However, if we consider this image (data set) to be but a part of a larger object, whereby the relationship between that object and the smaller one is defined by an affine transformation, we are beginning to approach a hybrid system in which complex objects can be built up.

What is interesting to note is that while the techniques that we are planning to use are fractal based, the result lacks the one trait of fractals that we have dwelt upon in this part of the book; that is, the resulting complex object is not by any means self-similar in nature.

The various parts of the object are not in any way related to the parent object, except by the affine transformation that relates them to their other sibling parts. However, it is not necessarily a rule that the object be nonself-similar, merely that it is not generally the case that the child objects be represented by a formula similar to that of the parent.

All of the preceding discussion leads to the observation that if we are going to build up complex structures in real time, using a starting seed and employing fractal techniques to expand a data set, we had better be prepared to perform some complex and time-consuming mathematical contortions.

MULTIPLE OBJECTS (INHERITANCE)

In keeping with the self-similar nature of fractals (a concept that we have referred to many times), we can also say that there is little point in storing multiple copies of the same piece of information. For example, a chair and a table are actually very similar in construction. They both have legs, for instance, and it would be wasteful not to take advantage of the fact that the chair legs and table legs are not substantially different in construction.

We saw in Chapter 18, "Fractal Geometry and Its Role in Nature," that, for example, object classes can be similar and thus represented in a similar way. Inheritance is an extension of this observation—we are reducing the data needed to be stored even further, since we are not only sharing between similar objects, but also between subobjects.

So far, this is a restatement of the observation that we made in Chapter 18. If, however, we add the fact that a hand can be seen as a slightly different foot, and that a chair is a special kind of table, we have a type of inheritance that means that representing these objects becomes more compact.

FRACTALS VERSUS PROBABILITY EXTRAPOLATION

When we previously dealt with techniques to process and represent data, we did so using a model based on the probability of different objects or objects with different properties appearing with a certain relationship to each other.

Fractals allow us to examine this data in such a way as to use the natural patterns that are present in the data in order to reduce the data set to a set of algorithms. In fact, we can see this as an extension of our analysis in Part Three of the efficiency of various ways in which the data sets could be encoded.

In other words, by choosing to represent data in terms of algorithms, we move from a data-heavy representation to a code-heavy one, thus improving the code-data ratio, and thereby increasing the efficiency of the representation.

This does not mean that we should dismiss the other techniques; fractal techniques are only applied afterward, once the resampling phase is complete. The techniques that encode the data in such a way that it can be processed effectively by computer software stand up by themselves, and fractal techniques are an extension of these others.

THEORETICAL SIMILARITIES

When we build up a probability-based model, we look at a number of examples of the object that we are analyzing with a view to determining what

properties the average object might exhibit. If we take two poles, for example, one of height 2 units, and one of height 1, we might surmise that the average pole would be around 1.5 units in height.

Following from this, we might decide that a line-art representation could be proposed for the set of poles, whereby a population of poles might be constructed using the fact that from a position x,y, a line is drawn that is at least 1 unit in length and no longer than 2 units, with an angle to x of 90 degrees (straight up).

Thus, we build up a population of poles of varying heights, all of which stand straight up. If we then notice that a pole exists that stands (or leans) at an angle of 80 degrees, we might decide that our poles could lean from between 80 degrees to 90. This new information is fed into the line-art representation and leads to an average pole that leans to one side by 85 degrees.

The information has been represented in such a way that an infinite number of varying poles can be built up, from a base of information that is really not very complex.

Fractals, represented by IFS or affine transformation Collage systems are not so different. Here too, we are attempting to extrapolate a large population of points from a simple formula. In fact, the one is an extension of the other to the extent that they are closely related and can be combined.

FRACTAL EXTRAPOLATION

In the previous parts of this book, we saw how encoding the alphabet in a table allowed us to represent the likelihood of letter combinations that allow us to make up words. While these words are not part of the vocabulary that has been sampled in order to generate the data set, they are close enough to make believable words. They can be used for names or for some other application where no real meaning should be attached to the words.

We do, however, run the risk of generating a word entirely by accident that does actually exist. This is not a problem in itself, since the chance of it occurring is fairly slim given a large enough initial sample. However, it might be desirable to give the ensuing words an otherworldly twist.

We could apply an algorithm to the words that are generated by the algorithm, but it would be even easier simply to tweak the data set. In fact, we can take advantage of fractal techniques to perform this.

The theory assumes that we would, depending on circumstance, like to tweak the data set in a certain, repeatable way. It should be noted that this

is not necessarily a wise approach to take for all kinds of data. In particular, when we attempt to apply a fractally generated series of points to an existing data set that reflects a visual object, we run the risk of the fractal nature becoming apparent.

When this happens, the viewer (or player) may sense that a previously random landscape (for example) has a certain pattern. This will detract from the realism that we are attempting to build into the data set.

The application of this theory, then, also assumes that we are dealing with an *abstract* data set; that is, one that does not represent an object or objects that will be viewed directly. By way of example, let us assume that the data set represents the adjacency of letters in words.

If we have, say, two different planets, and we require that names for various features be generated for each, using the base matrix that was discussed in Part Two of this book, we have two choices as to how those names are generated.

The first is to apply a pseudorandom number generator seeded upon two unique values, separated from each other by an amount that is greater than the number of names that we wish to generate. This particular limitation of pseudorandom number techniques was addressed in Part One of this book.

In fact, this first method is not very practical in terms of the Infinite Universe, since we intrinsically deny ourselves knowledge of the number of names we need to generate. The idea is that every facet is generated without prior knowledge, but in a repeatable fashion.

Therefore, a better approach in a sense is to use a fractal algorithm, which repeats on an infinite basis, to tweak the base matrix in a certain way. The primary objection is, of course, that being self-similar in nature, there will come a time in the Infinite Universe where a base matrix modified by the fractal algorithm becomes identical to one that has previously been identified.

It is, however, better to run this risk, and be able to contain the impact that it might have, than it is to attempt to predict or limit the number of objects that can be generated using this technique.

In Figures 20.1a through 20.1c, we see how the base matrix is combined with the Mandelbrot set to produce a superimposed matrix that can be used to generate words.

The reader will recall from Chapter 17, "Mapping Systems," that the symbols in the adjacency table indicate the strength of possibility that two letters may be adjacent to each other. These range from a period,

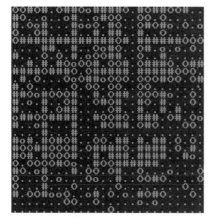

FIGURE 20.1a Mandelbrot table.

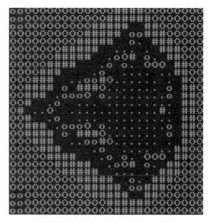

FIGURE 20.1b Adjacency table.

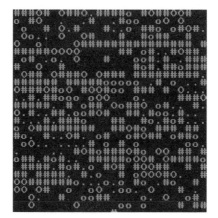

FIGURE 20.1c Combined table.

indicating the minimum, through to a gate (#) indicating the maximum, with "o" and "O" in between. This can be seen in Figure 20.1b. To these symbols, we now add the space character, indicating zero probability of two letters being adjacent.

The process for combining Figures 20.1a and 20.1b to arrive at Figure 20.1c is fairly straightforward. The values are compared for each of the cells. If the first is smaller than the second, the result is a value that corresponds to a demoted version of the second value. If it is higher, the result is a promoted value. The system of promotion and demotion is shown in

TABLE 20.1 Conversion Rules

N/A		.
	.	o
.	o	0
o	0	#
0	#	N/A
Demotion	← →	Promotion

Table 20.1. Of course, should the values be equal, no changes are made to the value.

ON THE CD The three pieces of software that generate the Mandelbrot set (MANDEL), letter adjacency table (LETTADJ), and combination algorithm (COMBINE) are included on the companion CD. All that is required is the fourth piece of software that builds the lists of words using a 26×26 input text file. This is called WRDGEN, and is also included on the CD-ROM.

The WRDGEN output for the Mandelbrot, adjacency table, and combined table is shown in Table 20.2, for runs of 20 words.

TABLE 20.2 Word Lists Generated by WRDGEN

UIEEE	FFOZS	OTAJE
RHU	XRA	FCU
PUJW	YFHH	KVSL
WEOEF	LCXNG	YFGST
EFOR	BCVV	JGVF
ETC	TTW	IHI
MSAOO	XEHTH	LSNGD
XSUL	SUEC	JVLE
OTEUE	DNAEN	OUVHP
LIALR	GXUEH	IEQDE
UCLMM	LQWQA	LUOMA
VNBS	HTHV	QABS
RSSW	LRFD	ASJE
LGNT	YVHW	FPJJ

(continues)

TABLE 20.2 *(continued)*

CIER	EGVG	YLME
KIH	ZLC	UHK
XIA	PES	HEM
EFOO	NBDV	IVCN
TMC	GYS	OJE
RTWET	UMASY	LALAF
RLR	BRG	PEP

While these may not be perfect in terms of "real" words, they do show the theory that using the same algorithm, the power of combining pregenerated tables leads to results that can be used in real applications.

CONCLUSION

We began by attempting to compare fractal techniques and probability extrapolation, and ended up by combining the two techniques to good effect.

In fact, the final example shows how we can put the two together in the Infinite Game Universe and use the techniques to generate an infinite number of different objects.

FRACTALS
AND CHAOS

In this last chapter dealing with fractals and their role in games programming, we must consider how the fractal theories can be applied to the Infinite Universe techniques that are at the center of the theories that we have seen in this book. In our discussion of the fractal technology that exists to facilitate the encoding of the naturally occurring patterns that exist in the data that makes up the game Backdrop, we have not considered how to use these encodings to generate multiple objects within the chosen Game Universe.

Chaos rears its head time and time again in fractal science. We call it *deterministic* chaos, since it can be reproduced and can be predicted. The first time that the numbers were generated, they were without pattern and could not be predicted; they represented a chaotic sequence of numbers.

We have met this phenomenon before, when we examined pseudorandom numbers in Part One of this book. However, fractal chaos is a little different; they also exhibit self-similar tendencies. This is akin to the periodic patterns that we saw in using Dewdney's technique with certain small numbers.

FRACTAL GEOMETRY AND RANDOM NUMBERS

Whatever data sets are to be manipulated using fractal techniques, there is an inherent problem when we need to attempt to populate multiple objects. The problem lies in the usefulness and strength of fractal technology: self-similarity. We use this property of the numbers that make up fractals

for a variety of purposes, not least of which is to generate data sets that can be translated into a tangible representation that conveys meaning within the confines of the Game Universe.

Unfortunately, self-similarity means that while data sets can be compressed easily and reliably, and meaning attached to the patterns that result in sets of input to specific algorithms that produce the final output, it also means that subsets of the data will tend to exhibit the same properties.

In terms of games programming, the effect will be different, depending on the particular attributes to which it is applied. If we apply it to features such as buildings, it will tend to mean that we will run into cases where buildings of the same "type" (constructed with the same algorithm) will have the same interior layout.

Then again, applied to trees or ferns, the result will be perfect examples, where the overall shape of the plant will be dictated by the branches and leaves in such a way that they will seem to be smaller versions of the larger example. This results in plants that are too perfect to be natural.

Furthermore, if we try to use self-similarity to govern behavioral aspects of the game, such that the overall behavior is modeled on a fractal algorithm, leaving the detail to be filled in by "zooming" in to the fractal, we will be rewarded with self-similar behavioral patterns that are less than ideal. The same tends to happen with music.

Fortunately, there are many solutions, all of which use the pseudorandom techniques that we discussed in Part One.

If we examine the problem in more detail, we see that the reason why self-similarity in a fractal asserts itself is that we are constrained to a discrete set of values. These values are generated by an algorithm, which although seemingly random in the short term, give rise to a discernable pattern when repetitively plotted.

Therefore, the first point to note is that if we only require a small set of numbers, we should not have a problem with patterns. That is to say, if we use the first n repetitions of an algorithm as input data to another algorithm, the player will not notice that a pattern ensues. Consider creating a fractal island using the Mandelbrot algorithm.

ON THE CD If we complete the algorithm by using an extended run, which we use to plot points, we will see that a pattern emerges, the traditional Mandelbrot fractal, such as is generated by the MANDEL program on the companion CD-ROM.

However, if we choose not to use the complete algorithm, but only use it as a generator, this pattern should not show itself. The reader will recall

that the MANDEL program works by calculating a set of numbers for the position x,y and testing to see if it tends to infinity. The resulting closeness to infinity dictates the color of the point.

If instead, we merely use a limited set of points and use the resulting stream of numbers (which are fed back into the algorithm each time) to plot points on a given plain, we will arrive at a figure that does not look like the full Mandelbrot set. It will, however, be possible to use the algorithm to increase the detail of the figure, thus availing us of the self-similar nature of the fractal system.

We will put a similar technique to work in our case study, "Fractal Landscapes," later in this chapter.

Assuming that we need an extended set of numbers, we must find a way to distort the results in a *repeatable* manner (see Parts One and Two) using pseudorandom generation techniques. In this way, we hope to reduce the pattern evident in the complete set, but in a way that makes sense to use in the Infinite Game Universe.

The most basic approach is to simply use the fractal set, generated by a specific algorithm as a series of seed values for input into a simple Lauwerier-style generator, such as we have already seen in Part One of this book. In this way, we can generate large numbers of value streams at a reduced computational cost, brought about by the fact that we will need fewer repetitions of the pseudorandom generator.

At the other end of the complexity scale, we have the possibility to use a Dewdney-style generator (see Part One) with different fractal algorithms providing values for the variable components. Of course, the usual caveats apply in terms of choice of input values, but experimentation will yield satisfactory results.

A special set of fractal generation routines known as *attractors* can also be used. While this is not the place to discuss them in detail, we provide a brief introduction; the readers are encouraged to refer to the list of books in Appendix A, "Extended References," to find a suitable text if these algorithms should be of use for their given application.

ATTRACTORS

Imagine a map, onto which we draw the outline of an island that is generated fractally. Following Richardson's experiment, we should theoretically be able to zoom in to the outline, revealing ever-smaller details. The

analysis of actual islands shows that, in general, the formation of the coast-line follows features that are a culmination of those already present.

By this we mean that if the island contains two mountains, then the base of these mountains will tend to form the natural outline of the coast. By a similar token, zooming into the coastline will reveal features caused by smaller hills or other landmarks.

Not only is this behavior apparent in land formations, something similar can also be seen in the tracing of planets and other stellar systems as they follow preset and predictable paths in the universe. This is dwelt on at length by Mandelbrot, who also proposes formulae that can be used to describe the various orbits.

Furthermore, we can creatively apply pseudorandom algorithms at several levels as previously discussed to modify the basic attractor output to provide a useful set of nondeterminable, repeatable values.

CASE STUDY: FRACTAL LANDSCAPES

Landscapes of one sort or another play an important part in many games. They may be mountains, hills, plains, and seas, buildings, or even strange planetary formations that do not have any reasonable comparison in Earthly terms. Traditionally, there are many different ways in which landscapes are put together.

One such technique is known as *ballistic deformation*, in which a flat plain is pushed up and down at random points to form mountains and valleys. The resulting terrain map can then be colored, or otherwise represented, according to the various heights of the points.

The output of the simple program BTERRAIN can be seen in Figure 21.1. To understand how it is building the terrain, imagine holding a sheet of paper upon which a grid is drawn. Choosing an intersection at random, imagine pushing down on to the paper.

The resulting dip is most prominent where pushed down, but each of the surrounding grid intersections is also affected to some extent. The BTERRAIN program mimics this by selecting a point from one of the compass points around the intersection that is being "pushed down" at random, and reducing it by a value proportional to the initial value.

In fractal terms, we could call this the *first order*, since we have only dealt with points that are displaced by one unit from the original point. We can, of course extend our program to apply a similar algorithm to each of the re-

FIGURE 21.1 BTerrain islands.

sulting *first order* points to arrive at the *second order* set of points. Subsequent applications of the algorithm take us through to the *nth point* data set.

Once we have generated sets of points to the required *depth*, we choose a second point and perform the same steps. This is repeated as required for a number of points, each with a random weight, or depth.

ON THE CD The program with which these terrains can be generated can be found on the accompanying CD-ROM, along with the full source code. For the sake of clarity, we have cheated slightly by using the standard C library stdlib.h to provide the random number generation routines *srand* (for seeding) and *rand* (to generate the actual number).

One might question why we are spending so much time discussing this terrain-building technique. The answer is because it is a very good example of an Iterated Function System (IFS), that we have previously encountered in the beginning chapters of this part of the book. In fact, the program chooses one of eight very simple transformations to apply to a given point.

However, it is not a pure IFS; because the initial point is generated at random, traditional IFS software will jump from one point to the other. On the other hand, it does satisfy the parameters set out by Mandelbrot in his ground-breaking book *The Fractal Geometry of Nature*, where he coins the term *fractal* and describes the fractal process in terms of a generator and a processor. In this case, the *generator* is used to create a set of random points, and the *processor* is the IFS as applied to the *generator*.

This should all seem remarkably familiar, since in Parts One and Two of this book, we discussed this kind of operation, using a generator and a

following processor to alter the result. Indeed, since we also encountered a system of feeding the results back through the iterator, we have in a real sense already discussed the algorithms behind Iterated Function Systems.

However natural in appearance these "islands" might seem, they suffer from two important drawbacks. First, they require many iterations to actually generate a believable landscape. To give an idea of how many are required, Figures 21.2a through 21.2d show the same basic configuration with different numbers of iterations.

FIGURE 21.2a 1 iteration.

FIGURE 21.2b 10 iterations.

FIGURE 21.2c 100 iterations.

FIGURE 21.2d 1000 iterations.

FIGURE 21.2 From islands to continents random IFS terrains.

The terrains in Figures 21.2a through 21.2d were all created using the BTerrain software that appears on the CD-ROM, with a width and height of 50 units, 10 initial "hits," and random seed of 1 and varying numbers of iterations. Additionally, for the final rendering, two Pels were used to give bitmaps measuring 100 by 100.

As can be seen in Figure 21.2b, a reasonable island shape can be achieved with 19 iterations, while a full-fledged continent requires 1000 iterations to assume a realistic shape. In between, at 100 iterations, lies a large island.

Considering the number of calculations required for each iteration, it is not efficient to generate landscapes in real time using this algorithm. On the other hand, it does create reliable landscapes with a relatively simple algorithm that is not over-intensive.

There is a second problem besides the time required to generate landscapes, that of detail. It is not possible, from the actual bitmap that represents the landscape, to derive a more detailed version at a higher resolution. To understand exactly what this means, we should imagine what happens if we artificially enlarge the center quarter of Figure 21.2b, as in Figure 21.3.

FIGURE 21.3 Enlarged island.

The result is a blocky version in which, rather than increasing the detail, the existing detail becomes enlarged. A pixel measuring 1×1 mm now measures 2×2 mm; we have not increased the detail, only the size. Richardson's

experiment that we have already described in the opening chapters dictates that the detail should increase in line with the increase in size.

Fractal Pseudorandom Numbers

To combat the unwanted effects that we saw in the preceding section, we need to ensure that for every pixel that we color, we must be able to define the color of that pixel using an algorithm that employs the x and y position, and a given seed value.

This approach is much like the pseudorandom number generators that we saw in Part One of this book, where we derived numbering schemes that enabled us to uniquely identify, and hence seed upon, individual cell values. The aim here is the same: we would like to use the cell position to determine its value, but also to define the value of zoomed-in cells that make up the cell when we increase the resolution.

Our main concern is that the pieces still fit together, which is the reason why we cannot just randomly populate the cells. A cell in the top-right corner still has to retain a certain relationship with a cell that is outside the current area of interest. This is easier to understand with an example.

Consider the four squares in Figure 21.4, which are all neighbors. The top-left square is colored blue (sea), and the others are green (land). If we then subdivide each of the four squares into four subsquares as in Figure 21.5, and zoom in to the center quadrant, we increase the detail. If we expand the center quadrant to fill the same area as the original four, we reduce the resolution as the detail increases.

The reason is that although the size of the image has increased, we have merely ensured that the pixels are larger. If we wish to increase the resolution, we need to subdivide the subsquares, as in Figure 21.6. Now we have reached the same state of affairs as at the outset, except that the detail has yet to be filled in. In order to fill in the detail, we should color the subsquares of Figure 21.6 accordingly.

However, if we do this at random, we run the risk of coloring a subsquare that should be green blue, or vice versa. We need to be able to determine if a given subsquare should be colored as land or sea the exact relationship will be a function of the surrounding squares. Figure 21.7 shows the effect of randomly populating the new subsquares.

FIGURE 21.4 A simple coastline.

FIGURE 21.5 The area to enlarge.

FIGURE 21.6 The detailed enlarged area.

FIGURE 21.7 Noncorrelating random detail.

We could simply average the surrounding squares, but more interesting results can be obtained using fractal techniques; in particular, the self-similar properties of fractals that we first encountered in previous chapters.

The key to using these techniques is that if four adjacent points in a fractal are computed, using a formula involving complex numbers (that is, numbers with a real and imaginary part), they will exhibit a relationship such that if the detail is increased, this relationship will still be respected. The unwanted effect seen earlier of noncorrelation in the increased detail is less likely to occur.

FIGURE 21.8 Correlated fractal detail.

If the detail is increased in this way, using the same formula, the detail will follow a similar shape as the parent, and the relationship between specific areas will be retained. That is, there will be a correlation between adjacent areas, or sets, of points.

This is shown in Figure 21.8, which uses the same pattern as in Figures 21.4 through 21.6, to increase the detail of the enlarged area. Thus, it can be seen that the effect is very different from that in Figure 21.7.

The only remaining question relates to the fact that if we draw an image, such as a coastline, following this technique as it is, the detail will end up looking very much like the parent. Figure 21.8 shows correlated detail.

CONCLUSION

In using this technique, we must add that element of pseudorandomness that allows the detail of the coastline (in this case) to look less like the parent. To do this, we generate a series of pseudorandom numbers that change only the detail, and not the theme of the coastline.

In the same way that Richardson's experiment detailed previously shows that more detail in a coastline is apparent the closer we examine it, we are free to meander the detail as much as we like, as long as the theme (or general shape) is respected. This is almost guaranteed by the use of fractal iterations.

THE GAMESPACE EXAMPLE

The last part of this book can be seen as the culmination of all the techniques and strategies that were described in the course of our examination of the mathematical (and semi-mathematical) principles behind the infinite game universe.

The reader will be taken through the steps required to break down a very simple game universe into its component objects and rules. From here, we will examine how they can be created from generic templates as required, and interact with each other and the player.

Although the Game Universe that we will describe is a simple one, it does represent a game that is playable. Indeed, it is hoped that the reader will enjoy playing it and learn from the information it represents.

It is a truly Infinite Universe; that is, the designer has no knowledge of just how far the universe extends, or exactly how many objects there are to explore. However, this does have one caveat: there is built-in limit to the number of base objects that can be generated, linked to the highest number that the standard ANSI C implementation of the largest possible data type; an *unsigned long* that according to Steve Summit (*Handbook to Programming Languages Volume II*, p. 92; edited by Peter H. Salus) offers numbers in the range 0–4,294,967,295. Whether this represents a real limit is left to be seen.

Furthermore, this is not a book about games programming per se. That is, we have not dealt with the advanced graphical or sound effects that are the hallmarks of today's most impressive games. Therefore, the game is limited in these areas. This may or may not hinder the player's enjoyment of the game itself, but the key behind this example is, after all, to learn

about what goes on behind the impressive audio-visual feast that is the norm in today's exciting industry.

As we said earlier, this part of the book brings together all the techniques we discussed in the previous pages. Each will be used, to varying degrees, to represent the Game Universe described in this introduction.

Before we proceed, let us first attempt to define what techniques we expect to find powering the Game Universe. There are techniques for generating abstract pieces. That is, how to programmatically describe the objects that the design calls for, in a fashion that means that each one can be used as a template for the creation of specific instances as required.

Next, we have a collection of techniques for representing instances of these abstract objects. We need to set their properties, give them shape, and enable each to interact with the other objects with which they may come into contact in the course of the playing session. Properties are quite often set within given limits; it is rare that they are set on an arbitrary basis.

Furthermore, objects may even be instantiated from each other (this is particularly the case for "container" objects such as Backdrop objects) using properties that may be inherited from other objects. In such cases, we may also choose to apply limitations to the properties that are set, generally using other objects to provide input to this process.

Finally, we need to translate the numerical abstractions of the objects into something that the player can understand and to which he or she can relate. This need not be particularly complex; often, giving just enough information for the player to recognize what he or she is looking at is enough. It is, however, a very important part of the process, since it is the only way in which the various changes that occur in the process of playing the game will be communicated to the player.

These techniques come together to define the Game Universe. This part of the book defines and implements one such universe. It borrows on games that the author has encountered in the course of researching the material for this book, as well as the games that have been designed that fall into the category of "infinite." There is a little piece of all of them in the game itself.

Indeed, the game exists on the companion CD-ROM, along with all the source code, which the reader is invited to borrow from. It is a real game and can be played, although some may find it a little limited in scope.

Before we embark on the details of implementation, let us first examine the general game design. The theme is exploration combined with world

domination, with some trading added for good measure. The player begins with a spacecraft, on a planet in a galaxy.

Piloting the spacecraft (which may be upgraded as the game progresses by purchasing and fitting new pieces) from solar system to solar system, the player may trade goods to increase his or her capital. The capital is vital to purchasing equipment and fuel.

Such is the basis for the game. It may all sound a little daunting, but when the proposed universe is broken down into its component parts, everything is made just that little bit easier. So, without further ado, let us begin the path to writing the demonstration game *PlanetQuest*.

THE UNIVERSE AND ITS OBJECTS

In this chapter, we will begin to define the various objects that will make up the *PlanetQuest* Universe. Mindful of the steps that we need to go through in our design, this is the abstraction phase, where we define each object by way of a template.

Although the reader is free to choose his or her own design paradigm (or representation), since the chosen language for the implementation is ANSI C++, it makes sense to use an object-oriented technique. Even here, there are an almost bewildering number of choices.

Since this is not a book about software engineering, we are not about to discuss the merits of one representation over another, especially since that is exactly what they are: representations. Indeed, which particular paradigm to choose is more a matter of personal preference.

Instead, we will be using a representation taken from Ian Somerville's excellent book, *Software Engineering* (Addison-Wesley, 1992). There is an entire chapter on software engineering that gives a possible representation for object-oriented designs, and it is on this that we will be loosely basing the representation of our universe.

With this in mind, the first section in the chapter is a brief summary of the object-oriented (OO) design methodology, and an introduction to the way in which we will be representing our simple game design.

INTRODUCTION TO OBJECT-ORIENTED DESIGN

One of the key reasons that the OO paradigm is so useful to us in designing games is because, as Somerville puts it:

"... it views a software system as a set of interacting objects, with their own private state..."

—Software Engineering, *p. 192*

which more or less mirrors the way in which our minds work. Thus, the jump from concept to code can be minimized, since it becomes easier to visualize the Game Universe in an abstract fashion. By way of example, consider a car engine. A car designer will design a car without paying much attention to the engine itself, except as a way in which the car will be propelled.

The team that designs the interior controls will also not concern themselves with the way in which the movement of those controls will cause the car to move, except that it happens in a way that they dictate. The engineers who design the engine probably are not too worried either about how the car looks, except that it must move.

The end user, or driver, buys the car (for the looks or for the performance) and drives it around, usually without a second glance under the hood. Everyone has his or her own view of the objects that make up the car. They don't care about the internal workings of objects outside their domain, but all of them realize that the interaction between the various pieces is what defines the behavior of the car itself.

With that in mind, OO design looks at objects, and the actions that they can perform, in terms of visible effects on the problem domain (the Game Universe, in this case). How the objects are represented internally, and how they do what they do is someone else's problem. This abstraction is useful in the design phase, because everyone can understand the components that make up the problem domain.

REPRESENTATION

Having stated the basic methodology that we are going to use, we need to define how we represent the objects as we design the game itself. Somerville suggests a representation similar to that shown in Figure 22.1.

The key point to note is that the properties are private to the object, accessible only via methods, which may be used to set, extract, or modify the values that the properties represent.

Of course, properties may include other objects, which are indicated by an asterisk next to the property name. Objects that are contained in this

FIGURE 22.1 Object representation.

way may only be communicated with directly if an appropriate method is defined. Thus, the Parent Object is responsible for communicating data to the child if no access method is specified.

This only gives us a way of representing discrete object templates, however. In order to complete the representation, we need to be able to define the ways in which the objects can interact, and the relationships that exist between the different objects. Therefore, two more diagrams are required.

The first is the Object hierarchy, a simple example of which is shown in Figure 22.2.

FIGURE 22.2 The object hierarchy.

In the terms that we have outlined during the course of this book, the objects whose names are in *italicized* text are Background Objects. The reader will remember that these objects may contain other non-Background Objects, and their properties do not change.

The final diagram that is needed in order to be able to completely represent a given Game Universe is the object interaction diagram. A very simple two-object example is shown in Figure 22.3.

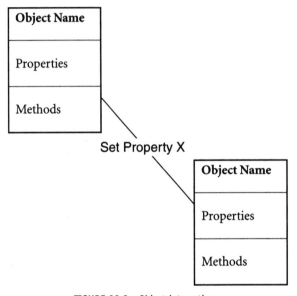

FIGURE 22.3 Object interactions.

These three diagrams enable us to specify what objects may exist, how they are related, and in what way they are allowed to interact. This is all that is needed to begin the implementation process. Further down the line, however, we will also need to depict the results of the interactions.

In other words, it is all very well stating that Object A may invoke Method B of Object C, but how can we depict the result of this in terms of the properties of Object C?

This is where we shall part company with traditional OO methodologies and explore our own variant for showing the cause-and-effect processes that will take place within a play session. We will discuss this in detail in Chapter 23, "Universe Interaction," but for now, we will begin to design the *PlanetQuest* Game Universe.

THE *PLANETQUEST* GAME BACKDROP

Now that we have an insight into the theory behind OO design, let us put it into practice. We have mentioned in the course of this book that there are three types of objects that make up the Game Universe: Backdrops, Objects, and the Player.

The underlying Backdrop of the Game Universe in this case is the Galaxy, of which there may be more than one. The Galaxy Backdrop is a container for one or more Star Objects. The properties and methods of the Galaxy Backdrop are represented in Figure 22.4.

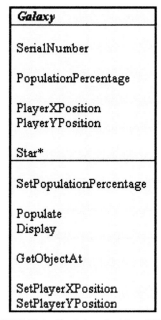

FIGURE 22.4 The Galaxy Backdrop Object.

The reader will recall that the asterisk (*) next to the Star Object means that the Parent Object (Galaxy, in this case) may contain one or more objects of that type.

Upon instantiation of a Galaxy Object (of which there may be many inside the Universe), we use the *SetPopulationPercentage* method to determine the number of possible stars that may exist inside the Galaxy's sphere of influence. We can do this via a hard-coded value; more interesting,

though, is to use the *SerialNumber* property as a seed from which we generate the percentage based on a pseudorandom number generation algorithm. We might also choose to limit the population percentage based on a minimum and maximum value.

Either way, we store the result in the *PopulationPercentage* member property. Using this, we may then call the *Populate* method to assign a list of Star Objects.

Each Star Object has the properties and methods detailed in Figure 22.5.

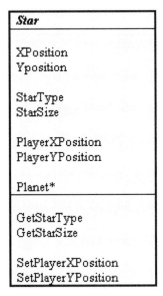

FIGURE 22.5 The Star Object definition.

In keeping with the theme of the book, we use the *XPosition* and *YPosition* properties, set through the instantiation of the Star Object to generate a series of pseudorandom numbers that form the basis for setting the remaining properties: *StarType* and *StarSize*.

Since the Galaxy instantiates itself with a list of stars, we have chosen also to store the position of the player in the Galaxy Object itself. This is the result of an implementation concern, as is the decision to store the position of the player within the solar system.

Both sets of objects use an instantiation technique to place the player within the set of objects, such that if players change galaxy, or system, they

find themselves positioned at a Star or Planet Object. The basic technique chooses a position at the center of the object set (in this case, a two-dimensional array), and scans left until it encounters an object. The player's position is then set to the position of that object.

From the StarType and StarSize, it becomes possible to determine the number of planets that will orbit the star.

We can, therefore, generate the list of Planet Objects, each of which is defined as in the example in Figure 22.6.

Planet
SerialNumber
PlanetType PlanetWealth PlanetTechnology
PlanetSize
PlanetXPosition PlanetYPosition
GetPlanetSize GetPlanetPopulation
GetPlanetType GetPlanetWealth GetPlanetTechnology

FIGURE 22.6 The Planet Object definition.

The SerialNumber is set as a function of the Parent Object's (Star) properties—namely, its position in the Galaxy—and the serial number of the Galaxy. It is then used as a seed to provide the other properties, in a similar fashion to the Galaxy and Star examples described earlier.

In addition, the three values that actually provide the substance to the Planet Object—Type, Wealth, and Technology—are calculated algorithmically. In fact, the algorithm is a simple modulo operation based on the

assumption that since each of the values has a different number of choices, and since the positioning values are set at random, then this is an acceptable way to give reasonable values to the properties in question.

One point to note is that we do not actually need to store any of the properties that remain static and are set by using a seeded random number generator. This is because as long as the seeds do not change unexpectedly, we can be sure that they will always yield the same result. For the sake of clarity, however, we have chosen to store these properties.

This collection of objects represents the Backdrop against which the game is to be played. The preceding figures are representations of a possible implementation. To keep the code simple, however, the actual source code does not use embedded lists of Child Objects as depicted in the diagrams.

Instead, the objects are stored in arrays, once instantiated, defined as classes, with associated access functions. This is not ideal, but it does serve to reduce the complexity of the code such that the core algorithms that actually initialize the various properties of the objects are not overshadowed by linked list management code.

The Player Object
In the case of *PlanetQuest*, the Player Object is represented by a spacecraft. The spacecraft contains all the properties that are required to manage the relationship between the player and the universe. These various values that are stored are nonstatic; in other words, they change with every almost move that the player makes.

The Player Object is often one of the most important objects that float over the Game Universe Backdrop, as it represents the sole interface between the player and the universe. By this, we do not mean to imply that the universe Backdrop Objects do not give any clues as to the effect of the player, merely that it is the only direct clue as to how the play is progressing.

Figure 22.7 shows the Ship Object that represents the player's interface with the Game Universe.

The player is informed of the status of his or her craft via a representation of the Fuel and Shields values, updated as required by the actions of the player within the Game Universe. The Goods property is a list of the current trade items that the player holds in his ship at a given moment in time. Upon instantiation, this list is empty.

In Figure 22.8, we can see the base definition of the Goods Object.

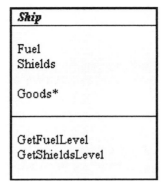

FIGURE 22.7 The Ship Object definition.

This object is dual purpose, since it can also be used to show the stock of various items at a given planet. The actual prices, type, and quantity of goods that can be traded depend largely on the properties of the planet, its type, wealth, and technological levels.

As an example, we might say that a planet that has type INDUSTRIAL will tend not to sell food and other AGRICULTURAL items; rather, it will sell machinery. For the higher technology levels, it is no longer called simply "machinery," but becomes electronics and computers.

Of course, RESIDENTIAL planets will be more in the market for purchasing goods than selling them, giving a discrepancy in the buying and

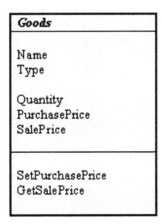

FIGURE 22.8 The Goods Object definition.

selling prices. Here again, the technology level will dictate which goods fetch a better price.

Synchronization of Backdrop Object Properties

We have seen how all the objects in the universe have their own discrete properties; what we have not seen is how they relate to one another. In order to inject some realism into the game, it is a requirement that the objects interact in some way.

This chapter deals with the Backdrop Objects. In the *PlanetQuest* example, the Star Objects are quite definitely Backdrop Objects. The Planet Objects occupy a strange position, being Backdrop Objects with some aspects that are non-Backdrop. This should become clearer as we progress.

We can break down the properties of Backdrop Objects into two kinds: static and nonstatic. Static properties are those that do not change, such as the position of a Star Object, and its type and size.

Nonstatic properties are those that may change with time, or may change between play sessions, such as the price of goods on a given Planet Object.

Static Properties

This interaction begins with keeping the Background Objects synchronized in some way. In the next chapter, we will consider how the nonplayer objects should be synchronized. This chapter is concerned with keeping a constant theme against which the game is to be played.

Our first consideration is that each time the game session is begun, the initial Backdrop is familiar to the player; that is, the Game Universe should not change between game sessions. This is not to say that the details cannot change, simply that the principal Backdrop Object placement should not change.

In fact, the properties of the Backdrop Objects may change, within strict limits. These limits are not set in stone; it is up to the game designer to define limits that are realistic within the confines of the Game Universe.

In the case of our *PlanetQuest* example, we could say, for example, that we allow the price of goods to change within a certain margin. Likewise, for a given Planet Object, we might also decide that the range of Goods available may also change, as could the quantity in stock.

The algorithm that manages these subtle changes in the properties of the Backdrop Objects is based on the Planet type and technological level. The reason for this is that planets of the same type and similar technological

level should logically buy and sell the same goods, with prices that may fluctuate, within set boundaries.

In a sense, this is almost as important as the placement of objects within the universe; as detailed in Part Two of this book, the predictability allows the game to be playable. How can the player be expected to make decisions about what goods to purchase to take to another planet if the prices cannot be predicted?

Nonstatic Properties

Of course, some of the static properties that we have seen also overlap with a separate class of properties: those that may change according to time, situation, or player action. These nonstatic or semistatic properties can be either set at the time that the universe is instantiated, or can be set when other objects are instantiated.

In general, all objects, be they Backdrop or Game Objects, have properties that fall into the nonstatic class. Even if a Backdrop Object does not actually move (which is one of the definitions of Backdrop Objects), it may contain other properties that vary.

Following this theory, we can say that the Star Objects in the *PlanetQuest* example have only static properties. Planet Objects, on the other hand have a mixture of static (positioning coordinates) and Nonstatic (goods prices) properties.

The Player Object, of course, consists only of nonstatic properties. Everything about it may change, from the fuel to the goods carried.

We count it as a Backdrop Object since it is ever-present, it may never be removed, and from the moment that it is created it remains part of the Game Universe. In addition, the Ship Object, and in fact any Player Object, *can* contain other objects that are not Backdrop Objects.

Consider, for example, a player in a real-time strategy game, travelling through some Middle Ages township. The township can be created using the infinite techniques proposed in this book—simply substituting planets with buildings goes a long way to achieving this in the design phases.

Suppose that in our generated township, we come across an object. While it is within the sphere of influence of the player, it exists, but as soon as the player drops it and wanders off, it may cease to exist (at least until the player returns to the point at which he dropped it—upon doing so, the player might reasonably expect it to still be there).

The player in this case has taken possession of a Game Object, thus containing it. The paradox in this case is that unless the object is a homing

pigeon, it probably will not return to where the player first encountered it, and therefore should be left where it is dropped.

This is an example of a Game Object that is dynamic, becoming a Background Object for a limited period of time.

CONCLUSION

We have spent this chapter examining the different types of objects, how they may be instantiated, and what happens to them during the play session.

We have spent so much time on this because it is important to understand how (and possibly as importantly, how not) to apply the infinite techniques presented in the bulk of this book.

Along the way, we have also broken down our particular Game Universe into objects, and the source code that appears on the companion CD mirrors this discussion fairly accurately. The instantiation techniques use the infinite algorithms detailed in the book.

Of course, since *PlanetQuest* is not a complete game, there are many other aspects that could take advantage of the techniques presented here. However, the complexity is enough for another entire book, and so is not presented in detail.

By way of compensation, the final chapter of the book details how the ideas presented in the *PlanetQuest* game could be extended using material from different sections of the book.

Before we do that, we need to spend some time examining the way in which these objects interact within the confines of the Infinite Game Universe.

UNIVERSE INTERACTION

Since each object in the universe has a behavior that has been defined by way of either an algorithm or static actions, we can predict with some certainty what the state of an object will be at a given moment in game-time. This is very useful when it comes to making the universe react to itself in a realistic fashion.

By this, we mean that in a given Game Universe, objects do not exist in isolation. In order for the game to be realistic, we must ensure that the objects interact. That is, changes in the properties of one object should affect other game objects within their sphere of influence.

Backdrop Objects, for example, will have an effect on other autonomous objects that "move" around within the Game Universe. To be more specific, using our *PlanetQuest* game as an example, if a given Galaxy Object is instantiated at time *t*, all the stars contained within will be in predefined positions, set by the serial number of the galaxy.

When we come to instantiate a Star Object at position *x,y* at time *t*, the properties will be set in terms of the star's position at that time. Stars, however, do not move, but their properties influence the number of planets that orbit the star.

In the preceding chapter, we saw how the Backdrop Objects interact with each other. In the case of the *PlanetQuest* game, we have designated the Star and Planet Objects to be Backdrops, along with the Galaxy Object. The Ship Object floats around on the Solar System Object, which shares Backdrop status with Galaxy Objects.

PLAYER–UNIVERSE INTERACTION

This type of interaction relates to the opposite of that in the preceding section. That is, rather than discussing the way in which the Backdrop affects the Player Object (and the other objects, such as the Planet Object), we are now going to look at how the player can affect the Backdrop Objects.

The simplest way in which this can take place is when the player decides to move the Ship Object from one point to another. The game engine (represented by the "main.cpp" file) controls what this action leads to. In Code Segment 23.1, the implementation of a player moving within the Galaxy is shown. Some code has been omitted for the sake of clarity.

CODE SEGMENT 23.1 User interaction.

```
Case WM_LBUTTONUP:
{
  int xPos, yPos;
  .
  .
  .

  // Attempt to move the user
  if (oGalaxy->SetUserPos(xPos,yPos) == 0)
  {
    // Remove the old objects from scope
    delete oSolar;
    delete oPlanet;

    // Move the objects to where we are moving INTO scope
    oSolar = new cSolar(oGalaxy->GetGalaxySerialNumber() +
                        ((oGalaxy->GetUserX() *
SOLAR_DIMENSION) +
                        oGalaxy->GetUserY())
                       );
    oPlanet = new cPlanet(oSolar->GetSolarNumber() +
                         ((oSolar->GetUserX() *
SOLAR_DIMENSION) +
                         oSolar->GetUserY())
                        );
  }
}
```

```
break;

  .
  .
  .
}
```

The code in Segment 23.1 is fairly self-explanatory. Note, however, that we treat the objects in terms of being in the scope of the Player Object, and recreate them as necessary. As can be seen from the processing of the WM_LBUTTONUP Windows message, this is a good example of hardware user interaction, described in detail in Part Two of this book.

When defining the boundaries of the Game Universe, one must be sure to allow for all possible interactions between the Player Object and every other object in the universe. The way in which the Player Object manifests its interaction in the universe is via the relationship between properties.

For example, the Player Object may share properties with the rest of the universe, such as the amount of goods that the player may hold at any one time. The Goods Object is, as we have already mentioned, dual purpose in this aspect.

Both the Planet and the Ship Objects hold a list of Goods Objects, each with various attributes such as the purchase and sale price and stock held. They also have a *Class* attribute that specifies what type of goods they are. In fact, this is only held because different classes that come from different types of planets might have different descriptions. It has been implemented as a possible extension to the game itself.

Further extensions are possible in that when a player arrives at a given planet with a large amount of a certain good, this might have an influence on the price for which the goods can be sold. This gives the effect of supply and demand; the more one has to sell, the better price one should offer for it.

The mechanics of Property Interaction require only that the core process that manages the interaction between the objects notes the relationships and alters affected properties accordingly. This represents an indirect relationship between the objects. Direct interaction requires that the actions of a player affect the properties of a given object in the Game Universe.

In Code Segment 23.2, taken from the "main.cpp" file, which manages the interaction between the different Game Objects, we can see how Property Interaction in the form of manipulating the Goods lists takes place.

CODE SEGMENT 23.2 Managed Property Interaction.

```
// The ship is purchasing goods...
oShip->BuyGoods(szGoods, nPrice, nQuantity);
// ... from the Planet
oGoodsList->SellGoods(szGoods, nPrice, nQuantity);
```

Of course, it might be better to contain the Goods Object within the Planet Object, and access it via the main Planet Class. In fact, the design shown in Chapter 22 implies this. However, for ease of understanding, it has been implemented in the way shown in Code Segment 23.2.

There are some pitfalls to watch out for, as always. The first point that should always be remembered is that if a player changes an object in some way, and that object falls out of scope and is destroyed, the next time it is created should be with the new properties taken into account.

We have already seen one example of this in the preceding chapter, when we discussed what happens when a travelling player in a role-playing game drops an object. The same applied then as it does now: in order to retain the reality that is offered by using an Infinite Game Universe, we must also ensure that we do not lose it by recreating objects as if it is the first time that the player encounters them.

At the design level, this problem can be overcome by simply stating that the object is placed into temporary storage of some kind. This solves the problem in a simple, if inelegant, way. One wonders how many objects in an Infinite Universe can be placed into temporary storage before the storage runs out.

A better solution is to ensure that any properties affected by the player are altered in a way that means that they bear some relationship to the player. This is not always possible, especially in the case of the player leaving an object at a specific place, but it will serve to alleviate some of the temporary storage requirements.

In the *PlanetQuest* example, we could choose to apply this by tying the Goods Carried properties to the Goods Prices property when a player arrives at a planet. In essence, this would simply mean that due to the laws of Value for Money, the more the player is carrying, the lower the per unit price is.

This relationship will ensure that the congruence between the properties is maintained, and that there are no instances where the reality will be impaired by a sudden reversal in price.

The astute reader will have noticed that we first discussed such aspects of the Infinite Game Universe in Part Two, where we saw how Software Interaction allowed us to manipulate the Game Universe. This manipulation adds depth and reality to the game, but it does mean that a close check must be made to avoid unrealistic facets creeping in.

Staying with our example of buying and selling goods, we could also say that if the player were to purchase a large quantity of goods, in relation to the stock held by the Planet, then this direct action would possibly cause a rise in prices.

One might expect that this price increase should be applied both to the purchase and sale prices. However, closer inspection of the relationship between such objects in the real world shows that only the purchase prices should increase, at least in the short term.

OBJECT–OBJECT INTERACTION

Of course, the Backdrop Objects should also be able to interact. In the *PlanetQuest* game, there is not much call for this. One extension would be to add some nonplayer characters to the game in the form of other Ship Objects that would interact with the player.

This is actually foreseen in the design, each ship has a *Shields* property that could be used to simulate battles between two craft.

In the scope of the Infinite Universe, we can of course use our algorithms to simulate how the rival ships might move. The simple *Pac-Man* clone that appears on the companion CD (and which is discussed in more detail in Appendix B) shows one way of doing this.

Essentially, at the time of instantiation, the object in question is given a series of letters that determine its movements. These letters translate into specific actions, such as move left, move right, fire, and so on.

During the play session, these randomly assigned letters can be changed, in the light of experience, or simply by choosing another set entirely at random.

This approach is fairly isolationist; in a simple example such as this one, the letters change by themselves. Of course, the more sophisticated the game, the more actions are possible. If we consider that we are to use this technique to provide rudimentary Artificial Intelligence, we might say that there is a direct relationship between the way in which one object moves and the future moves of another object.

CONCLUSION

Having considered how the various pieces of the Universe can interact, along the lines discussed throughout the book, we have effectively completed our analysis of the abstract part of the *PlanetQuest* game.

The Objects and their various interactions make up an abstraction of the Game Universe, a nonconcrete description. We have not yet dealt with how the abstraction will be presented to the player. In the next chapter, we will describe how the *PlanetQuest* Game Universe is presented to the player, and in doing so, we will attempt to point the way forward for similar developments.

THE ENTIRE PACKAGE

So far, we have discussed the abstraction of the universe and the rules that guide the interaction of the various objects. As far as the code for these pieces is concerned, that is exactly what we have defined: an abstraction. All software is, in essence, an abstraction of a concept. This is what makes it so difficult to envisage and manage.

One could look at Chapters 22 and 23 as being aimed at the game designers, and Chapter 24 at the programmers. It is at this stage that we will begin to see how the different aspects of the Infinite Universe that we are attempting to describe come together in the final game.

OBJECT REPRESENTATION

All the pieces have a relationship with each other, within the context of the entire game. This has already been explained from a pure design point of view, using the object-oriented paradigm. In the Infinite Universe, however, and most especially one built on mathematical foundations, the implementation will also have a fairly profound effect on the relationships between the objects.

The design phase is simply an abstraction. We talk glibly in terms of instantiating a Planet Object such that its properties are within certain bounds, without paying much attention to the actual mechanism by which this is achieved.

The code in Segment 24.1 shows how the Galaxy Object is coded as a C++ Class. It follows the guidelines set forth in Chapters 22 and 23, using

access functions to allow interaction between the object and player, and to provide information to other objects.

CODE EXAMPLE 24.1 The Galaxy Object class definition.

```
class cGalaxy
{
// Galaxy properties
private:

  // Galaxy size, number and users position
  char szMap[GALAXY_DIMENSION][GALAXY_DIMENSION];
  long int lGalaxyNumber;
  int nxUser, nyUser;
// Access and instantiation methods
public:

  // Default constructor
  cGalaxy(long int lSerial);

  // Windows specific display routine
  void Display(HDC hdc, int nLeft, int nTop, int nxChar, int
nyChar);

  // For use in future child & related object generation
  long int GetGalaxySerialNumber() { return this-
>lGalaxyNumber; }

  // The users position inside the Backdrop object
  int GetUserX() { return this->nxUser; }
  int GetUserY() { return this->nyUser; }
  // The user is moving (User Interaction routine)
  int SetUserPos(int x, int y);

  // Windows specific routine to show the star info on the fly
  void ShowStarInfo(HWND hWndParent, int xPos, int yPos);
};
```

Besides specifying the abstract way in which the objects will interact, we need to ensure that at the implementation level there is some mechanism

by which the objects may be allowed to interact: we must define the relationships in concrete terms.

For example, we have defined the Planet Object as existing at a certain place within a Solar System Object, giving it an x and y coordinate. As to how we determine the exact nature of the planet, we have two choices.

On the one hand, we can generate (calculate) a serial number based on the Planet Object's exact position within the entire Game Universe, and use that. Alternatively, we may choose to make use of the fact that the planet has already been generated at a given point, that choice being based on an algorithm. If we choose the latter, we can simply use the local position (within the solar system) of the planet as a seed to an algorithm that will be used to specify the other properties of the Planet Object.

For the Solar Object, which represents a solar system, and for each Planet Object that is associated with it, the generation code follows a similar pattern that embodies the first approach mentioned earlier. Code Segment 24.2 shows how this is achieved in the *PlanetQuest* game.

CODE SEGMENT 24.2 Object instantiation example code.

```
// Set up Solar object based on its position
oSolar = new cSolar(
  oGalaxy->GetGalaxySerialNumber() +
  ((oGalaxy->GetUserX() * GALAXY_DIMENSION) +
  oGalaxy->GetUserY())
  );
// Set up Planet object based on its position
oPlanet = new cPlanet(
  oSolar->GetSolarNumber() +
  ((oSolar->GetUserX() * SOLAR_DIMENSION) +
  oSolar->GetUserY())
  );
```

There is even a third option: simply generate the Galaxy Object, each possible Star Object, and their associated Planet Objects, and store the entire family in memory. There are two drawbacks to this approach.

The first is that there will be a certain amount of overhead associated with pregenerating the objects and storing them for the required duration. This overhead may or may not overstep the restrictions placed on the game

programmer by the platform (PC, console, handheld) or desired complexity of universe (level of detail).

The second drawback is that processing in this way takes a certain amount of time. The player may or may not be willing to wait for the length of time that it takes to generate the universe. Of course, there are ways around this, such as spooling some video, music, or other distraction, but in the long term, the wait time may become annoying to the player.

The only other real representation issues that we have in the *PlanetQuest* game as it is implemented are the various Goods lists. These are the lists of goods that can be bought or sold at each planet. The list remains the same, but the prices change.

The prices are affected by the type of planet, and we can decide that they should not fluctuate randomly, and be set to absolute values depending on the planet type. In a truly Infinite Universe, of course, they would fluctuate randomly.

A simple technique is simply to seed based on elapsed game-time, or time of day. In this case, it is the perfect solution, since it allows us to build in some level of unpredictability that is useful to add reality. Of course, this does mean that we need to calculate the prices and hold them in memory. It is not good to recalculate them too often, unless we wish to represent an extremely volatile market.

This last example is given to show that we need to be aware of when to use the techniques presented in this book, and know when to avoid overcomplicating the issue and just rely on pure hardware and software interaction techniques that we first saw in Part Two of this book.

THE INTERFACE TO THE OBJECTS

The next step is to put some kind of flesh on to the bones of abstraction. Depending on the game style, and the depth of play, this can range from a plain-text interface to a fully graphical immersive Game Universe. The *PlanetQuest* implementation lies somewhere in between the two extremes, but slightly to the side of the textual interface.

From one point of view, we can say that the deeper the game, in terms of complexity, the less need there is for a rich graphical interface. Some adventure games, for example, can provide an entirely immersive and atmospheric universe with a text-only interface. This, however, is very rare.

More common is either a game that is entirely action based, using graphics heavily, and at speed, or one that contains strategy and action in roughly equal measures.

In any case, the visualization that can be built up will always be abstract. Packaging the abstract components from the coded pieces using some kind of interface, or visualization, is what lends reality to the abstraction.

ON THE CD The *PlanetQuest* that is implemented and whose source code appears on the companion CD-ROM is rather simplistic in its user interface. That is, the visualization is entirely abstract. In place of stars and planets, there are characters and words. A screen shot of the interface is shown in Figure 24.1.

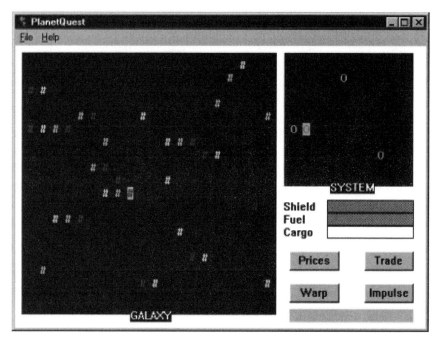

FIGURE 24.1 *PlanetQuest* screen shot

The only "real" graphics show the level of fuel and shields of the player's spacecraft. Everything else is represented by strange hieroglyphics.

One might argue that this is enough to satisfy most requirements; that the essence of the game is not in the graphics, as it would be in an action game, but in the depth. It is, however, an unavoidable fact that visual

effects can be put to good use and make the game much more attractive, as do music and sound effects.

VISUALIZATION

Besides the interface visualization, there are also other areas of the final package that can have visual elements that can be entirely generated using the algorithms presented in the course of this book.

We looked at a case study that included a terrain generator in Part Four. While the *PlanetQuest* game does not have any actual planet maps to speak of, the techniques that were mentioned in the first section of this chapter can be easily extended to prepare terrain maps.

For example, let us assume that we will be using the BTerrain style of map generation. Our first task is to choose a serial number upon which the random number generator will be seeded. This is done using the same algorithm that was used to seed the Galaxy and Solar Objects. This time, however, we need to base it on the galaxy, solar system, and the planet's x,y position within the solar system.

This guarantees us a fairly good, unique seed. In fact, we could also play a little on the fact that the planet is already uniquely generated and just use the serial number from the planet to reseed. We could afford to do this since the property that we are generating is different from the first time that we used the seed.

In either case, we need to generate a number that will represent the number of "hits" (see the BTerrain software analysis in Appendix B) that we will perform on the surface of our abstract planet.

A point to note is that this number should be greater than zero; otherwise, we run the risk of having a very strange-looking terrain—no hills or plains, just water, for example.

Once we know how many ballistic points we are going to generate, we also need to set the number of iterations. In general, the more iterations we use, the larger the generated "islands" will be. Again, it is good practice to choose a number that is greater than a set minimum to avoid small clusters of islands with no great variation.

Finally, we can generate the landscape using our chosen random number generator, and be fairly confident that it will be unique within our solar system, and unique in our galaxy.

There are many refinements that we can use that will enable us to increase the reality even further, without a substantial increase in complexity. For example, the planets have been color-coded. We could assume that green is a planet that is mostly land, and that blue represents a planet that is mostly water.

Using these as a guideline, we could choose our hits and iterations such that the amount of land or water is varied according to the type of planet. Simply stated, a low number of hits and iterations will mean a more water-filled planet, and a high number of each will mean a more land-based planet.

Indeed, taking this idea one step further, we could also say that the planet type will influence the color scheme that we choose to put in place.

As an aside, if we wanted to provide more micro-infinite detail, we could also choose to use the ballistic terrain generation algorithm to make towns of varying shapes and sizes, all with a minimum of impact on the core model.

CONCLUSION

As we have progressed through Part Five, we have seen how to put many of the techniques that we have discussed during the course of this book into action. It is hoped that the reader has a better understanding of how the algorithms that have been presented can be used to create games of depth and breadth.

The power of the mathematical techniques behind Infinite Universe generators is such that the complexity and processing requirements are kept to a minimum. Indeed, the *PlanetQuest* game itself has a very small memory footprint.

In essence, the storage of the various vectors upon which the *PlanetQuest* game objects are built is already predefined. The only storage is that which is needed for the objects that fall within the scope of the Player Object.

EXTENDED REFERENCES

INTRODUCTION

The following is a list of books that were consulted during the writing of this work. Each book that has been referred to appears in this list. Due to the nature of the subject, it was deemed important that each book that has been referenced be given a summary so that you may choose those that best suit your interests.

The list of books does not include all possible books on the subjects that they cover, but they are those that the author found most useful at the time of writing. The list is split into categories, which roughly mirrors the way in which this book has been constructed; however, there are books that do not fit into any one category.

MATHEMATICAL TEXTS

Discovering Advanced Mathematics: AS Mathematics; John Berry, et al; Collins Educational, 2000
This text is intended for the UK market, aimed at students between the ages of 16 and 19 who are studying mathematics at a precollege level. It covers many pure mathematics topics in an informative and easy-to-read style.

Strange as it may seem, I was unable to find a good introductory text that covered all the points that I required; this book was as close as I could come to the perfect text. If any reader can recommend a good mathematical text along these lines, I would be very grateful.

FRACTAL MATHEMATICS TEXTS

Fractal Geometry of Nature; Benoit B. Mandelbrot; W.H. Freeman & Company, 1982

Benoit B. Mandelbrot coined the term *fractal* in a paper that later became the basis for this excellent book. It is quite advanced in terms of mathematical language, but once one pushes through the surface complexity, a whole new universe unfolds.

In part, this book is a mathematical text, but there is much within that will be of use to game programmers, since Mandelbrot dwells on all aspects of fractals in simulation. This begins with the more obvious applications stemming from Richardson's experiments, such as coastlines and landforms, and continues into more advanced modeling applications, including orbital mechanics.

More than simply being the introduction to a fascinating mathematical theory, the book is also a practical guide to the application of the theories to the outside world.

Fractals; Hans Lauwerier; Penguin Books, 1991

Somewhat slimmer than Mandelbrot's text, a more readable and accessible short introduction to fractal science is provided by Dr. Lauwerier. Even more interesting is the fact that the book includes sample source code with which the intrepid programmer can build his own fractal creations.

The mathematics is easy to grasp, and as an introduction to fractals, this book is indispensable.

COMPUTER UNIVERSE TEXTS

The Armchair Universe; A. K. Dewdney; W.H. Freeman & Company, 1988
The Tinkertoy Computer; A. K. Dewdney; W.H. Freeman & Company, 1993

These books are collections of columns from *Scientific American* and *Algorithm* magazines, at least on the surface. Where they come into their own is in the additions that Dewdney has made to the original texts in writing the books.

Quite simply, they take the reader through a fascinating series of applications of computer programming and algorithm design to real-world problems. These include ways to enumerate pie, excursions into artificial intelligence, and solving mathematical conundrums.

Along the way, one can pick up some useful tips for programming and algorithm design techniques that give the books more worth than simply being useful, easy-to-read popular science.

SOFTWARE ENGINEERING

Software Engineering; Ian Sommerville; Addison-Wesley, 2000
This book is strictly for those interested in the entire process of software engineering, beginning with design, and ending with testing. It is, however, readable and well written, covering many topics that go beyond traditional software engineering issues.

WINDOWS PROGRAMMING

Programming Windows 3.1, 3/e; Charles Petzold; Microsoft Press, 1992
Charles Petzold has long been *the* authority for Microsoft Windows operating systems programming, and this book is an excellent guide. However, it is a little dated, and has been superceded by *Programming Windows 95*, and by the time this book is published, probably *Programming Windows 2000*.

His books are well written, cover all the required material, and come with many coded examples. As an introduction to the Windows architecture, this book stands out above all others.

GENERAL PROGRAMMING

*The Handbook of Programming Languages; Peter H. Salus (ed);
 MacMillan Publishing Co., 1998*
Far from being a single book, this is a set of programming theory manuals written in large part by the designers of the languages themselves. Although not the cheapest on the market, for those who really want to know everything about all the mainstream (and some of the other) languages and tools, this is the definitive guide.

Unfortunately, the complete set is now out of print; however, the best of the individual books from the series are still available.

ABOUT THE CD-ROM

INTRODUCTION

In the course of this book, a number of software packages have been introduced that accompany this text. They have been used to demonstrate the techniques and algorithms detailed in the book, and provide a means by which the reader can experiment.

All the software is written for the Microsoft Win32 platform, which includes Windows 95, NT 4.0, 98, and 2000. It can be recompiled to run under Windows 3.11, but not Windows 3.0, due to the use of several 32-bit libraries that require Win32s.

The source code is provided for every piece of software, and as far as possible, the core functionality has been kept separate from the Windows API. This means that everything that is Windows specific is kept, as far as possible, separate from the code that is under demonstration. The Windows API code serves only to provide a way to visualize the output.

There are also a number of pieces of software that have been written for the standard ANSI C command-line interface, and contain no Windows API code at all. These will recompile under any platform that supports the ANSI C language set, and has a command-line interface.

CODE STRUCTURE

In order to help those who wish to port the software to other platforms, here follows a brief insight into the way in which the source code was structured.

It will also give the reader clues as to how the software is written, with a view to adapting the code for their own use.

The source code for each of the applications is contained within its own folder on the CD, with an executable version in the "bin" subfolder. Any last-minute instructions, addenda, or additional installation guidelines are in the "doc" subfolder. If there is no "doc" subfolder, then the application package follows these generic guidelines.

Each piece of software has an entry point in the source code file named "main.cpp" or "main.c," accompanied by a "main.h" file for Windows applications. In addition to the header file, Windows applications also come with the "main.rc" and "main.ico" files, in which the resources (dialog boxes, icons, etc.) and icon definitions are stored.

An excellent text for Windows programming is the Microsoft Press *Programming Windows 95* by Charles Petzold. Indeed, by the time you read this, there will certainly be a *Programming Windows 2000* by the same author, and if Petzold follows his usual record of excellence, these are well worth the investment.

The other files in each folder are the code files that actually do the work, and are liberally commented on to indicate the purpose of each function.

INSTALLING THE SOFTWARE

The software, unless indicated by specific instructions in the associated "doc" subfolder, requires no more installation than simply copying the executable file onto the reader's hard disk. Indeed, most of the packages can actually be run from the CD, since they do not write to the default drive.

For those packages that must be copied to the user's hard drive, instructions are included in a plain-text file in the relevant "doc" subfolder.

DISTRIBUTE—RANDOM SEQUENCE ANALYSIS

PURPOSE OF THE SOFTWARE

The Distribute package produces the types of graphs that appear in Part One of the book. While a cursory explanation as to their use has been given, the application is worthy of a more detailed description. One of its uses is in finding combinations of seed values that produce reasonably random distributions of numbers.

Although the key algorithms are taken from the opening chapters of the book—namely, the Dewdney and Lauwerier style algorithms introduced in Chapter 2—there are refinements in the form of wave modifiers that can be used to influence the distribution of values.

USING THE SOFTWARE

The general layout of the Distribute application is shown in Figure B.1. The menu consists of several items, enabling the user to choose an algorithm to set up, set various plot styles, and generate a graph using the options that have been set.

This is the general pattern of use, but the actual details will depend on exactly what type of graph should be produced. The simplest type is one in which the generated numbers are plotted, with a central line that indicates whether the number is higher, lower, or equal to the one before.

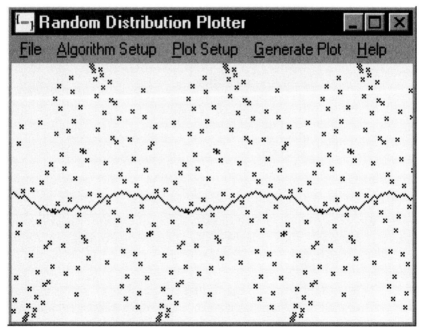

FIGURE B.1 Distribute application main screen.

SETTING ALGORITHM PARAMETERS

Each generated sequence of values requires a core algorithm to be specified that is used to generate each value. The Algorithm Setup menu allows the user to choose which algorithm should be used, along with the input values.

The setup options that are available are discussed in Chapter 2 of this book, and it might be worth rereading this section before experimenting with the software. The reader may also take a look at the source code to further understand the inner workings of the software.

Figure B.2 shows the algorithm setup screen for the Lauwerier algorithm. Briefly, the seed can be any four-digit number, the multiplier can be any number, and the digits field should be set to a number between 1 and 4.

FIGURE B.2 The Lauwerier Parameters dialog.

There are a few points to note. The first is that if zero is used for the multiplier, the software will square the seed each time before stripping the front and rear digits. Care must be taken when specifying "high" multipliers, as the standard ANSI C "long int" data type range must not be exceeded.

Finally, the number of digits specifies the amount of numbers to be stripped from the front and rear: it is the length of the numbers remaining. Specifying a value less than three will tend to yield results with a large pattern.

The second algorithm that can be used is the Dewdney algorithm, and the setup dialog box is shown in Figure B.3.

FIGURE B.3 The Dewdney Parameters dialog box.

Here again, the user must be careful that the numbers chosen are not large enough that the data type range is not exceeded. Aside from that, the parameters that should be chosen are as described in Chapter 2 of this book.

The third and final core-generation algorithm is based on Fibonacci sequences, which are discussed in various places in Part One of the book. While not a true pseudorandom generator, it is interesting to experiment with. The dialog box used to manage the Fibonacci generator is shown in Figure B.4.

FIGURE B.4 The Fibonacci Parameters dialog box.

Here again, the Parameter entry dialog box is constrained only by size of number.

GENERATING PLOTS

There are two modes for plotting sequences of numbers. The first, "Clear and Plot," will blank the screen before plotting the requested sequence. The second mode, "Plot on Top," does not. The behavior is such that it is possible to plot two different algorithm sequences one on top of the other.

The screen is only cleared if the window loses the input focus and becomes obscured by another, or the "Clear and Plot" generation mode.

During the plotting sequence, a dialog will appear that contains the current values to be plotted. If the user does not wish the software to continue displaying these values, he or she should select "No" from the dialog box options.

Plots are generated in such a way as to make full use of the available screen. That is, if the window is maximized, then the software will use the entire screen, minus the title bar area for plotting. The default is with a window suitable for taking screen shots, which is the method used by the author to generate the figures in this book.

SIMULATION RUNS

The final way in which the software can be used is to simulate choices, such as flipping a coin or selecting a card from a deck. The setup dialog box is shown in Figure B.5.

FIGURE B.5 Simulation dialog box.

The "Choices" parameter is simply the number of valid options. For a deck of cards, for example, this value would be 52. The list box to the right indicates whether a wave-form modifier is required. For more details concurring wave-form modifiers, the reader should refer to Parts One and Two of this book.

FASTGEN AND SEQGEN—RANDOM GENERATORS

PURPOSE OF THE SOFTWARE

These two packages are very similar in appearance, with the only difference being that FastGen generates a table of pseudorandom numbers in a text file, and SeqGen produces a series of pseudorandomly generated letter sequences.

Both are designed to be used to create seed values that can be supplied with a game or similar application, that can be read by the game during the play session, and used to generate other values in the Game Universe.

USING THE SOFTWARE

The interface to these applications is identical in each case, so only screen shots from FastGen are included here. The main screen is shown in Figure B.6. There are only two menu options used to set the parameters for the generation algorithm and to begin the generation sequence.

FIGURE B.6 FastGen main screen.

The algorithm setup dialog box is the same as shown in the section, "Distribute—Random Analysis," and is therefore not repeated here.

GENERATING THE DATA SET

Once the algorithm has been set up, the user can generate the data set using the parameters specified. The generation setup dialog box appears when the Generate menu item is chosen, and is depicted in Figure B.7. The "Number of" field specifies the number of times that the algorithm should be repeated, and hence the number of values that should be generated.

FIGURE B.7 FastGen main screen.

It is here that the two applications differ slightly. In order to generate the letter strings, the algorithm must be called 1 to n times, where n is the number of letters required. If the average for n is 6, then, on average, the algorithm will be called six times more often in SeqGen than in FastGen.

This is because FastGen only requires that the algorithm is called once per required element (number), and is significant when one considers the level of repetition that can occur. As we noted in Chapter 2, the level of repetition is related to the maximum number of choices.

If the number of required values is significantly greater than the maximum number of choices, then repetition may occur. Comparing FastGen and SeqGen, we could say that using an average string length of 6, SeqGen will repeat six times earlier than FastGen, and so the maximum number of practicable repetitions is six times less than using FastGen.

EATEM—A SIMPLE PAC-MAN CLONE

PURPOSE OF THE SOFTWARE

This is a very simple *Pac-Man* clone in which the player guides a little yellow figure around a maze, trying not to be eaten by ghosts. It illustrates static behavior strings, predetermined by a random algorithm.

PLAYING THE GAME

There are a number of parameters that the player may set up either before or during a playing session. The appropriate dialog box is depicted in Figure B.8.

FIGURE B.8 FastGen generation parameters.

The only setup options refer to the movement of the ghosts, and these are set as being the default, and a randomly generated string of movements. The way that these are used is defined both in the accompanying text in Part One and in the code itself.

Briefly, each ghost has a string associated with it that contains seven letters. Each of the seven letters may be one of "U" for up, "D" for down, "L" for left, and "R" for right. The way that these are combined leads to the behavioral pattern of the ghost in question.

The user may use the dialog box in Figure B.9 to either set the movement letters themselves, or to randomize them by pressing the Randomize button.

FIGURE B.9 Mandelbrot text-graphics example.

THE ASCII MANDELBROT GENERATOR

PURPOSE OF THE SOFTWARE

The MANDEL software serves two purposes, the first being as input to the COMBINE software, which takes an object analysis table and combines it with a generated pattern to produce the final table upon which object sets may be generated.

INSTRUCTIONS FOR USE

Before running this software, it is important to note that to produce graphical images such as the one in Figure B.10, the DOS Prompt screen height should be set to a high value. In Figure B.9, the DOS Screen is approximately two-thirds as high as it is wide.

The software operates in two modes, textual and graphical. The textual mode is useful for producing the types of tables that are used in Part Four of the book to combine with object adjacency tables. This is also discussed at length in the section, "The DataSet Tools," along with the tools required to perform letter adjacency analysis and word generation.

The second mode is more of an exploratory one, and is useful for depicting the Mandelbrot set in all its glory as an ASCII-graphics drawing. Readers can explore the Mandelbrot set by altering the values in the source code and recompiling as necessary.

In both modes, the arguments to be passed on the command line are almost identical. That is, with no arguments, the software defaults to graphics mode, with the dimensions set in the source code. With two arguments, the software takes these to be the width and height of the desired image, again in graphics mode.

To set textual (table) mode, it is necessary to affix a third argument "T" to the other two. To use textual mode, both the width and height must also be set in the first and second arguments.

THE DataSet Tools

Purpose of the Software

First encountered in Chapter 20, these tools are used for manipulating letter adjacency tables such that a text can be analyzed, an adjacency table built, the table combined with other tables, and words generated using the resulting combined table.

The work is done by three separate applications. The first, LETTADJ, is used to generate a letter adjacency table based on a text specified in the command line. COMBINE takes two tables and generates a third based on the combination of the two. Finally, WRDGEN can be used to build words based on the table that is produced by COMBINE.

As noted in the preceding section, the MANDEL application can be used in conjunction with COMBINE to produce interesting words based on the Mandelbrot set and an analysis of a text. The exact working theory is discussed in Chapter 20. It is, however, important to note that by and large, the reason that the software works is due to the fact that the analysis of an actual set of objects serves to smooth out the effects of a table built on a nonrelated pattern, by removing impossibilities.

All of the software packages are DOS Prompt command-line oriented.

Using LETTADJ

The software takes two arguments, the output table file name and input text file name. It will then generate a table that is 27 characters wide and 27

characters deep. Each cell in the 27 × 27 grid will contain a character that determines the chances of two letters being adjacent in a word.

The grid is 27 × 27 in size to allow for the space character, which is used to designate which letters may begin a word.

There are no real limits on the input file, save that larger files will take more time. The software will work for any language, provided that any special characters, such as those with accents, are removed.

USING COMBINE

The Combine software takes four arguments. The first two specify the file names of the table files to combine. Both files should be the same dimension, and respect the format generated by LettAdj, described in Chapter 20.

Arguments three and four are the width and height of the table files that are to be combined. These will also be the dimensions of the output.

Once the software has been launched, it will read in both tables and compare each cell. Depending on the rules defined in Chapter 20, a character will be output to the screen that shows the end effect. In order to use the tables that are generated by this software, it is recommended that the output be redirected to a file.

Redirection is performed under both DOS and Unix by affixing a greater-than sign and file name to the command line, as in the following example:

```
COMBINE fileone.txt filetwo.txt 27 27 > fileout.txt
```

If the output dimensions are greater than the screen dimensions, the resulting file will be larger than the screen can display. However, the line breaks will be preserved in the file; that is, for lines that wrap around on the standard display, there will not be a corresponding effect in the text file that is created using the redirection.

USING WRDGEN

This software is specifically used to generate word lists, and takes four arguments. The first is the file name of the table file that is the result of either the LettAdj software or the Combine software detailed earlier. The table dimension should be 27 × 27.

The second and third arguments are the minimum and maximum word lengths. All words that are generated will have a length that is between these values. The fourth argument specifies the number of words to generate.

Once launched, WrdGen will proceed to generate the specified number of words, using the table to determine the adjacent letters. The actual technique is described in Parts One and Four of this book.

It is recommended that the output of this software be redirected in the manner specified earlier in the description of the Combine software.

THE BTERRAIN GENERATOR

PURPOSE OF THE SOFTWARE

The Ballistic Terrain Generator uses a fractal technique that is discussed at length in Chapter 21, where there are also some example figures that show the output of the software. The graphical format of the output is a Windows bitmap file, which is a format that should be readable by most operating systems.

USING BTERRAIN

The software runs as a command-line application, and takes five mandatory and two optional arguments. The first two arguments are the width and height of the desired image. These are followed by the number of ballistic "hits" that should be made on the landscape. These will be placed at random coordinates on the starting plain, and will have random height values associated with them.

The fourth argument indicates the number of iterations that each ballistic point should be expanded by. For a full analysis of the technique by which the image is built up, the reader should refer to Chapter 21. In essence, though, the iterations value specifies the number of passes that should be made to build up each "island."

The final mandatory argument specifies the value that is needed to seed the random number generator. The values from the generator are then used to determine each ballistic coordinate, the height of each coordinate, and during the generation phase, the exact position of affected coordinates based on the eight possible neighbors for each ballistic coordinate.

The two optional arguments specify the output bitmap file, and the number of pixels per coordinate that should be plotted in the file. If these arguments are not present, then the output is directed to the screen in much the same way as the Mandel software discussed previously.

If an output bitmap file is required, then the width and height, when multiplied by the number of pixels, should be a multiple of 4. This is due to the constraints of the bitmap format. For further information about the bitmap file format, the reader should refer to the Windows programming documentation, of which a reference is included in Appendix A.

THE FERN GENERATOR

PURPOSE OF THE SOFTWARE

The Fern generator is a piece of software that can generate a very simple fern leaf using a set of affine transformations. The exact transformations that are used are described in Chapter 21. It will generate either an ASCII graphics or Windows bitmap image that is created using the aforementioned affine transformations and algorithm.

USING FERN

The Fern generator takes the same number of arguments as the Ballistic Terrain generator described earlier; namely, the width and height of image, number of hits and iterations, random number generator seed, and, optionally, the output file and resolution.

The difference is in the way that the two pieces of software treat the hits and iterations parameters. Essentially, in the case of the Fern generator, the number of points that are generated in total is equal to the number of hits multiplied by the number of iterations.

Experimentation will be the key to finding values that work well, but it is important to remember that the more iterations there are, the more lines will be drawn, but that the more hits there are, the more the algorithm will "jump" around.

FACEMAKER

PURPOSE OF THE SOFTWARE

This package is simply an illustration of the technique of converting a co-ordinate-based system to a visual representation. It takes as input a file

containing a set of coordinate values, separated by commas, and with zero values to separate items.

By way of example, a data file is included with the software called "Face-data.dat," which contains a set of values that depict an average face. The values are derived from an image in Dewdney's book *The Tinkertoy Computer*, mentioned in Appendix A.

Each item (eye, hair, head, etc.) is constructed from a set of values, derived from the grid representation shown in Chapter 15.

USING FACEMAKER

Once the application is run, the screen looks like that shown in Figure B.10.

The main options are in the Size menu, which contains the options shown in Figure B.11 for increasing and decreasing the size of the image according to the user's desire.

The Mode menu serves to set the drawing mode, either a single face, or a "crowd" of different faces all based on the original, but with differing scaling.

FIGURE B.10 The FaceMaker main screen.

FIGURE B.11 The FaceMaker Size menu.

THE DATA FILE

The data file should be in the same folder as the executable file, and must adhere to a strict format; namely, the file should begin with a two-number coordinate that is the coordinate of the center of the object.

Next, each feature of the object should be translated into coordinate pairs, and these should be listed in the file, each on a separate line, and separated by commas.

Each set of coordinates must begin with a double-zero coordinate, on its own line. The file must be named "facedata.dat"; the reader should take a look at the existing one for more details about the layout of the file itself.

PAIRS2K

PURPOSE OF THE SOFTWARE

This is a very simple card game, described early in the book. Figure B.12 shows a screen shot of the opening screen.

FIGURE B.12 The Pairs2K Screen.

OBJECT OF THE GAME

The aim of Pairs is to match cards, numerically by suit color, by turning them over two at a time. If the two cards that the player turns over match, then they remain turned over. If they do not, then they are returned to their former state. The game is finished when all the cards have been turned over.

To turn over a card, the user simply clicks on it, and the face will be shown.

INDEX